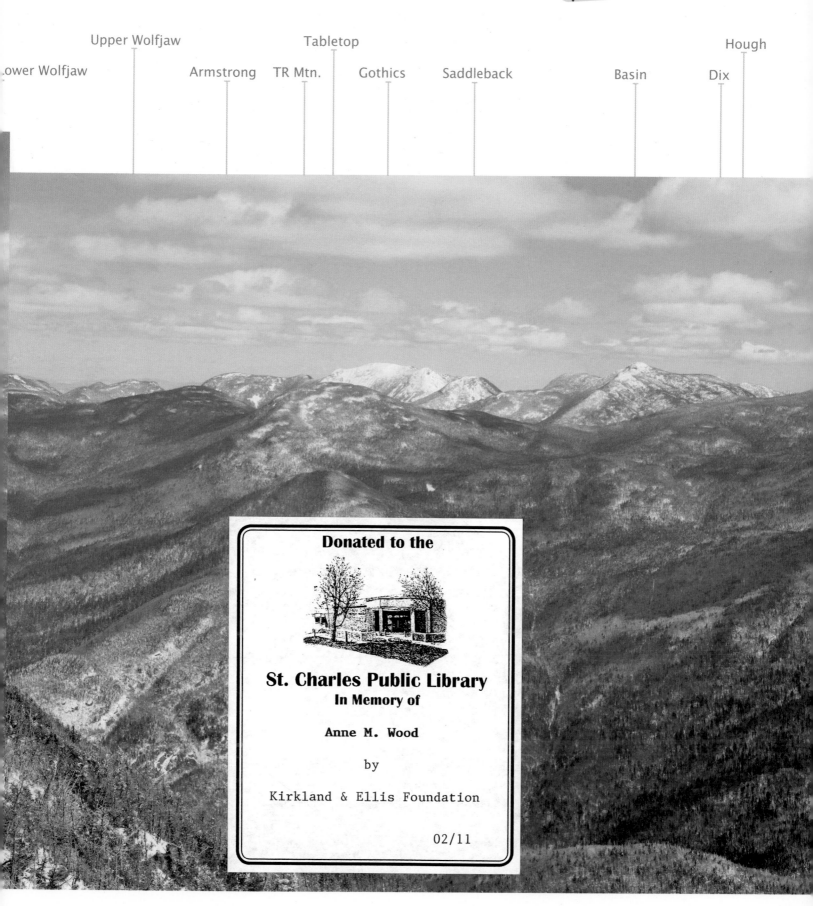

ower Wolfjaw Upper Wolfjaw Armstrong TR Mtn. Tabletop Gothics Saddleback Basin Dix Hough

VIEW FROM WRIGHT PEAK

ADIRONDACK WILDERNESS

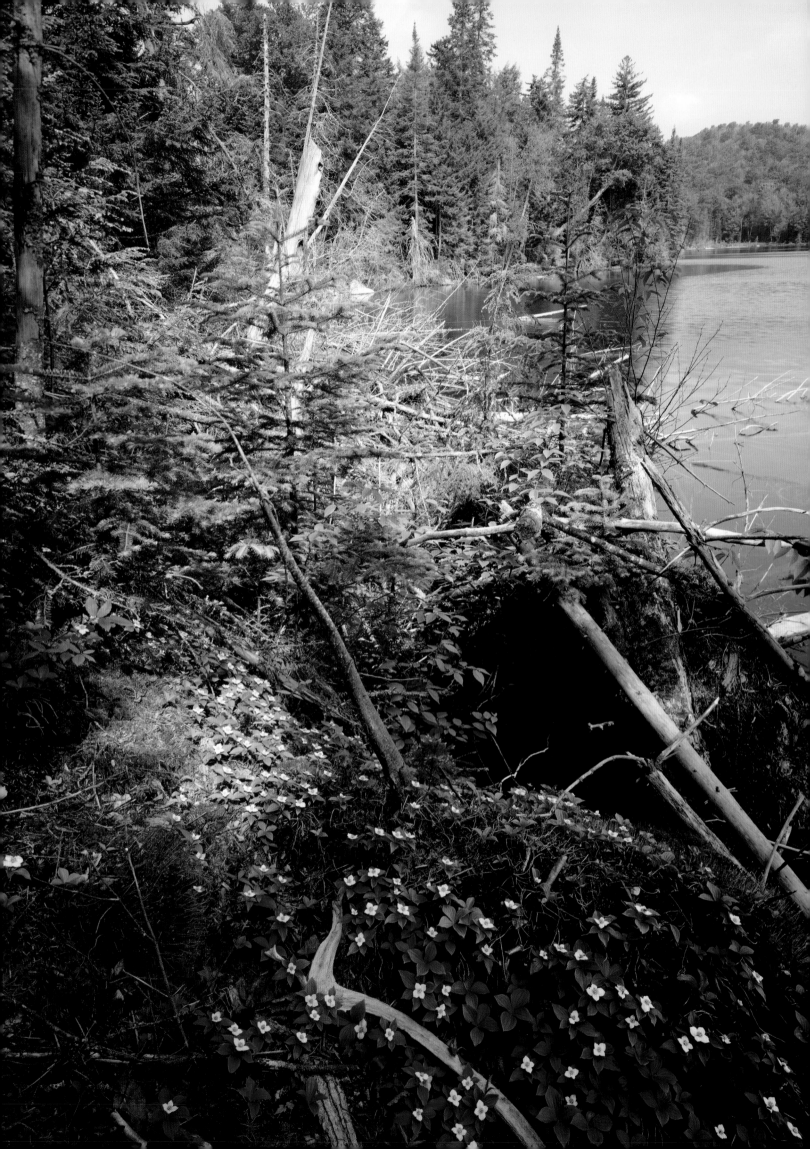

ADIRONDACK WILDERNESS
NATHAN FARB

Foreword by Russell Banks
Afterword by Bill McKibben
Selected Naturalist's Notes by Jerry Jenkins

SAVING THE LAST GREAT PLACES ON EARTH

NEW YORK

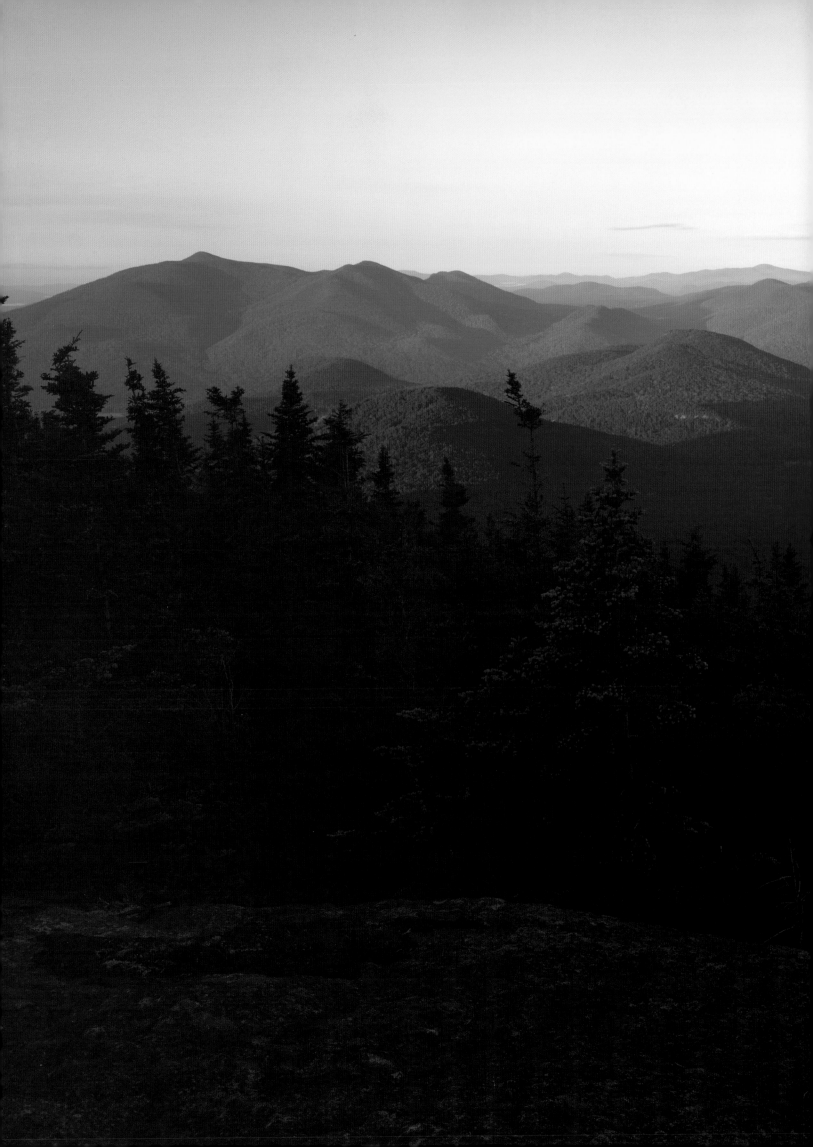

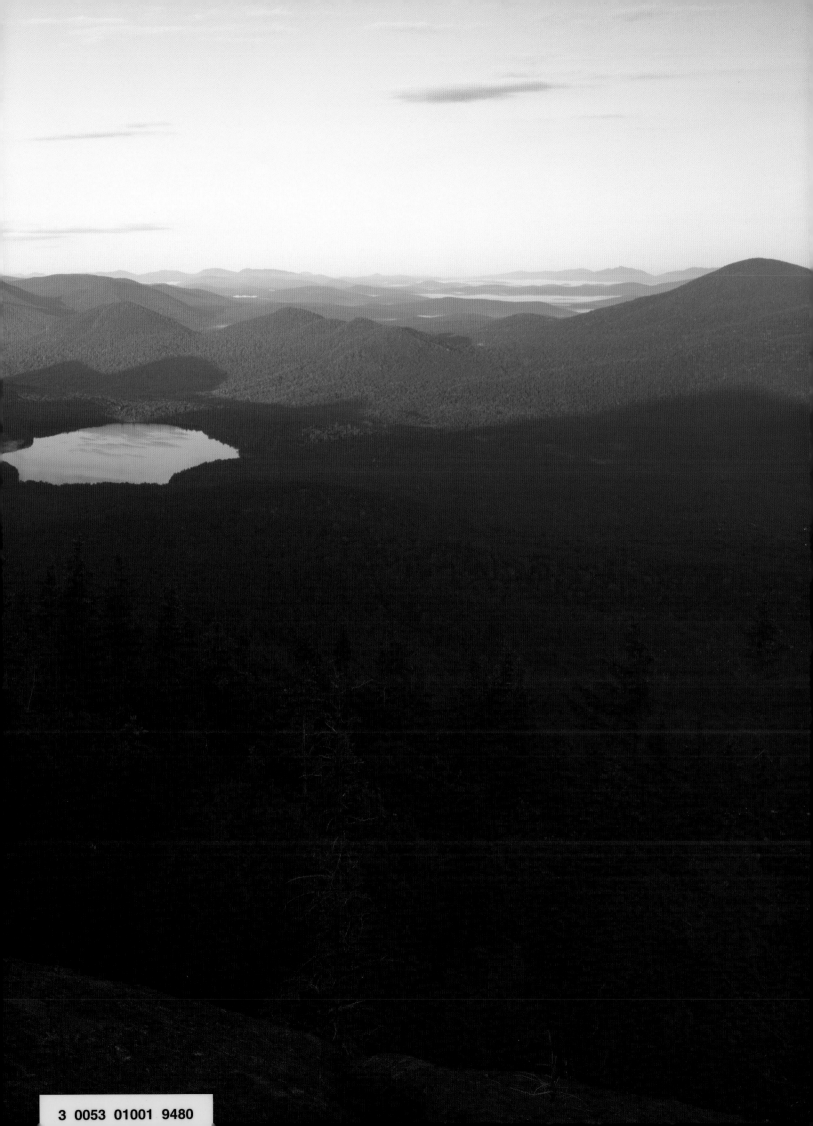

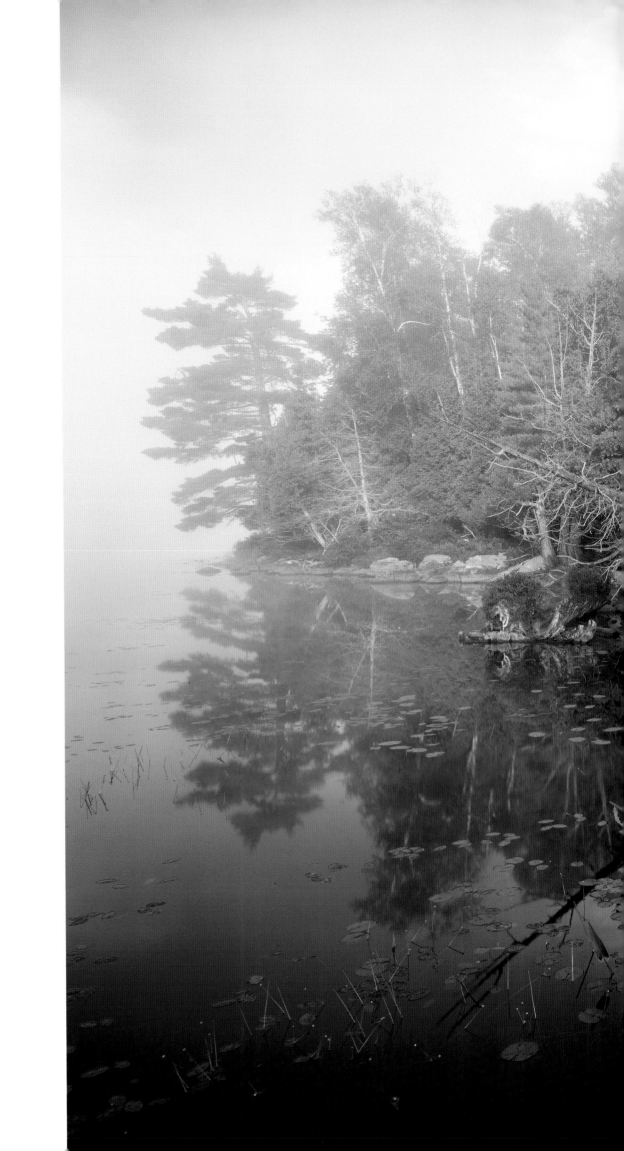

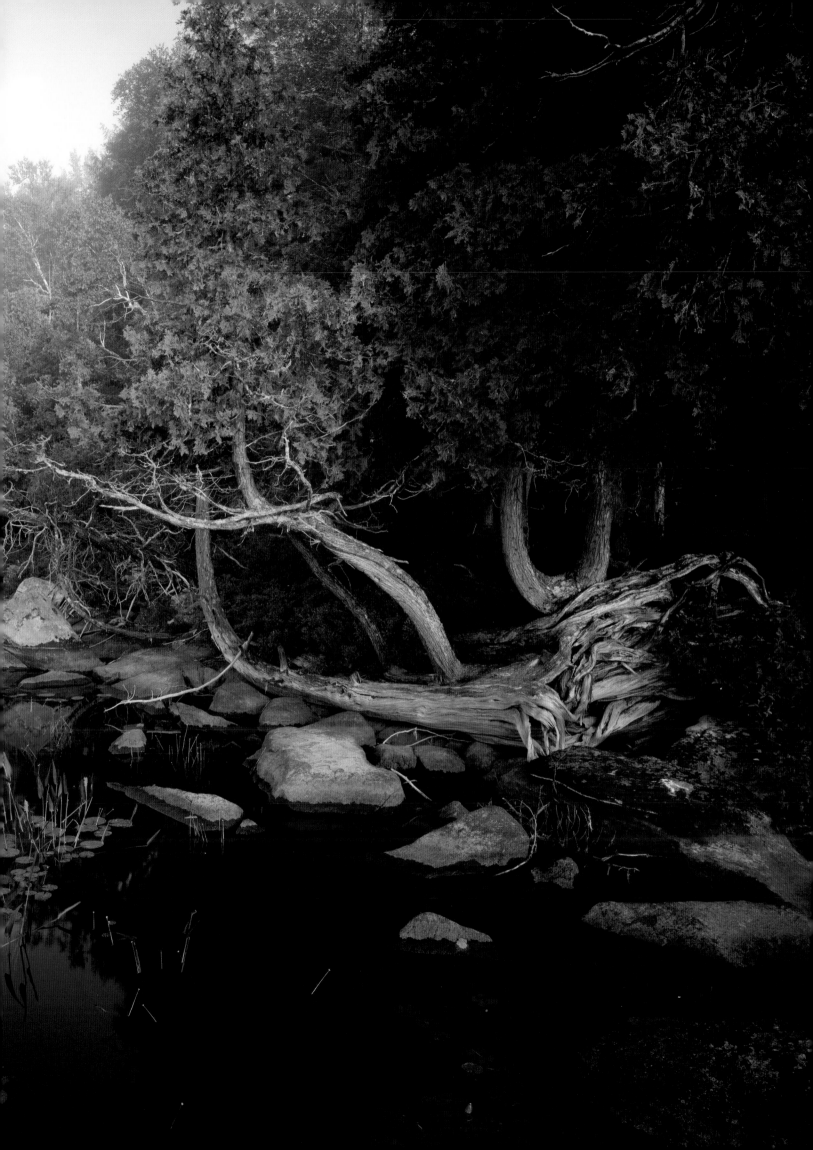

For Esmé, whose embrace of life is more powerful than anything I could have ever imagined.

And for Kathleen.

And in memoriam, for Anne E. Lacy, 1951–2002, and Robin Pell, 1934–2003.

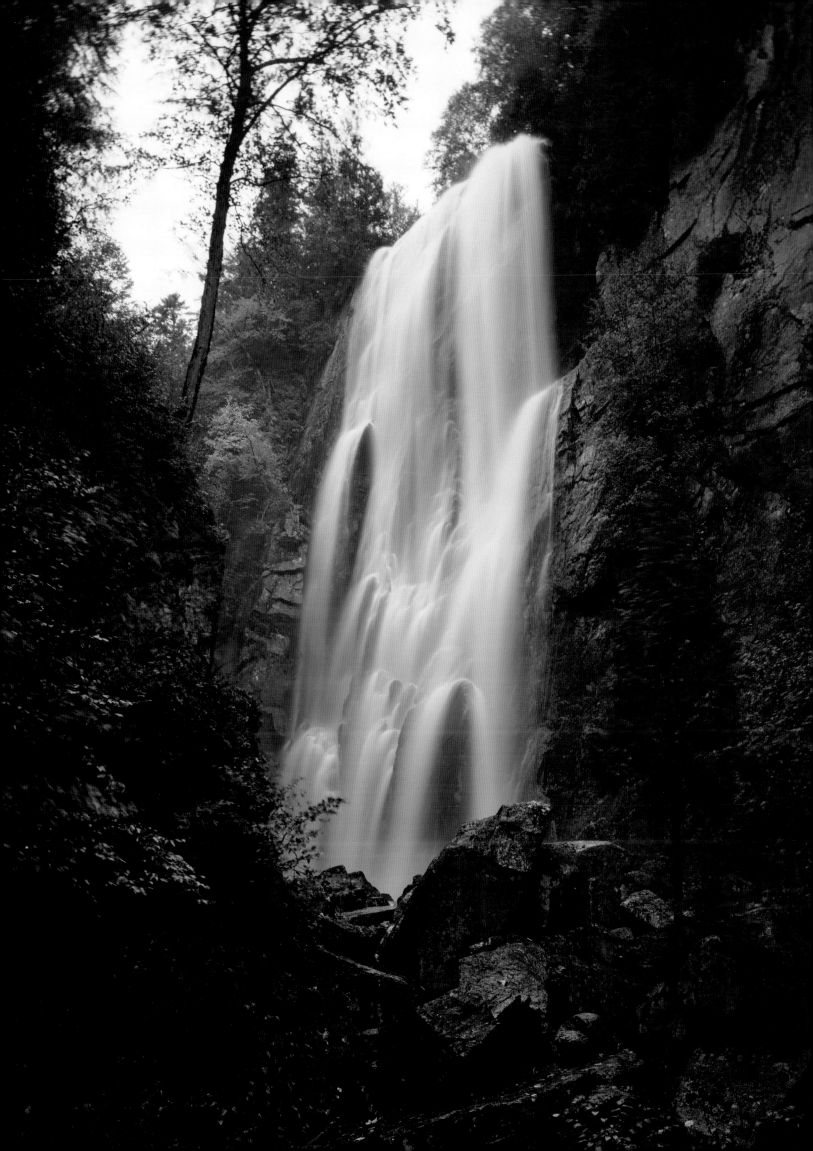

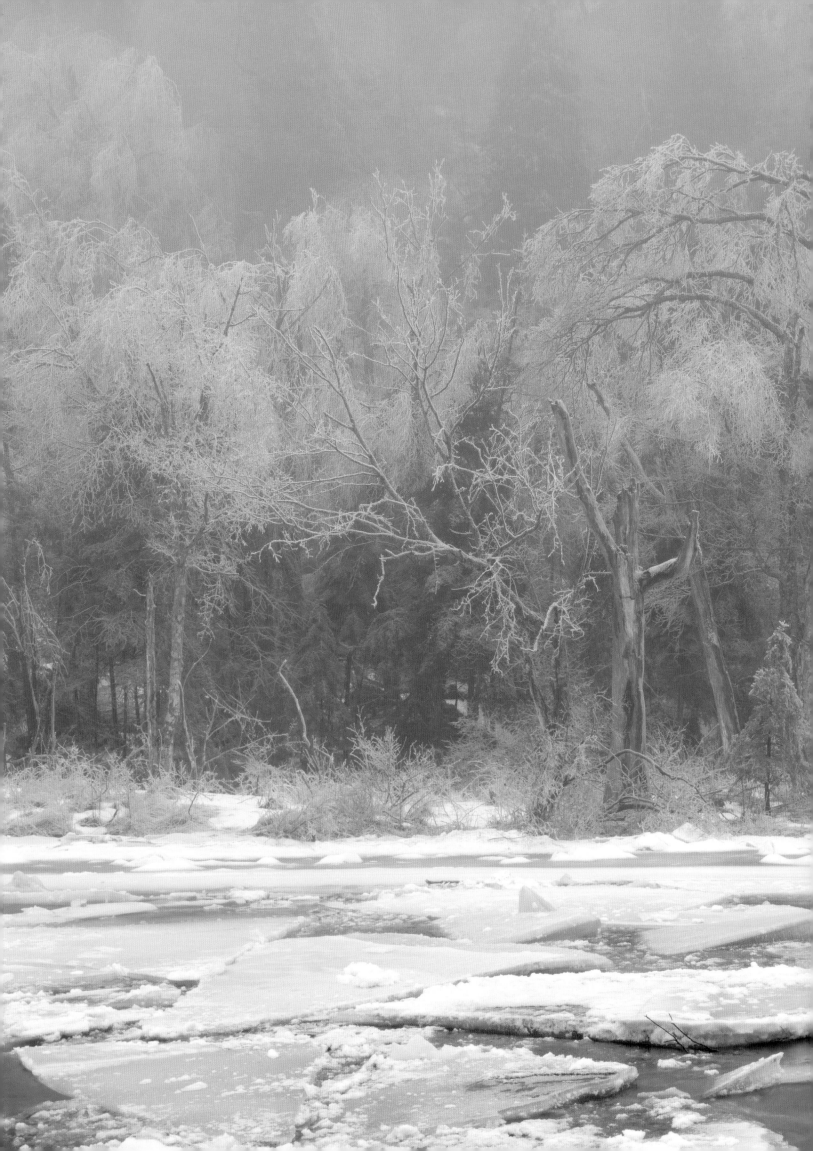

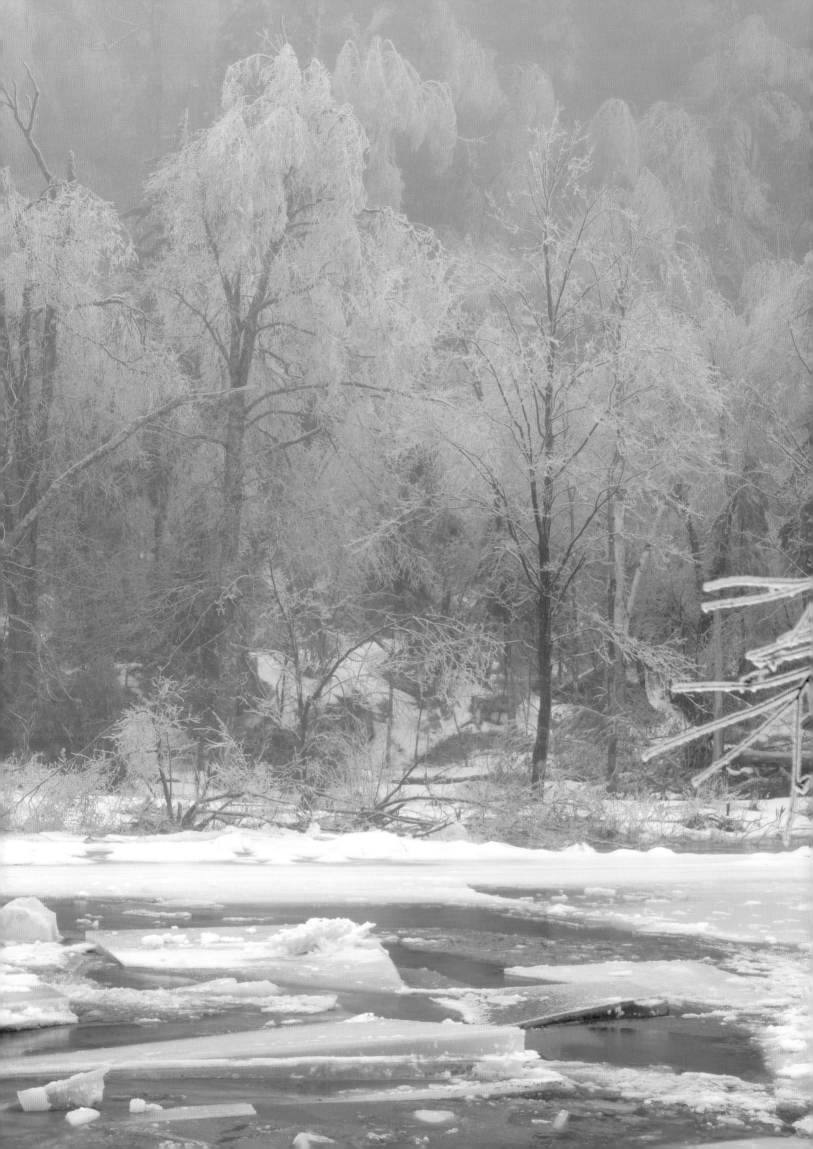

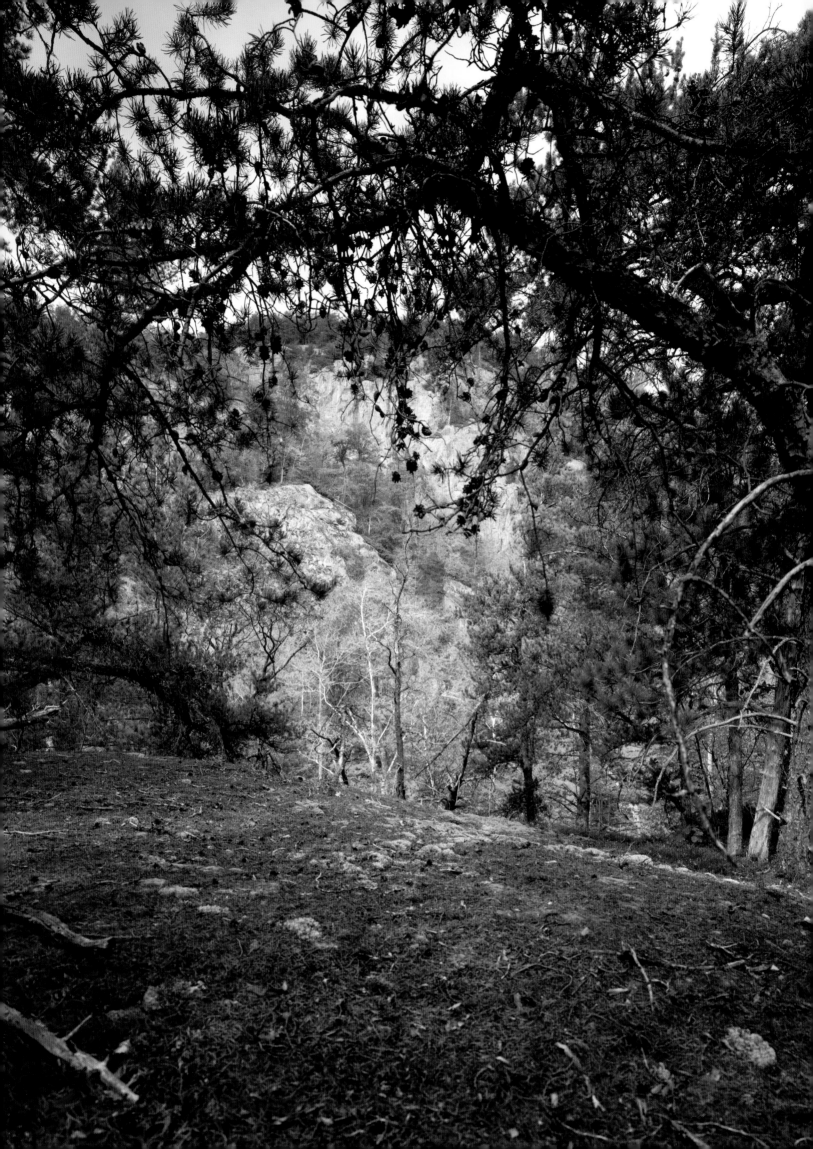

Contents

FOREWORD

On Transcendent Ground

At first glance, but only at first glance, these are images of nature. Nature capitalized. At the most apparent level, they are cartographic—eye maps designed to lead us into and through the vast Adirondack wilderness of northern New York. They situate us in a scenically familiar spot on the rugged surface of the planet in a plain manner sufficiently conventional to let us momentarily get our bearings. We feel comfortable here. We're both in the wild and very much at home. But the six-million-acre Adirondack Park is merely the locus for these photographs, their momentary locale. It is a gate, a deceptively familiar gate that opens the way to a dizzying, Dantesque descent, initiating a plunge into the earth, where we swiftly come to ground, chased there by physics (gravity, temperature, and light) and Nathan Farb's furiously concentrated gaze. "The walking of man and of all animals," Emerson said, "is a falling forward." And the images that open to us on the near side of that gate—enormous, sense-surrounding, dead-on visions of the earth—as soon as we do more than glance at them, shove us forward and down through water, scree, lichen, rock walls, ice and snow, into deep geological time and space, where ice is transformed into water, water into vapor, where rocks are crumbled and devoured by plants, and trees give birth to boulders. There foreground switches place with background, and the figures in the ground, the rocks and dirt and mouldering leaves one walks upon, become the literal ground itself. And one suddenly recalls that "ground" is a noun that is also emphatically a verb, the past tense of "grind." In these images, layers and levels of concrete and spiritual reality grind constantly against one another.

Though the photographs gaze upon the physical world with unalloyed rapture and portray the tangible, material singularity of rock, water, and plant life, they are filled to the edges with the visual equivalent of linguistic leaps of allusion and reference. They overflow with double entendres, puns, and metaphors that we can only see rather than say. Like poetry, the images first disorient and then reorient the viewer's point of view. They change us, for when we look at them, the pictures don't move; we do. As in "Orebed Brook" (see page 119), where one's center of gravity shifts abruptly from a dizzying point overhead to the horizontal plane. First we think we're looking down upon rockface and icy water falling into a pool, and then unexpectedly we find ourselves gazing from a head-high point on a line parallel to the floor of the forest, as if we are standing inside an archaeological dig staring wonderstruck at the layered ruins of a series of ancient cities, or are driving in a car through a hill cut by a

highway, speeding past layers of sedimented rock, traveling through geological time. In these photographs Farb's true subject is time and the timeless. We look at them, and as the seconds pass, falling leaves and sand particles drift in scrims for eons to the bottom of an ancient lake bed, where they settle and slowly begin to mineralize. Farb's drama, his narrative, implicit in a single image, tectonic in scale, is measured both microscopically and telescopically, as if his intention, his deepest desire, were to provide us with an X-ray vision, as if he wished to open our eyes to the ground we stand simultaneously not only on, but in.

Typically, as in the photograph entitled "Spring Debris" (see page 116), the images swirl and reconfigure themselves like the components of a dream. For one thing is not like another; it *is* another. A pleat of old snow is the pelvic bone of a prehistoric horse. A boulder is a stone ax head used for killing. A cold corner of the forest is the grave site of a bog man, or it's the body of a Cro-Magnon hunter frozen to death in the Italian Alps. There is a continuous tension in these pictures between the literal and the figurative that corresponds to the ongoing exchange between figure and ground, between foreground and background. It is dialectical, engaged, and in deep metaphysical conflict, and is therefore profoundly dramatic. In every photograph, there is a mysteriously evocative narrative that is comprehensive and, insofar as every part contributes to the overall effect, is Aristotelian.

It can be perilous to open oneself to this narrative. For one's emotional and intellectual equilibrium, one wants to keep fixed relations between figure and ground, foreground and background, microcosmos and macrocosmos, close-up views and aerial views. One wants to be grounded. But in the fourteenth century, the word "ground," or *grund*, for Meister Eckhart, referred to the divine essence or center of the individual soul, the place where mystic union lies, where there resides a spark that is consubstantial with the unrealized presence of the deity. One might be led to speculate, given the evidence of the photographs, on the nature of Nathan Farb's deity. Many of the photographs are images of the female (not of the merely feminine): to Farb, the planet is moist, watery, filled with nutrients, constantly giving birth. His bogs and muskegs and ponds are primordial soups. "Vernal Pond" (see page 58)—stilled and wholly abstract when viewed from a distance—comes to life when seen close-up: polliwogs and tadpoles school and swirl like spermatozoa. Yet from the evidence of "French Brook" (see page 160), where light falls in pale bands and sunlit snow is inhabited by heat, the ground, or *grund*, evokes a male deity, one for whom light and temperature are as substantial a firmament between the firmaments as the earthworks thrown up to divide the waters above from the waters below by the Hebrew god of Genesis 1:6.

Are these religious pictures, then? Undeniably so. They invite us to contemplate the whole of Creation, to meditate on the spiritual paradox of its irreducible complexity and infinite simplicity. Like prayer, these images sustain us by making us larger than the sum

total of the minutes of our lives. At bottom, Nathan Farb's relation to Nature (capitalized) is echt-American, which is to say, transcendental. It is Emersonian in intent and locale and is Buddhist in scale and mental methodology. In "Follensby Pond" (see page 68) the swaying, dark, underwater stems of lily pads rise to the surface of the picture where they lie against the reflected pale sky like the brush strokes of a Zen calligrapher, and might have been pictured in the mind of Thoreau, who, looking from the shore of Walden Pond, saw not his private patch of Massachusetts, his small corner of the universe, but the whole of it. "Show us the arc of the curve," Emerson said, "and a good mathematician will find out the whole curve." In these photographs, Nathan Farb shows us his private patch of upstate New York, and from them, like good mathematicians, we can figure the earth itself and can know what lies beneath and soars overhead.

Russell Banks
Keene, New York

INTRODUCTION

Looking at the Adirondack Landscape

I have been looking hard at the Adirondack landscape for close to sixty years. My childhood teachers in Lake Placid would certainly tell you that I spent as much time as they would let me get away with just hanging out at the windows with a great view of the high peaks. There a small boy could see mountains covered with bold colors in the fall, snow in the winter, and subtle shades of green in the spring. I daydreamed of bushwhacking to places never seen by another person, perhaps finding and climbing into crevices with strange shapes and footholds that would allow me to scramble to the tops of those slopes.

I was first brought to the Adirondacks as a five-year-old boy in 1946. My mother, looking for a father for me, had answered a personal ad in a Jewish newspaper from a recently widowed rabbi. They met, married, and we moved to Glens Falls, New York. Then, when a position opened up at a congregation in Lake Placid, my mother urged my stepfather to take it. She knew Lake Placid as the home of the 1932 Winter Olympics and was excited by the possibility of living there. My stepfather was the only rabbi in the Adirondacks, so like a country doctor he traveled from town to town. He was also a chaplain at tuberculosis sanatoriums in Ray Brook, Saranac Lake, and Tupper Lake. My stepfather who grew up on New York's Lower East Side, had never learned to drive. My mother, a fourth-generation Arkansan, who claimed she started driving at age twelve, became the chauffeur, and I tagged along. Together we explored the Adirondacks. To a wide-eyed and impressionable seven- or eight-year-old, the towns all had exotic names—often Native American in origin, such as Onchiota and Ticonderoga. While my parents attended to their pastoral duties, I was free to wander into the nearby woods.

When I was eleven, I joined a Boy Scout troop, which was sponsored by the local American Legion Post. To go to our upstairs meetings we had to walk through the American Legion's barroom, which was an education in itself. We did not make rank as quickly or get nearly as many merit badges as the "uptown" church-sponsored troop, but we had a lot more fun.

We went on camping trips to "build character," which, in our case, usually meant going to a lean-to at Marcy Dam, smoking cigarettes, sharing a few cans of beer, and trying to act like tough woodsmen around the campfire at night. We also developed an appreciation of the forest and its streams, ponds, bogs, and high alpine terrain.

At about the same time, or perhaps even before I started making trips into the woods, I became interested in photography—or really, in the minute details of photographs. It is no accident that in later years I became obsessed with using large negatives in my photography to attain the maximum detail possible. As a boy, I would look searchingly through a mag-

nifying glass at photographs of my real father, who had died before I was born. I strained to find some clue that might help me know a little bit more about him and was frustrated when magnification only revealed film grain. I understood quickly that if someone had used a better camera I might have learned a bit more about him.

My father, Nathan Farb, circa 1929. Kanawa, Oklahoma

Photography was an avocation at first. I went to gradu-ate school in psychology and joined the National Guard. I tried writing and then painting. Neither was as easy or immediately satisfying as the first dozen rolls of film I exposed. I was working as a reporter for a suburban newspaper when I bought my first camera, and I quickly felt that I had found the right medium. It seemed both a means of self-expression and a tool of persuasion that can open people's minds to your way of seeing things.

My first ten years of photography were concerned al-most entirely with the social landscape. While I did not go to photography school, I respect-ed and studied the work of Dorthea Lange, Walker Evans, and Robert Frank. Later I got to know the photographs of August Sanders, eventually using his images and those of Michael Disfarmer as the intellectual framework for my 1980 book, *The Russians*. It had sparked a particular interest in photography's ability to catalog the world, its types and species.

The Russians, though an artistic success published in five countries and excerpted by magazines throughout the world, was not a financial success. This and the fact that my personal life was in shambles made me feel that I needed to spend some time in the woods to find my balance. I had taken some photographs in the Adirondacks in the 1960s and 1970s, but I really began working in the Adirondacks seriously in 1982, when I bought my first 8" x 10" Deardorff camera.

I chose an 8"x 10" view camera because it can capture fifty-five times the amount of detail that a 35mm camera can. While I had made some interesting images with small- and medium-format cameras, I knew that if I were to show the landscape with as much clarity and precision as possible, I needed to make these photographs with a large original transpar-ency. (The film that I use for this camera is actually positive and not a negative.) All but one image in this book was made that way.

There is a level of detail that the human eye can never fully see in these transparencies without using a magnifying glass to search through the image. This is comparable to looking at images from a powerful telescope or microscope and examining the pictures closely to discover what you might find. Now, with high-resolution scanners and extremely sharp computer screens, I have even better magnifying and searching tools. This book shares the benefits of this technology, allowing the viewer to jump into exposure details from several images.

Since the publication of *The Adirondacks* in 1985, I have been asked to give many talks at colleges and libraries as well as to conservation organizations. Those talks made me realize that my photographs can help people see how nature works. The book you are holding includes about twenty of my favorite previously published photographs and eighty-five new ones.

In my lifetime, I have seen many changes in the landscape, some of them quite simple and perhaps obvious. There are two striking changes that come to mind. One is that the forests have grown, which is due, at least in part, to less extraction of natural resources. The second, which is truly disturbing, is that the water in the wilderness is no longer drinkable. One of the great pleasures of my childhood was being able to drink out of any stream, but the reality is that people have not been careful with their waste, and now giardia is widespread.

These man-made changes and natural changes in the environment are sometimes difficult to separate. Changes such as wind influencing the shapes of the trees (page 100), ice erosion (page 10), water erosion, and new slides on the mountains are natural and continuous, but I wonder if some of these changes have been accelerated by atmospheric pollution.

While these changes are slow in human terms, they are observable over a lifetime. I hope my 8" x 10" negatives will provide some ecological baseline data of what existed during these times. I plan to go back to some places that I have photographed, make a GPS (Global Positioning System) reading, a compass bearing, and note the field of coverage for each lens I used. I hope this will help future scientists make accurate comparisons.

In the 1950s William Chapman White wrote, "As a man tramps the woods to the lake he knows he will find pines and lilies, pickerelweed, blue heron, and golden shiners as they were in the summer of 1352, 1852, as they will be in 2052 and beyond. He can stand on a rock by the shore and be in a past he could not have known, a future he will never see."

I grew up believing this implicitly, but now it seems to be in question. I wonder if we can still stand in that assumed future. I prefer to think that we can, because I believe that our psychological and spiritual well-being depends on it.

Another important change that affects how I see things is the unprecedented acceleration in scientific knowledge about the universe and about the Adirondacks. It is now known that the dome of Marcy and the slides on Gothics are made of the same type of rock

as that which has been found on the moon—anorthosite (see page 50). It just reemphasizes the connectivity of everything in our solar system, if not the universe.

I found it a bit amusing that Dr. Steven W. Squyres, lead scientist on the Mars Rover Mission and professor of astronomy at Cornell University, named the first rock that *Spirit* encountered "Adirondack." As I suspected, he is a fellow hiker who has enjoyed exploring these mountains.

Another scientist involved in the study of the universe has spent a good piece of his life in the Adirondacks. Dr. Peter Simmons, a former project manager of the Hubble Space Telescope, summers on an isolated island in a magnificent lake. He would often invite me to his camp to see the latest images from the edge of the universe. Those pictures showed what scientists believe to be the beginning of time.

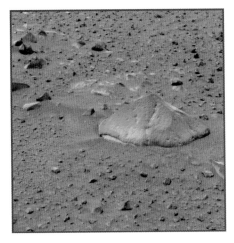

The rock "Adirondack," photographed on Mars by the rover Spirit

When I was a boy, one did not think about time itself having a beginning—unless one subscribed to a theological view of the universe. I felt that the Adirondacks were vast and unknowable. When I looked out at the stars or into the mountains, I mainly wondered where we came from. Now I am much more curious about where we are headed and what we are becoming. The Adirondacks are increasingly surrounded by development. Just outside my corner of the park, there are half a dozen big-box stores. Development, although regulated, continues aggressively inside the park as well.

In my life the character of the Adirondacks has changed, making it more of an island within a larger sea of commercial development than ever before. Does this make it any less beautiful or romantic? I would argue that it makes it even more so.

Where does the beauty come from and what is its nature? This asks a fundamental question. Does beauty in a platonic sense exist or is it purely relative? My instincts tell me that there is a uniquely harmonic balance of water and land and light in the Adirondacks. I have a completely speculative theory that such a mixture gave birth to Hellenistic civilization. I believe that in a similar way, the Adirondacks, inhabited for only a brief time, have had a profound influence on our culture and are in the midst of bringing some new gifts to humankind.

Most of us feel an instinctive connection to nature. In this book I share a few tales that might make you feel related to it even more, almost as if it were family, in much the same way that Native Americans speak of nature's elements. With expert help

from the highly respected Adirondack ecologist Jerry Jenkins, I have also tried to offer some natural history and ecology to help you understand the earth's processes. The Selected Naturalist's Notes, which appear in the index of the book, provide an added accompaniment to a selection of the photographs that are of particular ecological interest. Many factors, such as the geology, the climate, the microclimate, the time of year, and the amount of light, lie behind the beauty of a picture. I hope that with a greater appreciation of what is going on in the images will come an even keener appreciation of the natural world itself.

Nathan Farb
Jay, New York

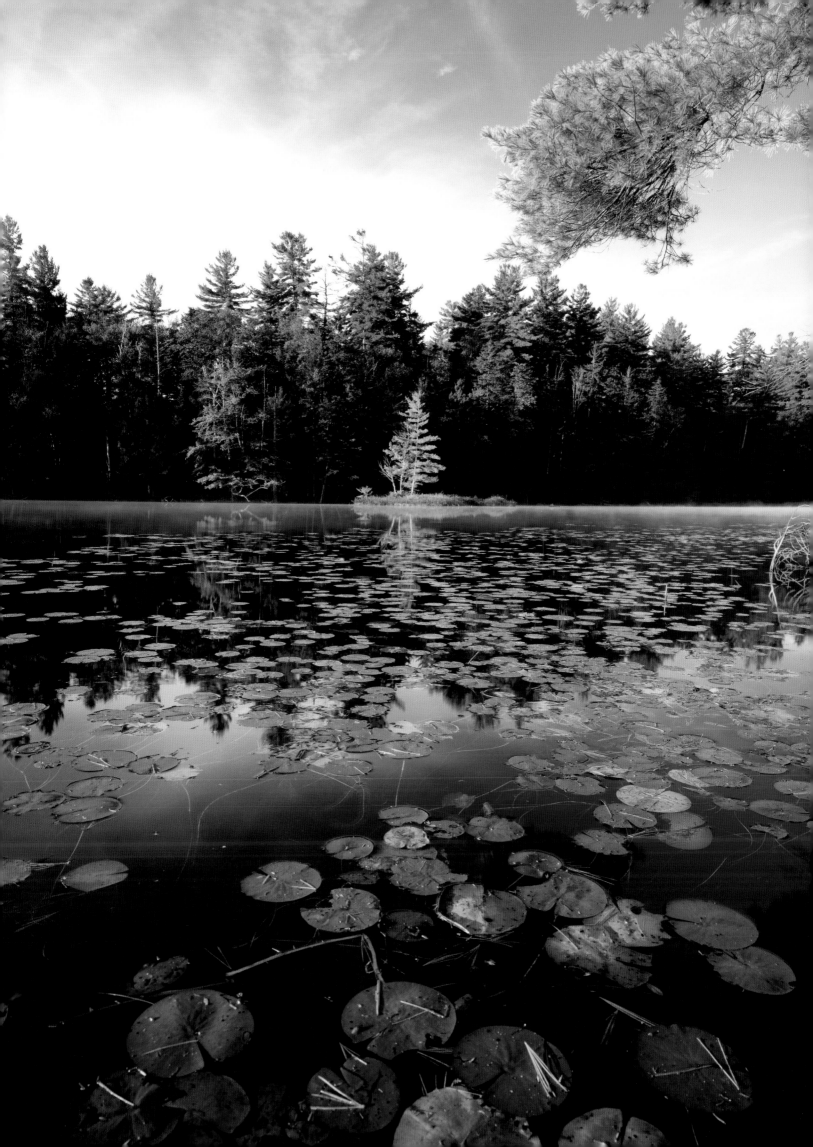

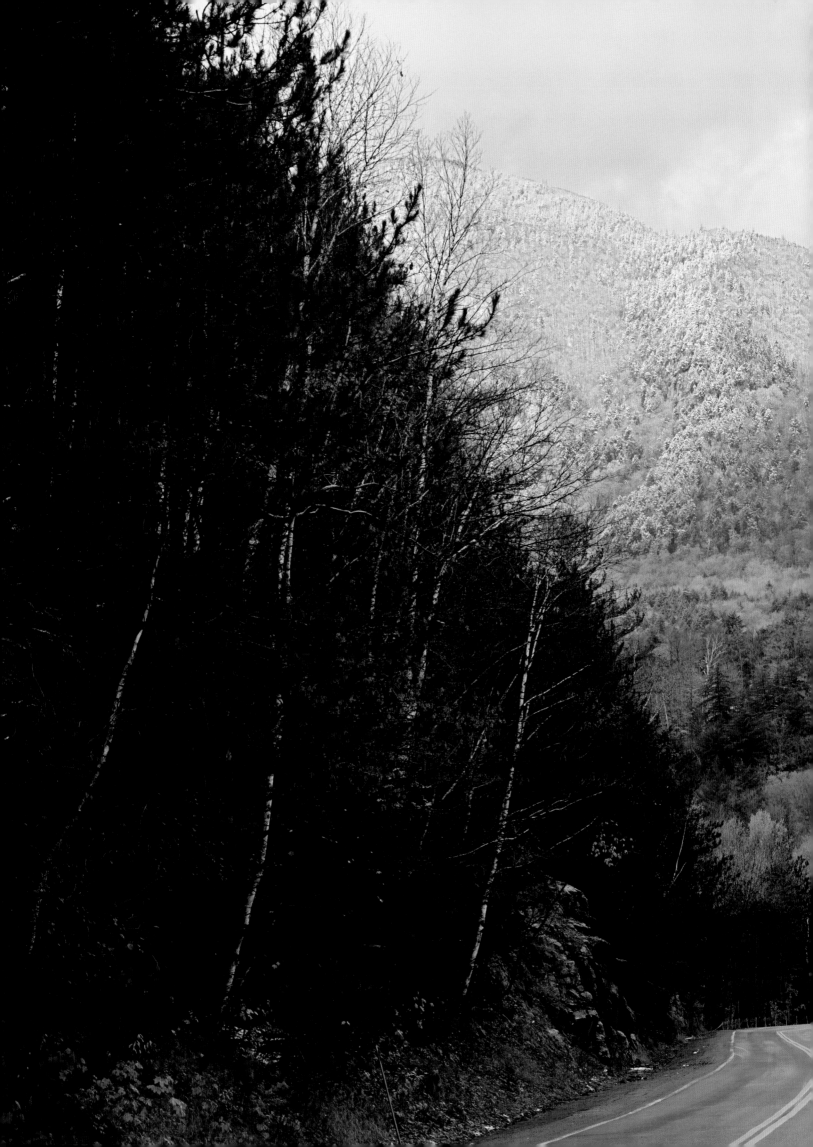

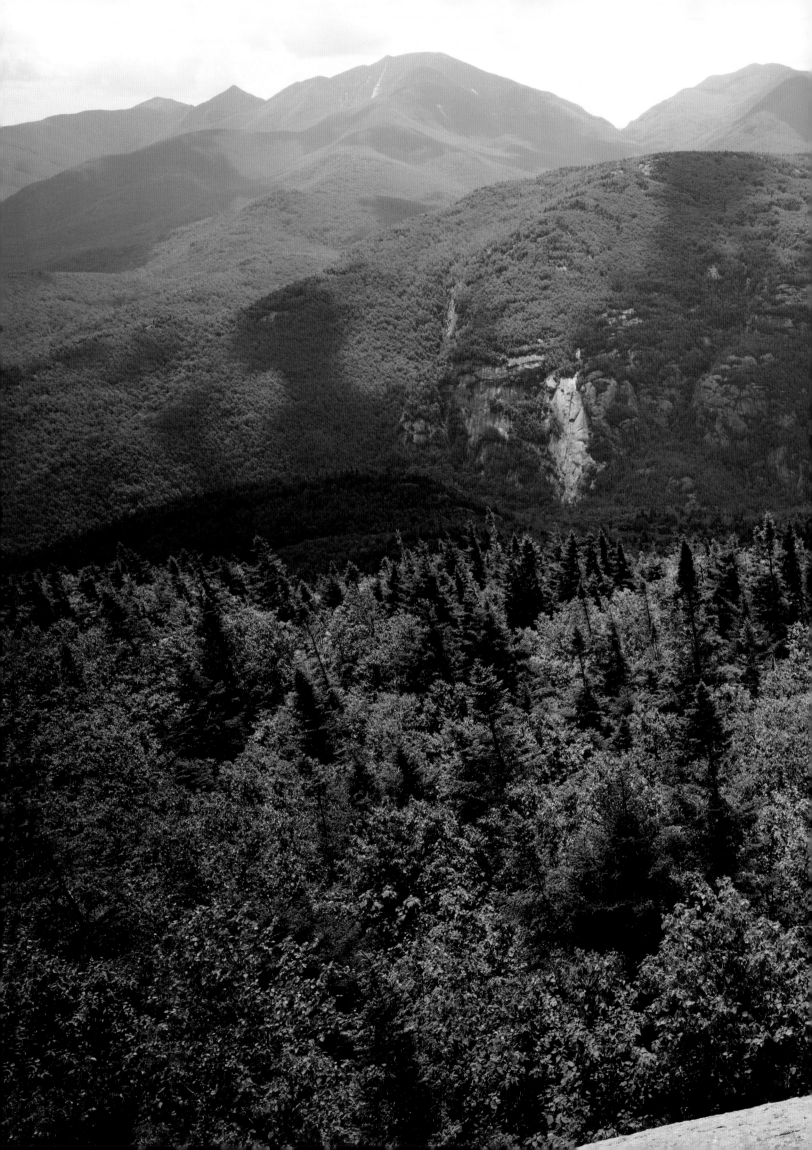

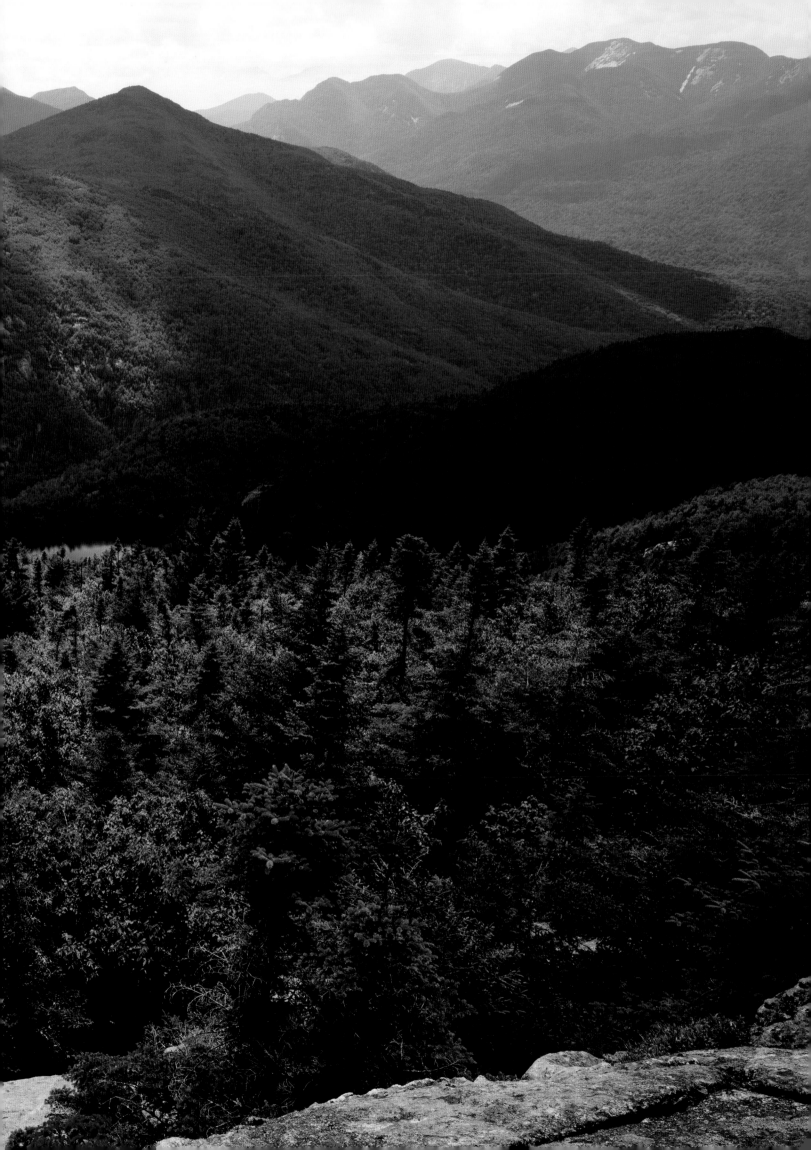

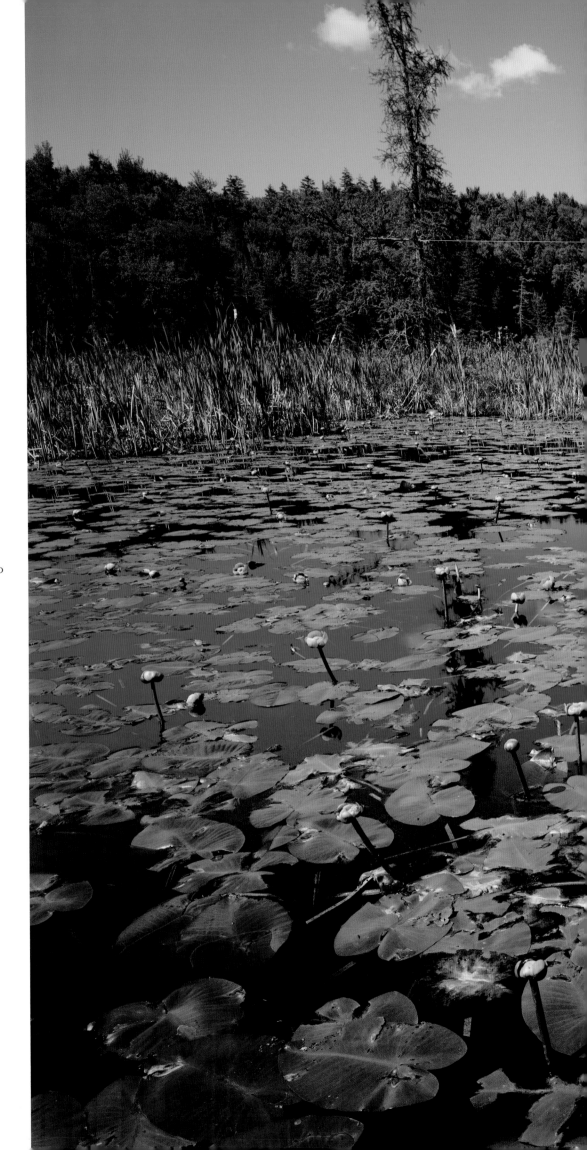

Little Cherry Patch Pond

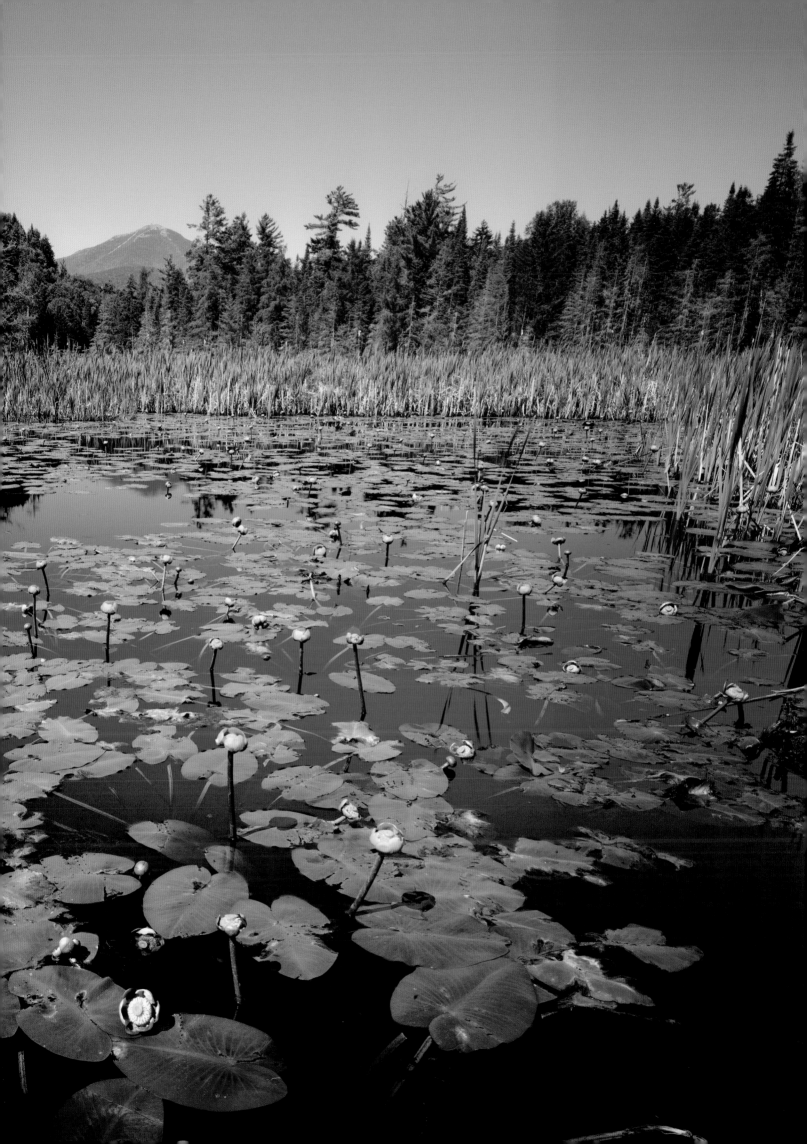

The Familiar in a New Light

As a kid I would sometimes ride my bike from the traffic light in Lake Placid to Little Cherry Patch Pond five miles away. It is on the road to Whiteface Mountain, so it is easy to return there time and again. It is a big open space by Adirondack standards, and on most days there is a clear view of the top of Whiteface Mountain. One can observe the constantly changing atmosphere and light at the top of the mountain. I know I am not alone in my appreciation of this site that the Adirondack Nature Conservancy helped protect as I frequently see motorists slowing down, many of them also stopping to take pictures.

The inner cattail ring around the pond seems to be out of sync with the outer spruce-alder ring. Cattails are rare in remote bog ponds, but scientists believe that the salt runoff from winter road maintenance has turned the pond water alkaline, thus encouraging the growth of cattails. They also hypothesize that increased nitrogen levels from airborne pollutants can act as fertilizer, which may account for the denser cattail stands and the profusion of yellow water lilies seen in this image (previous pages).

I have photographed this pond many times, but never have I seen it in more perfect form than on this bright warm day in late August of 2003. I passed the pond, stopped to take a look, and then went directly home to pick up my camera gear and change into a bathing suit and wet-shoes.

Upon returning I walked into the pond, finding the best location from which to photograph, about thirty-five feet from shore. Luckily, the water was only chest-deep at that point. I went back to shore and carefully carried the equipment over my head to my chosen spot. In the fifteen minutes it took me to set up the tripod and camera, the water became mirrorlike. I made four exposures, each time waiting for as calm conditions as possible.

Feeling I had done the best I could, I began maneuvering my way back, again awkwardly carrying my equipment overhead. In the last few steps, my legs became entangled in sharp, spiky, tamarack tree branches below the surface, causing me to drop the 150mm wide-angle Nikkor lens in the water. Although the lens was thoroughly wet, I was not discouraged. I had looked at Cherry Patch Pond many times but had never seen it with more yellow water lilies or more completely calm in midday.

Pitcher Plants at Spring Pond Bog ▶

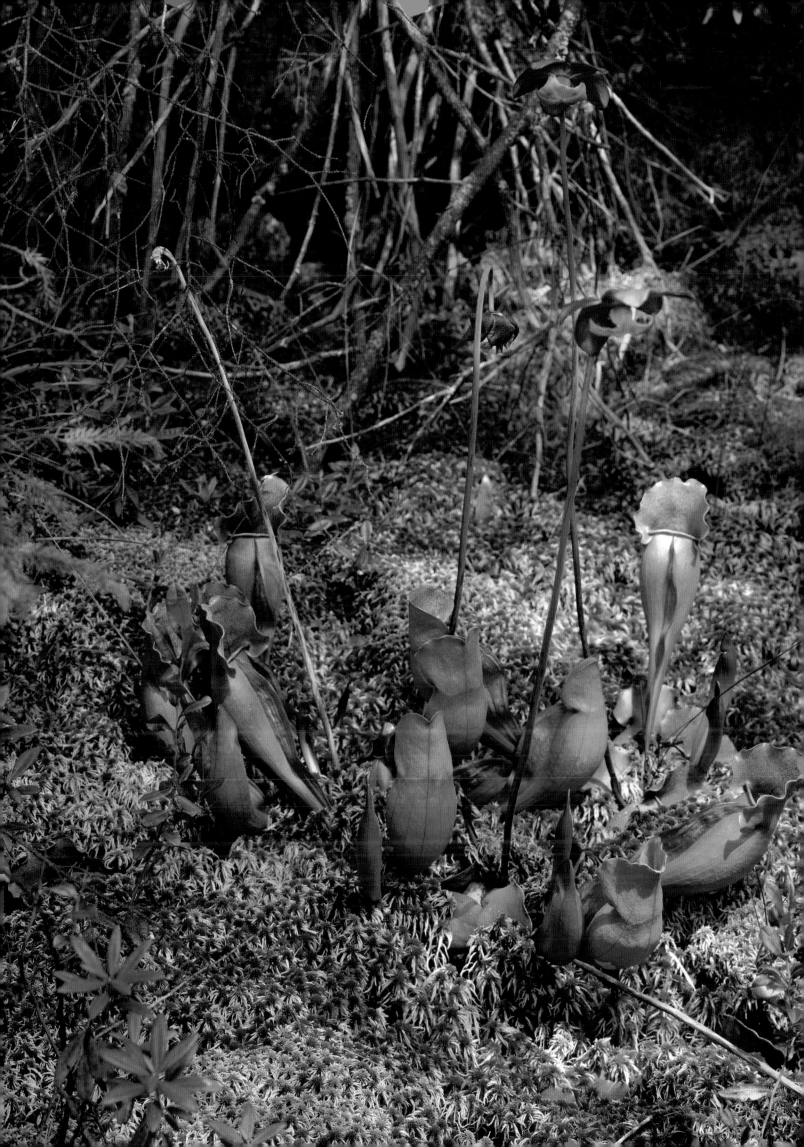

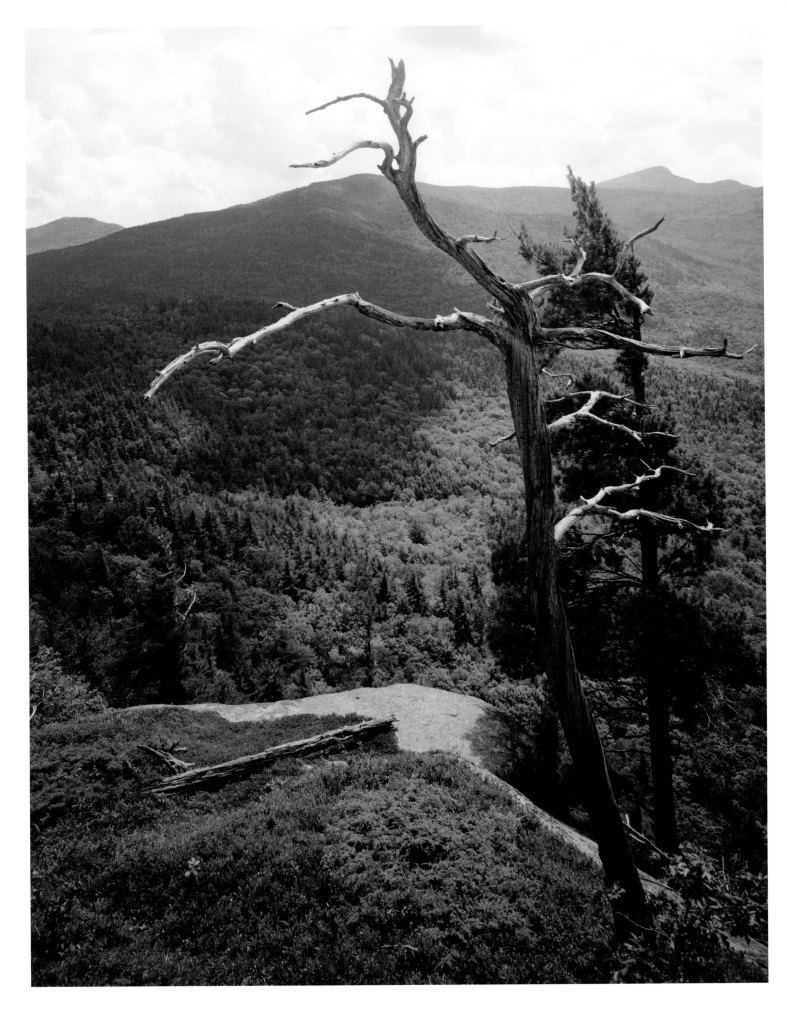

VIEW FROM BAXTER MOUNTAIN

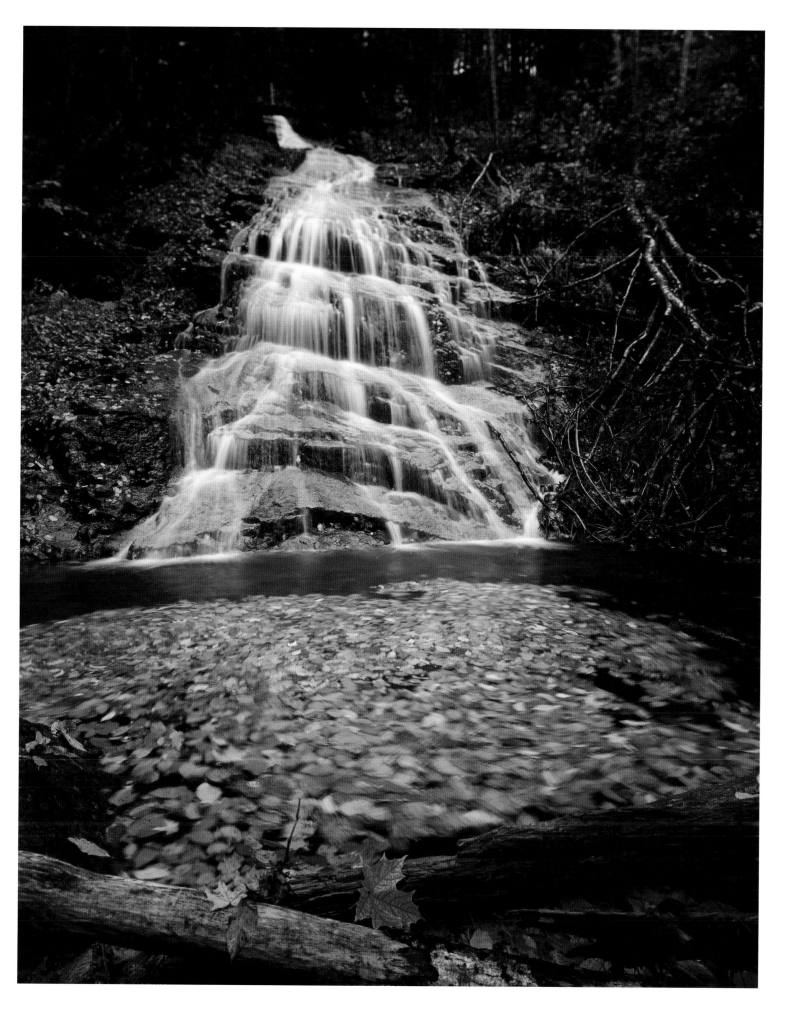

Snow Brook

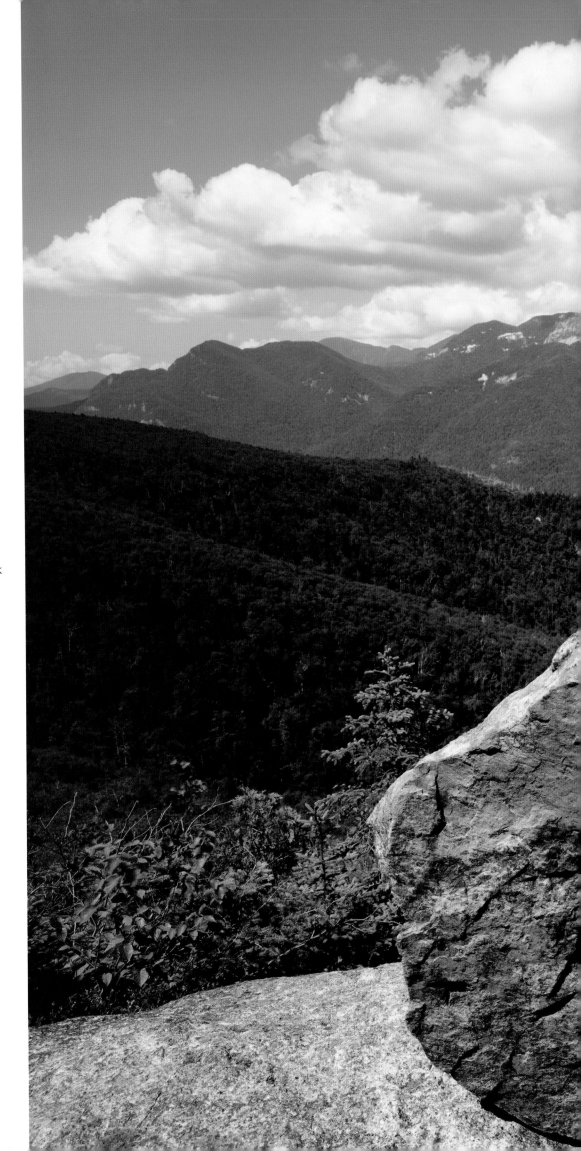

ROCK ON NOONMARK

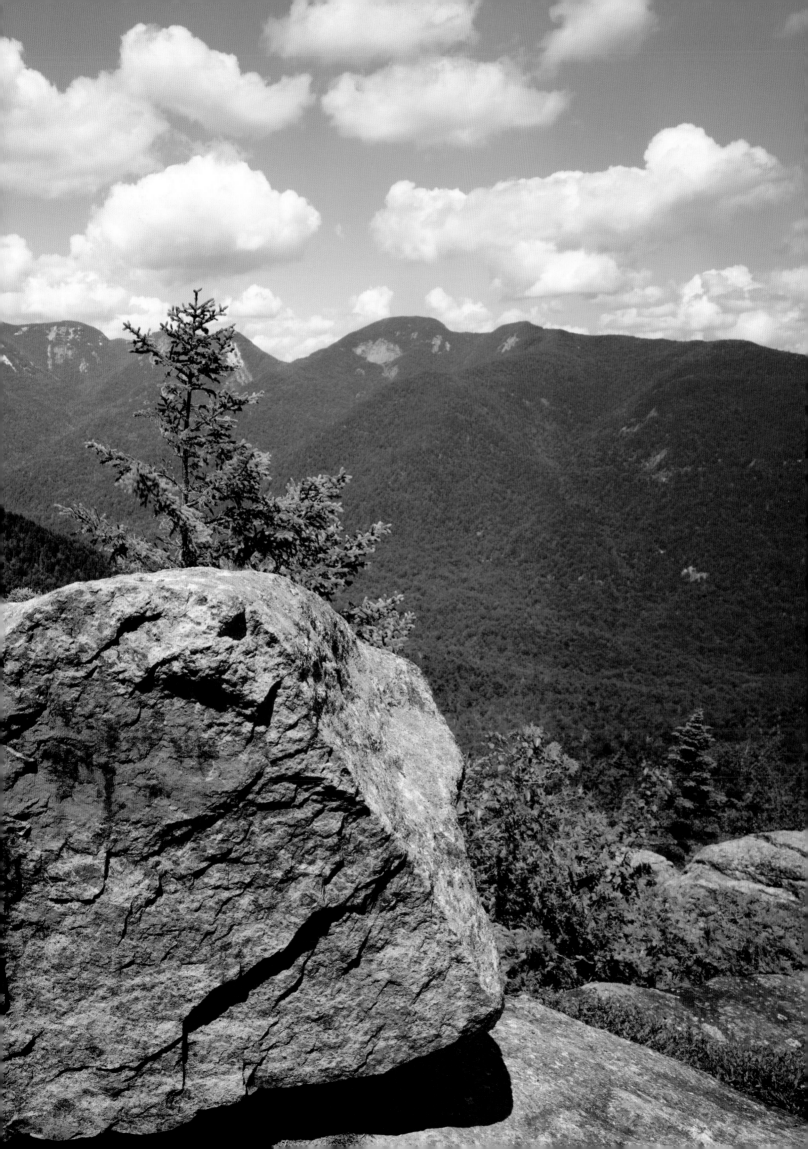

Van Hovenberg Summit

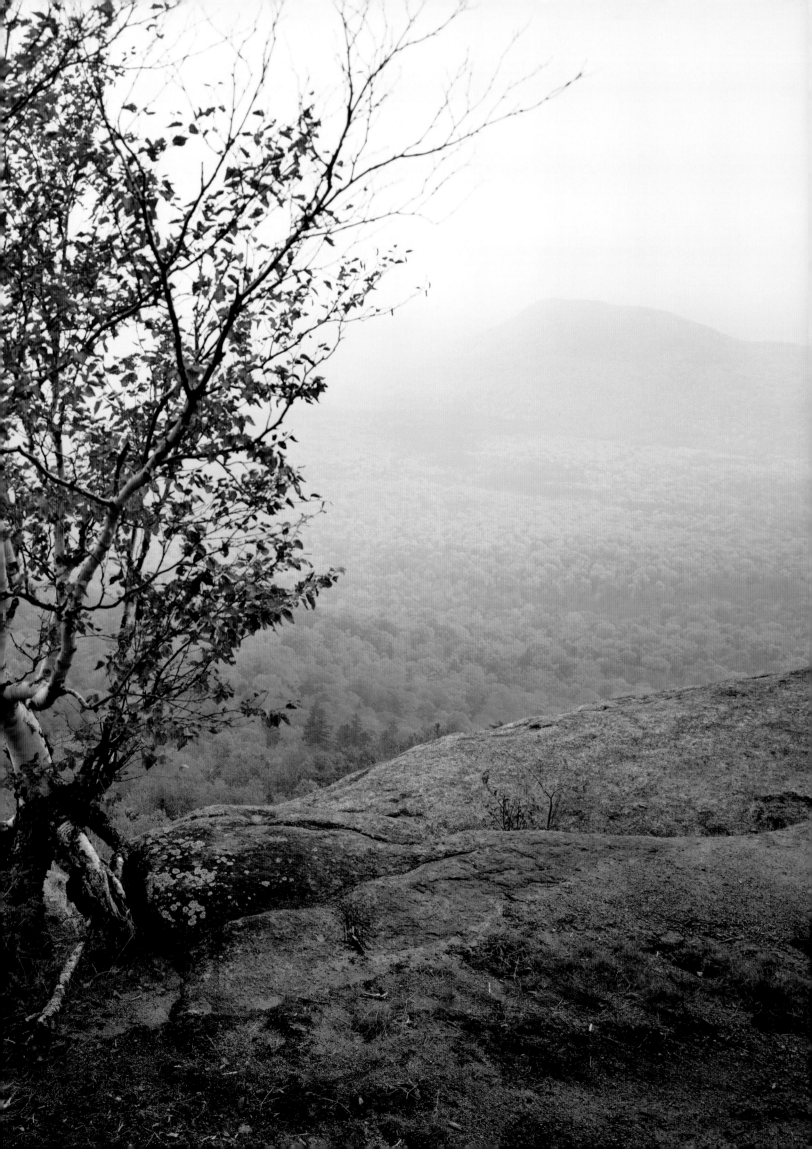

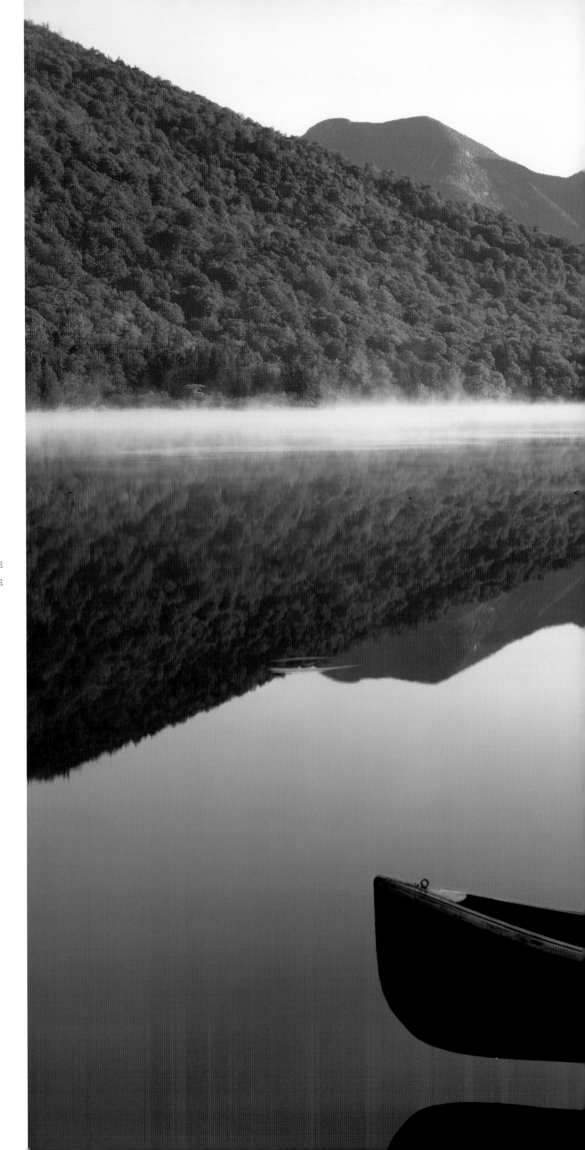

UPPER AUSABLE LAKE
WITH CANOE

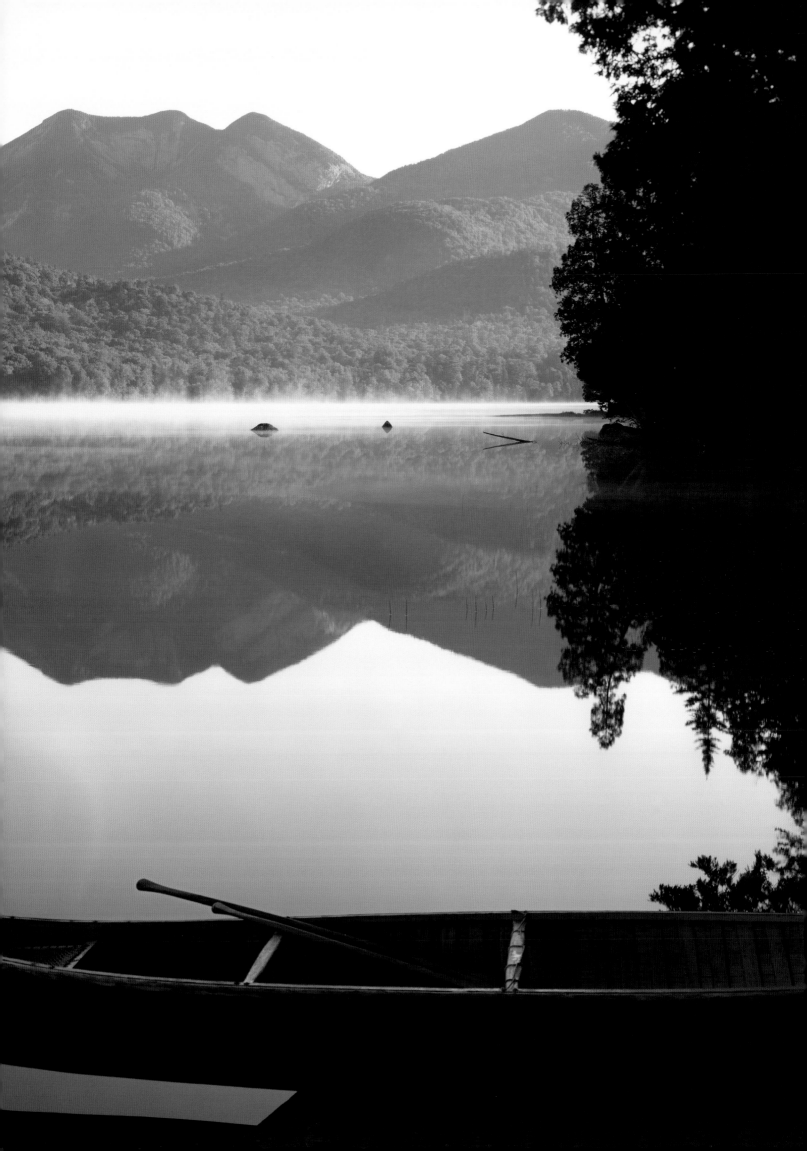

Summer Retreat for American Aristocracy

The Adirondacks were often the summer home of the ruling class. Families like the Rockefellers and the Whitneys built their great camps in the Adirondacks, and more than one American president made the Adirondacks his summer retreat.

A friend of mine, Robin Pell—who was part of that American aristocracy, a descendant of Declaration of Independence signers on both sides of his family—told me a remarkable story from his childhood. In early August 1945, Robin, then a ten-year-old boy, went hiking with none other than Henry Stimson, FDR's Secretary of War, on one of many miles of trail at the venerable Ausable Club, one of the oldest retreats in the Adirondacks. Robin voiced his worries about the ongoing war, which he heard adults discussing all of the time. Stimson told Robin not to worry about the outcome of the war and assured the boy that the war would be over in a couple of days. In the tranquil, perhaps eerie silence of the Adirondacks, Stimson apparently confided in a child that which he would tell no adult. That hike was two days before the atomic bomb was dropped on Hiroshima.

Indeed the putative father of that weapon, Albert Einstein, learned of the holocaust at Hiroshima after waking from a nap on the shore of Lower Saranac Lake, where he had spent a peaceful morning gliding over its smooth waters. We know, sometimes in a very personal way, that this beauty cannot protect us or insulate us from the horrors of life, but still at times we embrace the illusion.

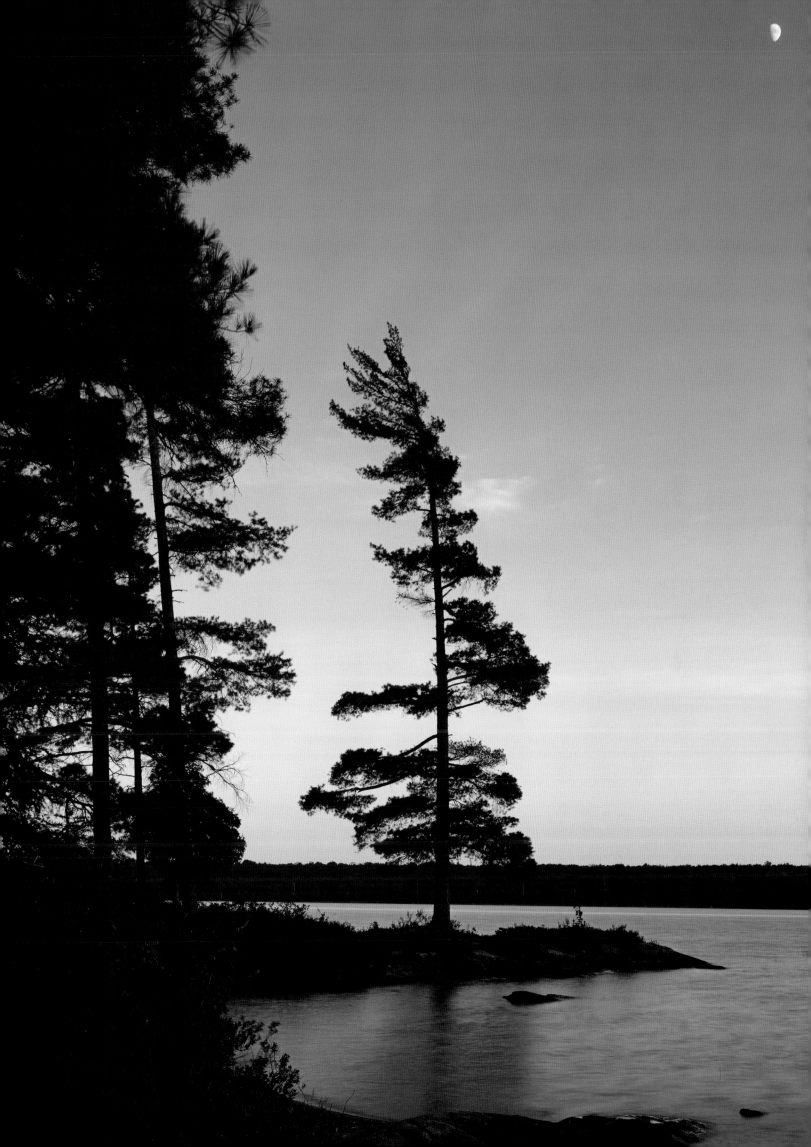

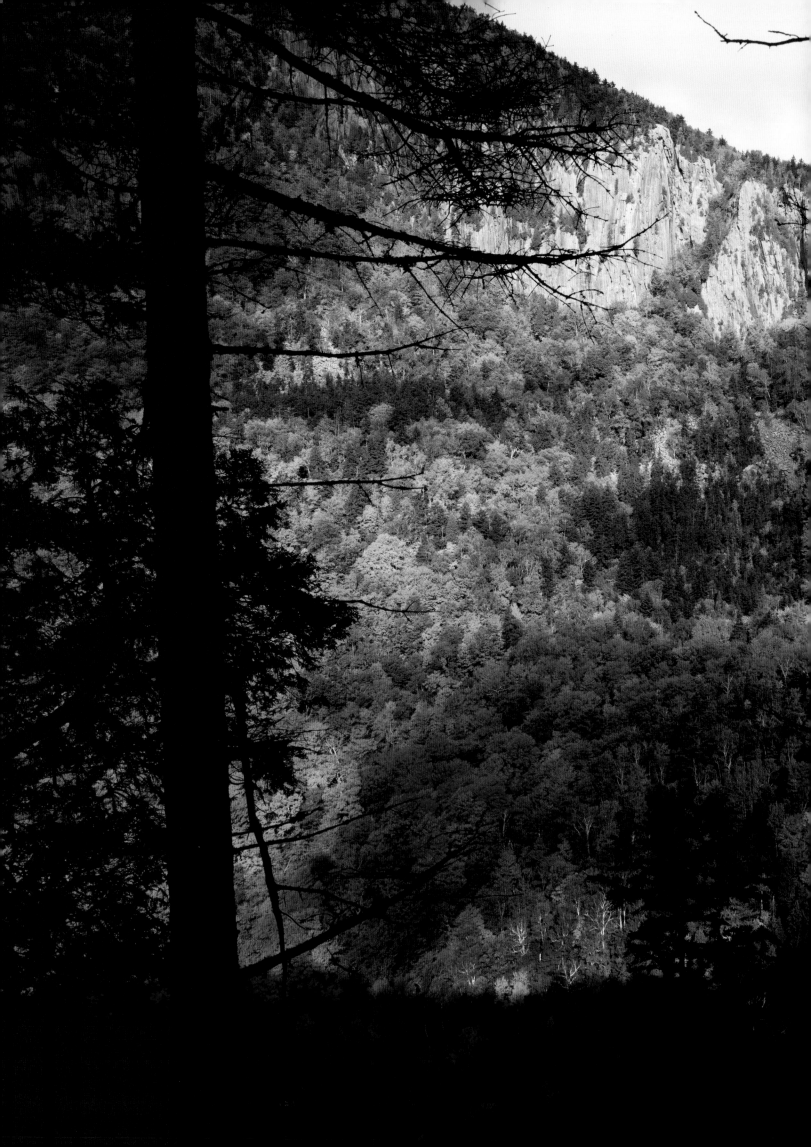

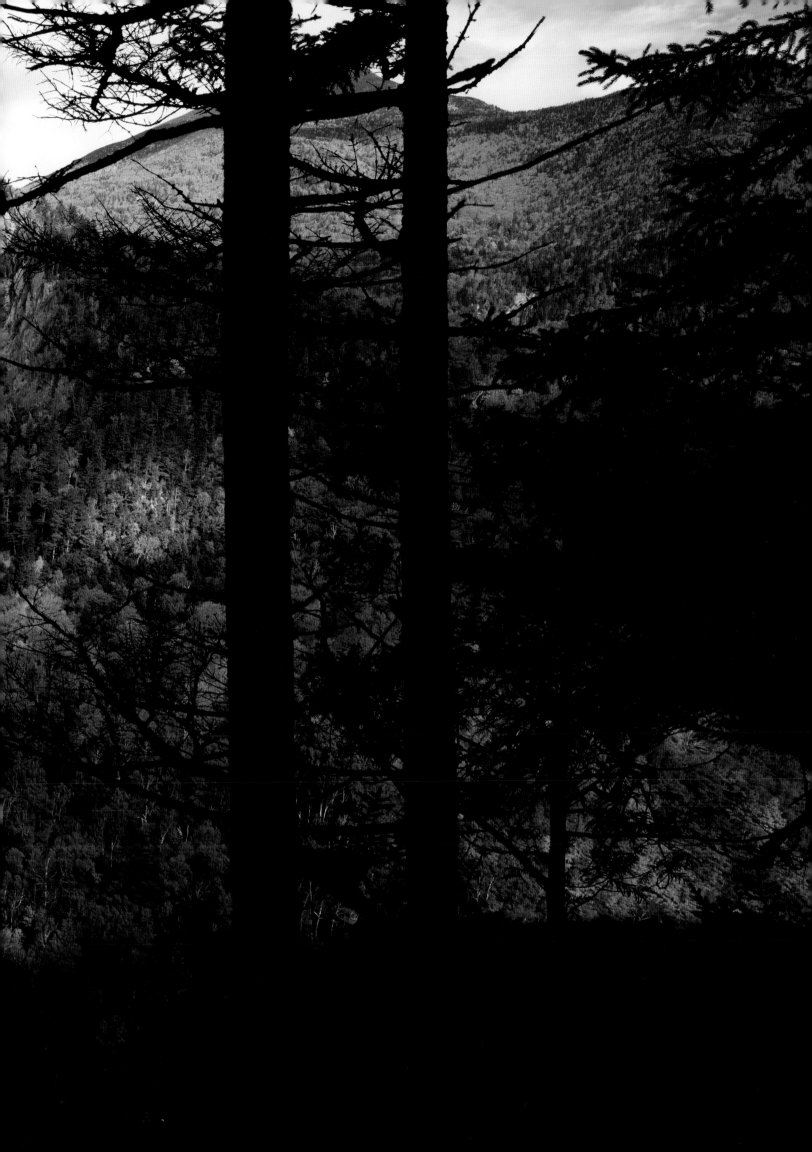

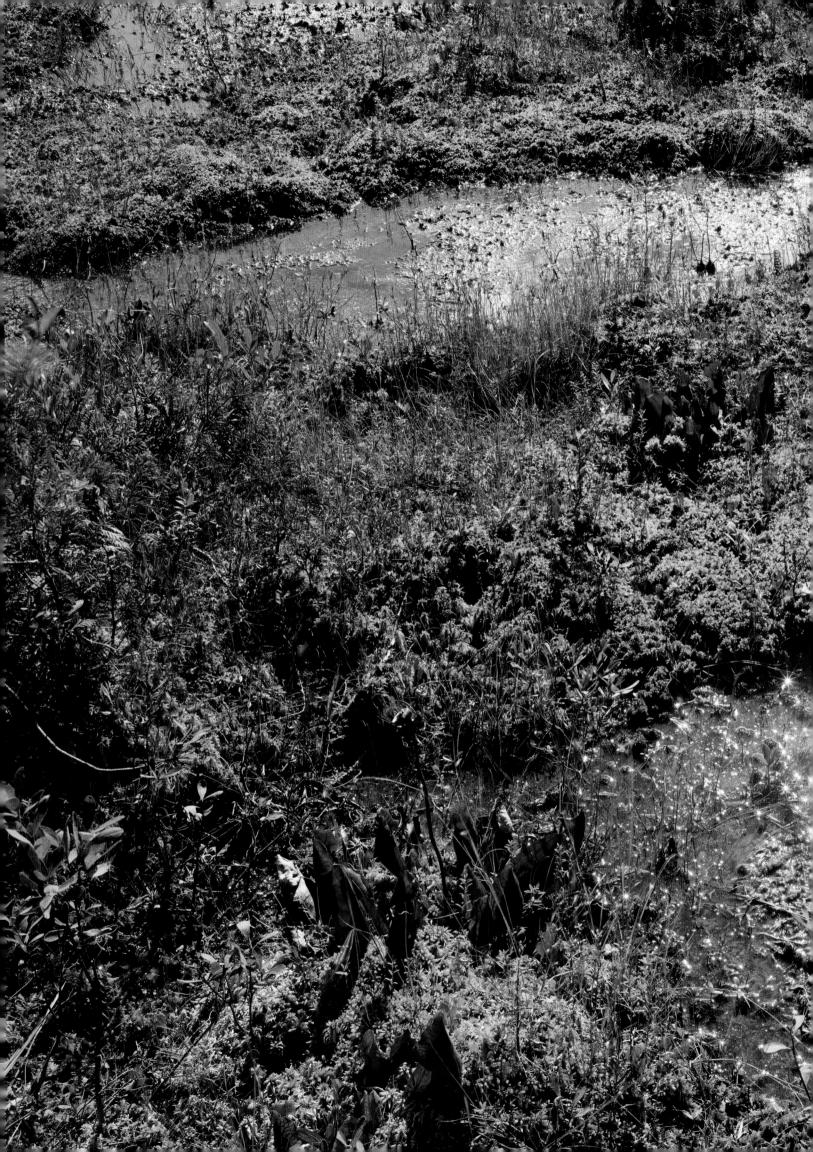

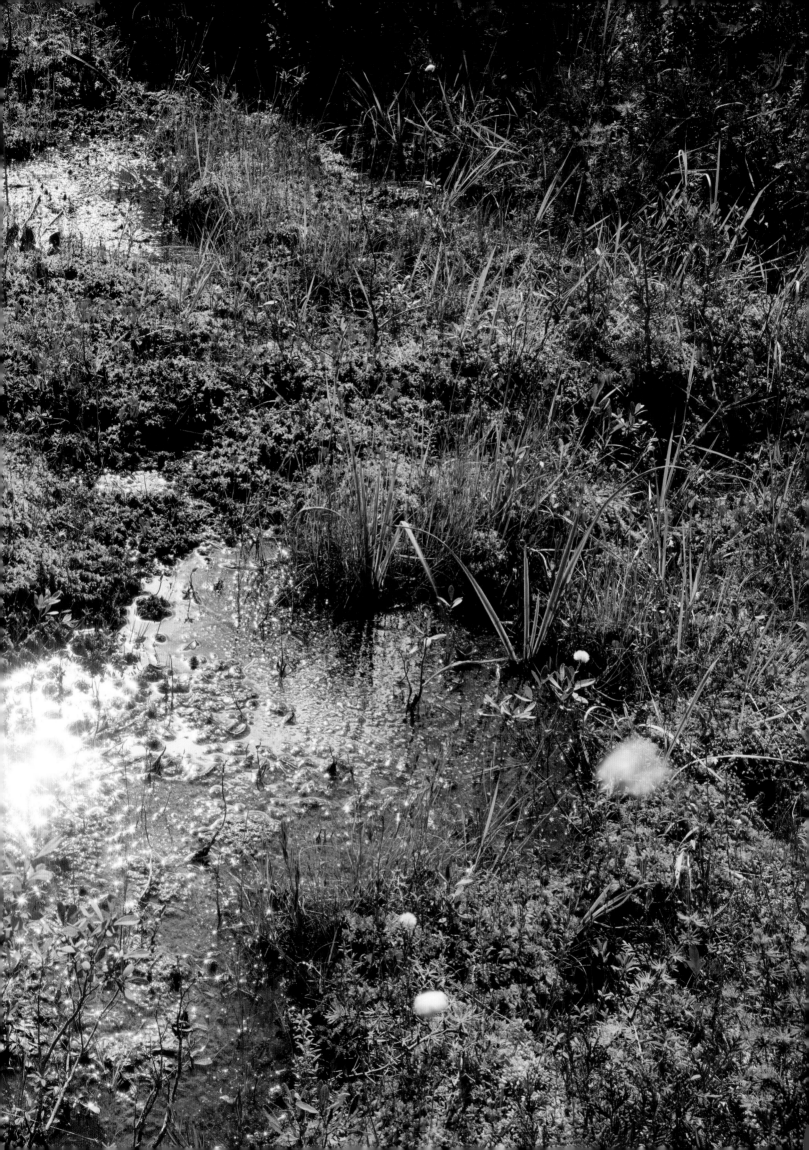

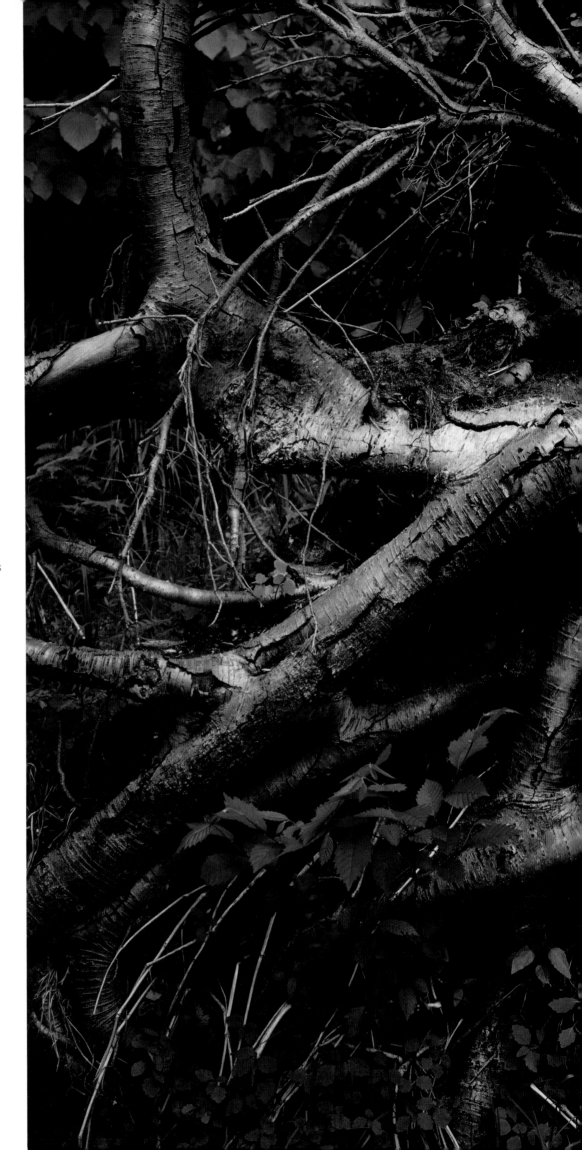

ROCK AND ROOTS

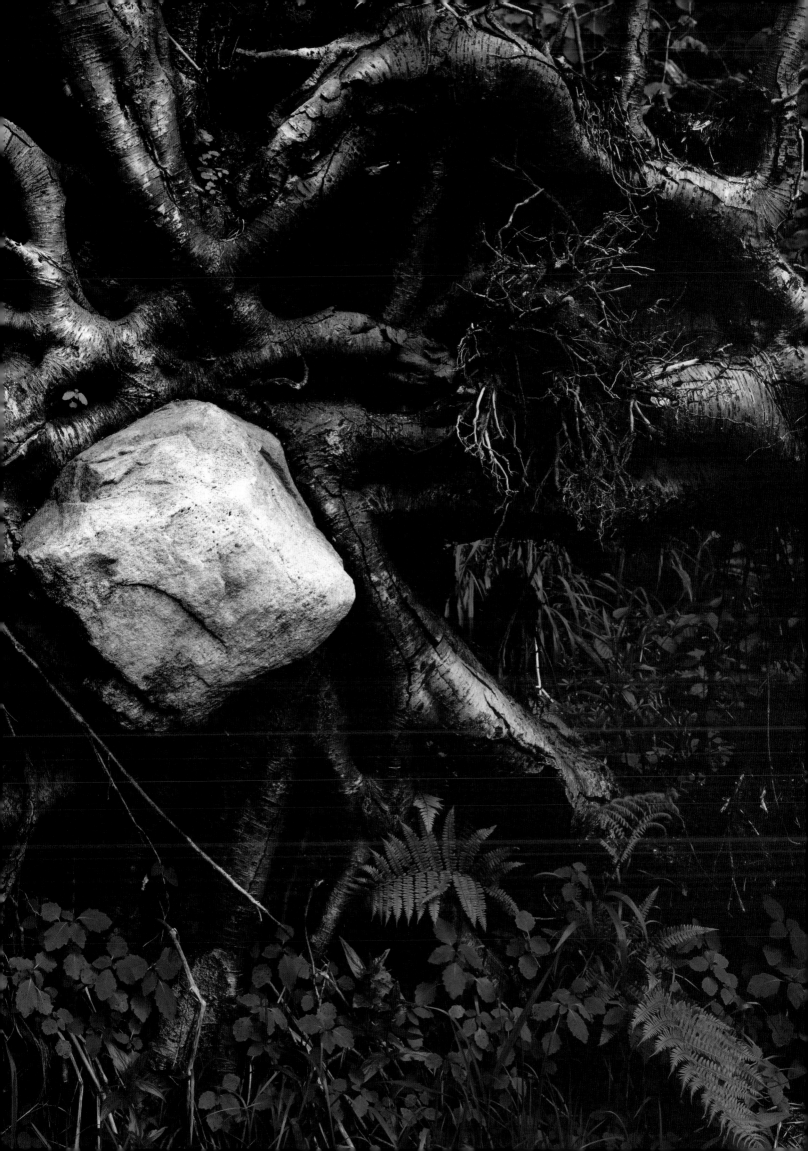

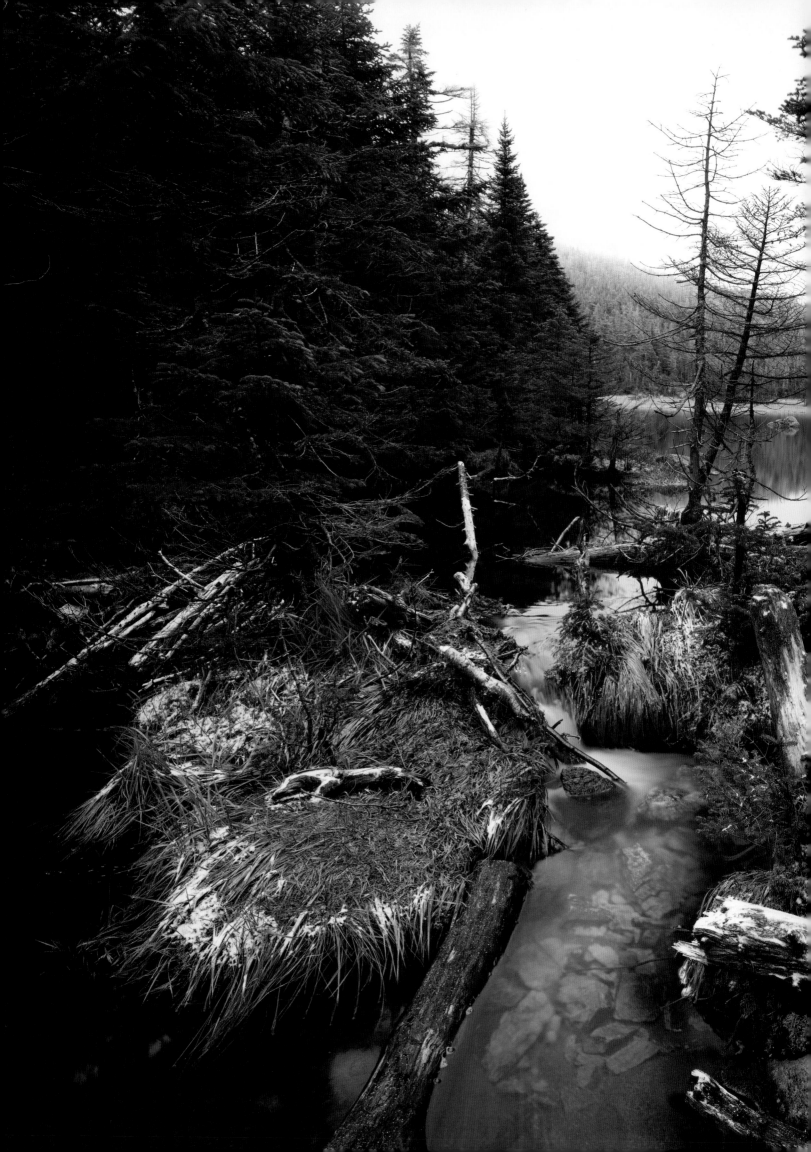

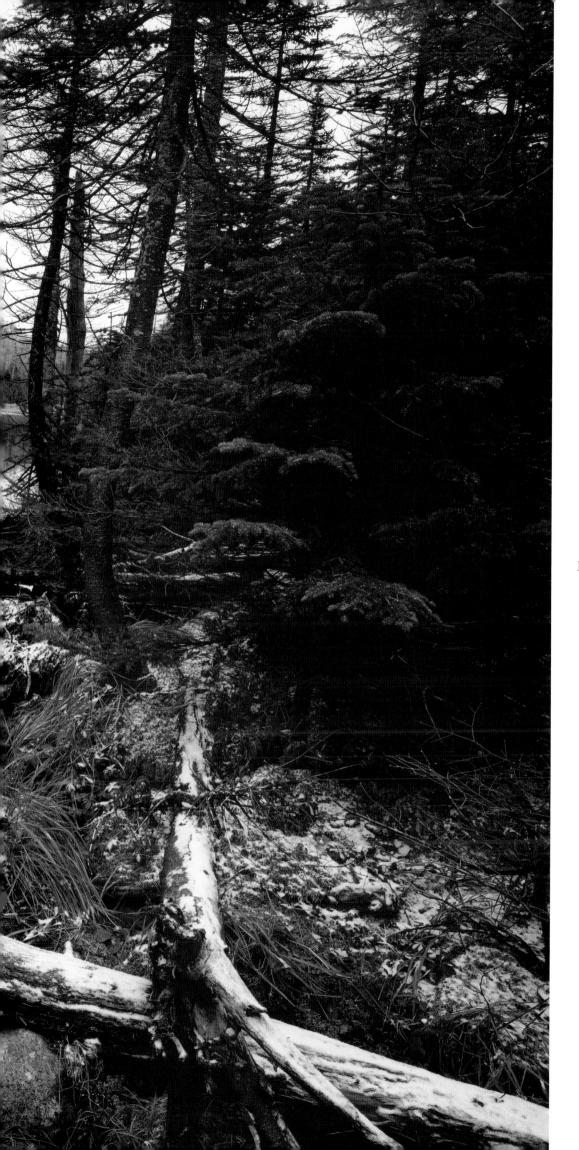

Lake Tear of the Clouds

From a Teardrop to a River

Resting on a shoulder of Mt. Marcy, the highest peak in the Adirondacks, is Lake Tear of the Clouds (pictured on the previous page), the highest source of the Hudson River. Looking down from the summit of Marcy on September 15, 1872, Verplanck Colvin, the first and most devoted surveyor of the Adirondacks, was struck by its teardrop shape and christened the lake with its poetic name. That same day he determined that Marcy was the highest point in the state and hammered his surveyor's bolt—#1—into its rocky summit.

This tiny glacial tarn is carved out of native anorthosite, an ancient rock type that makes up most of the Adirondacks. Anorthosite contains the elements calcium, sodium, aluminum, silicon, and oxygen, and it is found here in the same proportions as the rocks on the moon. Surrounded by evergreens and with a ring of marshy shores of sedges and mosses, Lake Tear of the Clouds, at about 4,300 feet, is typical of a high-elevation body of water. Because it is quite shallow, it freezes to its bottom each winter and does not support any fish.

The small outlet from Lake Tear at the bottom of the picture is the spot where the Hudson River begins. That rivulet becomes Feldspar Creek, which cascades through about a half a mile of waterfalls, including Hanging Spear Falls on the next page and then joins the Opalescent River. It then descends more than 2,500 feet before it becomes known as the Hudson River.

When I set up my camera to take this photograph, I found something that, had I been closer to the Hudson's mouth, may not have surprised me as much as it did—a rusted sardine can. While I almost never alter what is in a natural scene before me, I did remove the can from the water to make this picture. I also made another photograph with the rusted can in it.

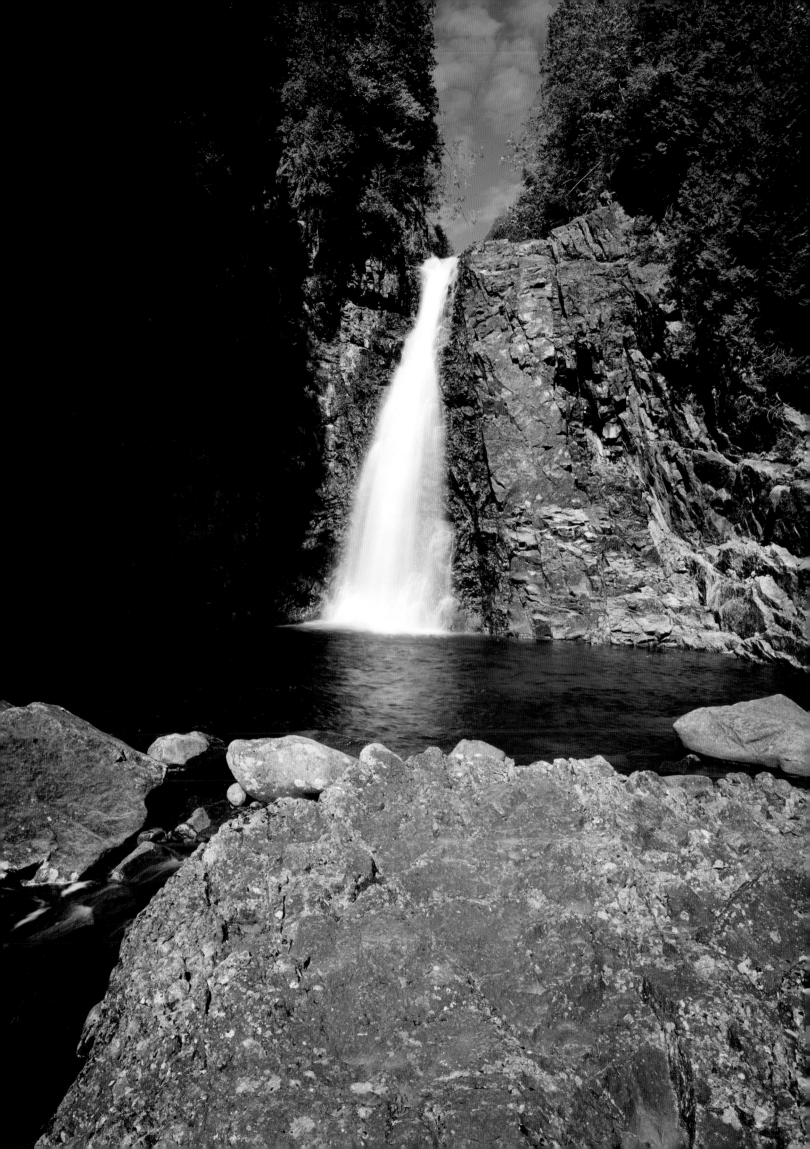

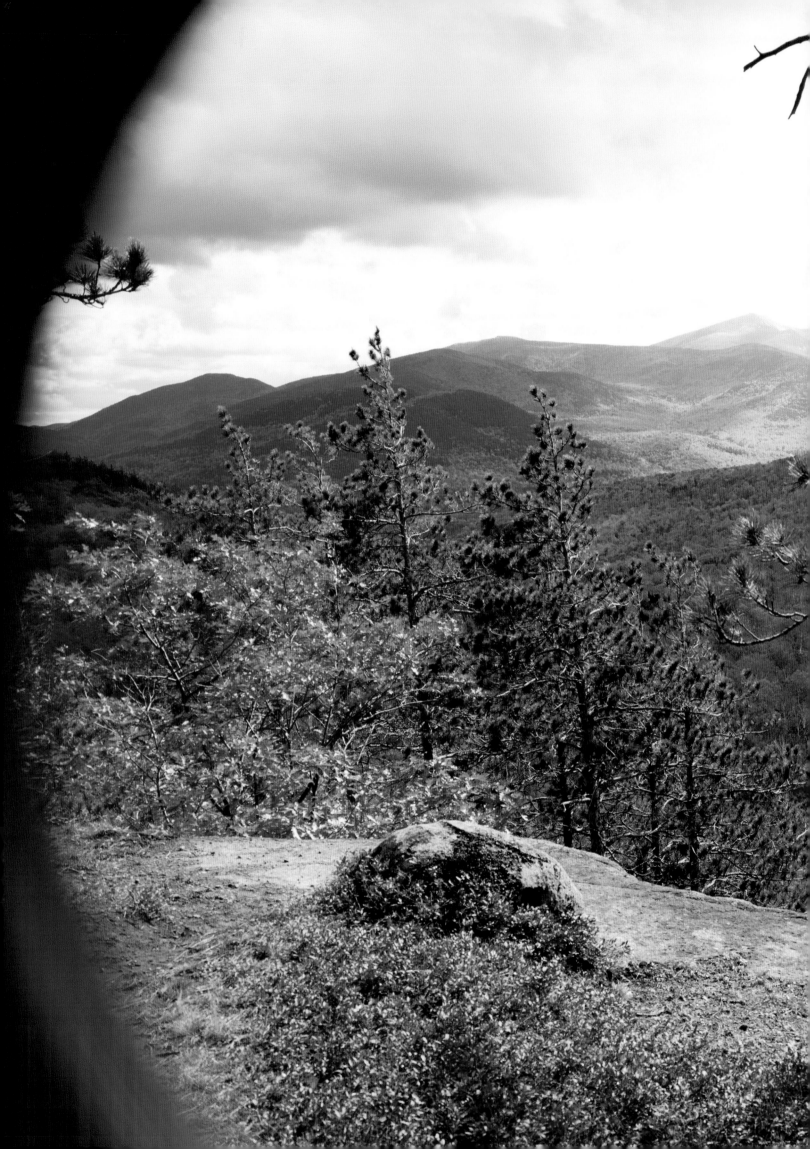

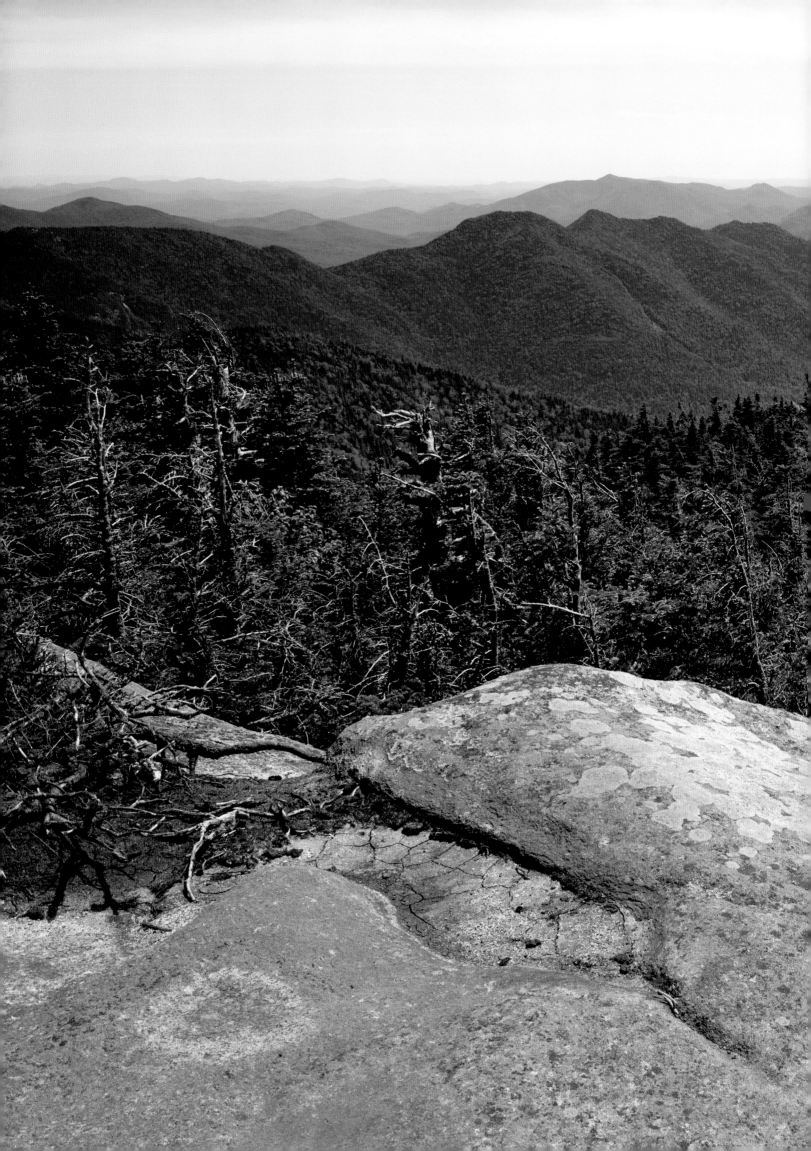

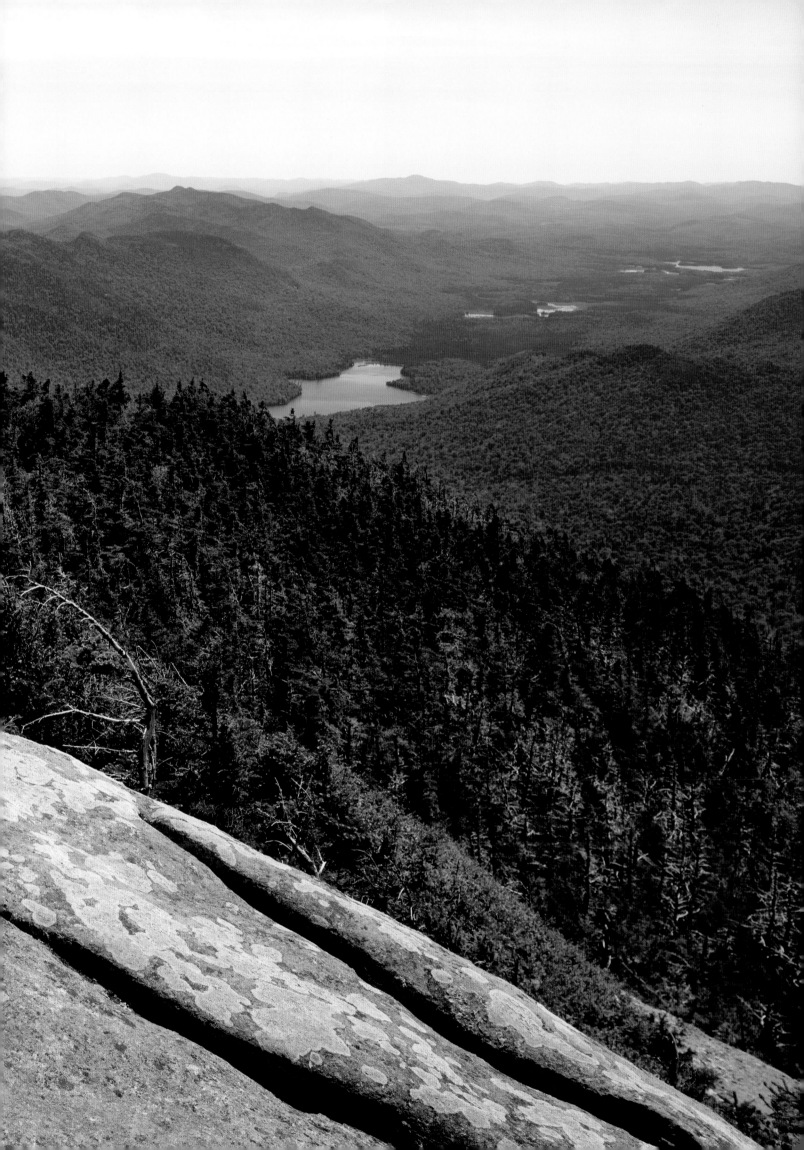

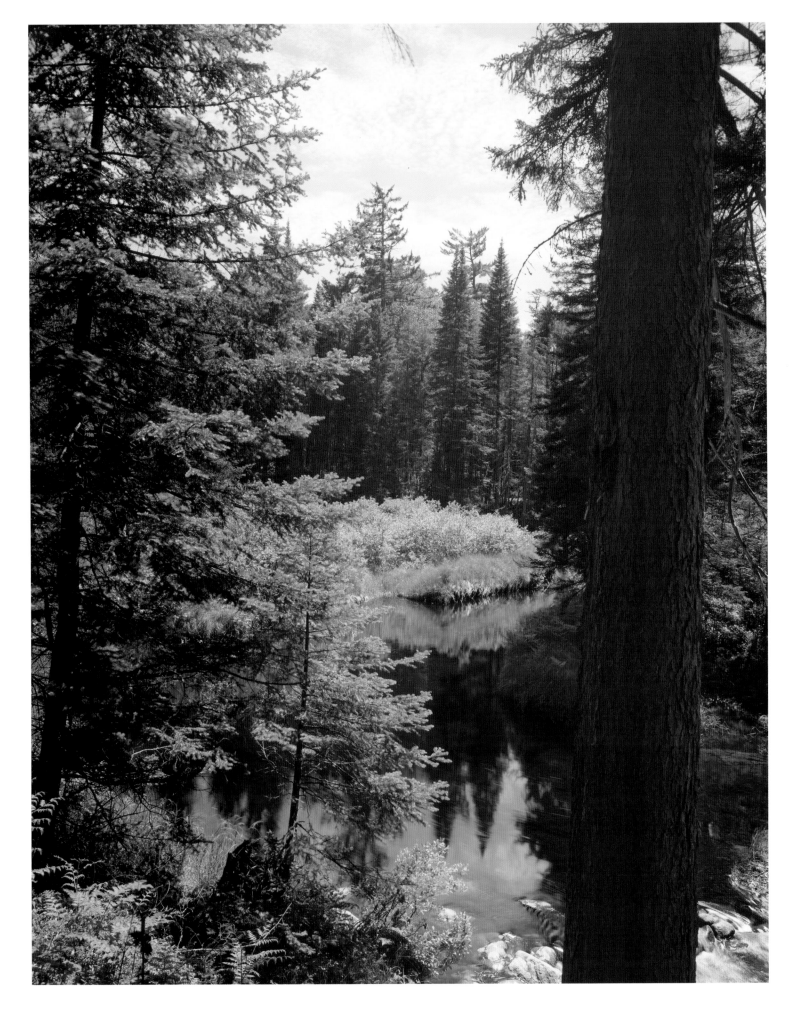

Near the Stillwater

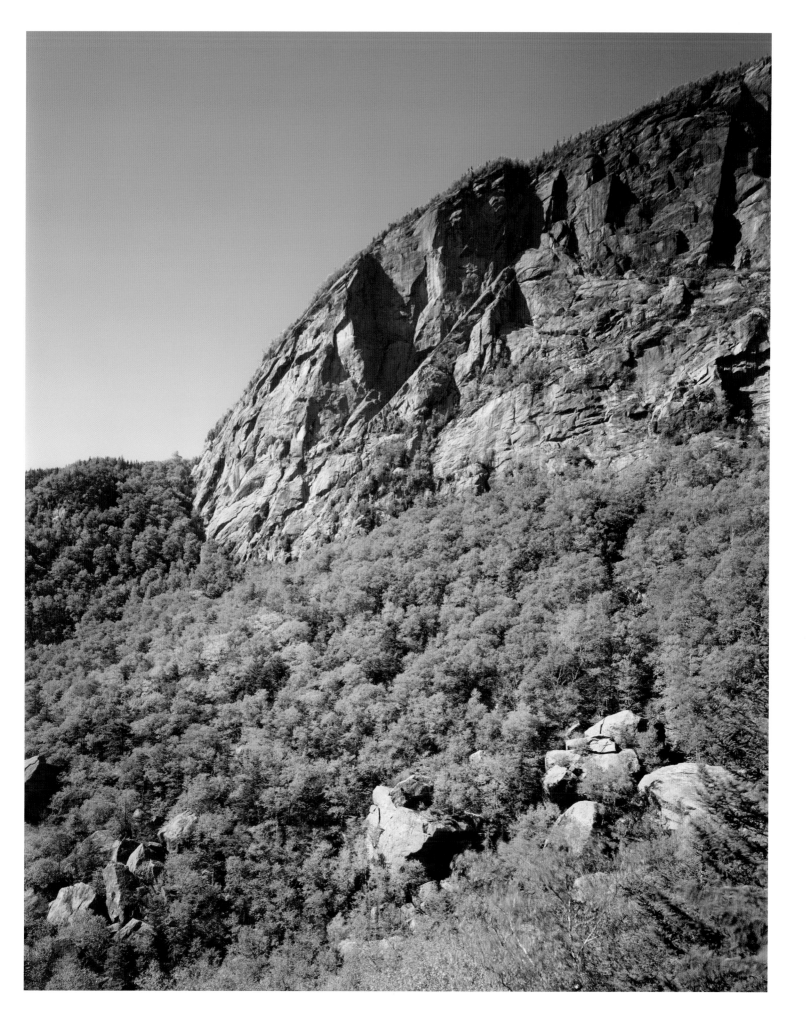

Wallface at Indian Pass

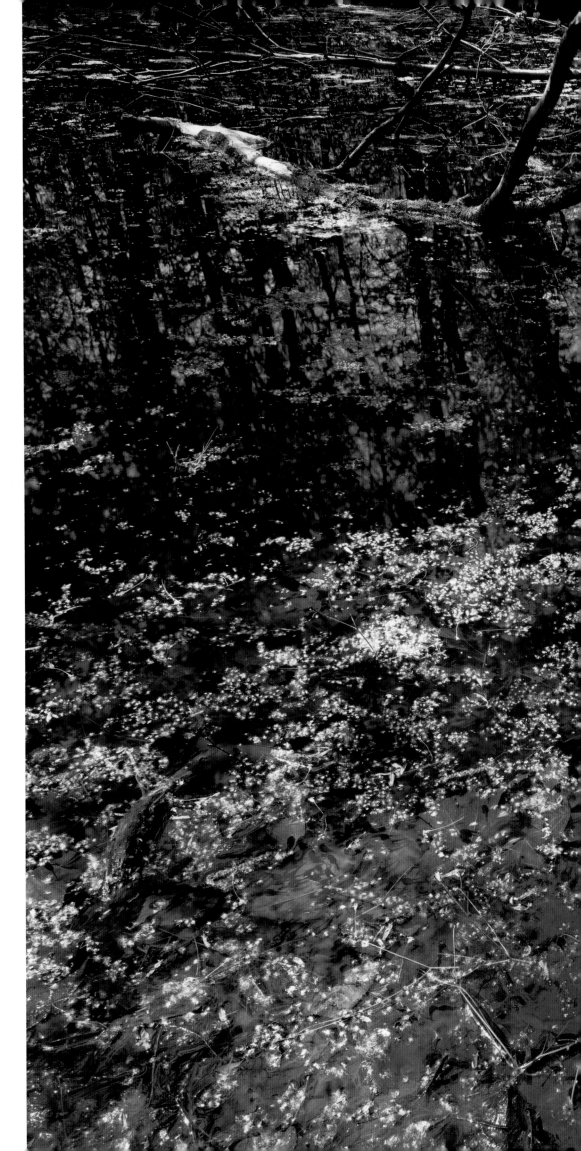

Vernal Pond

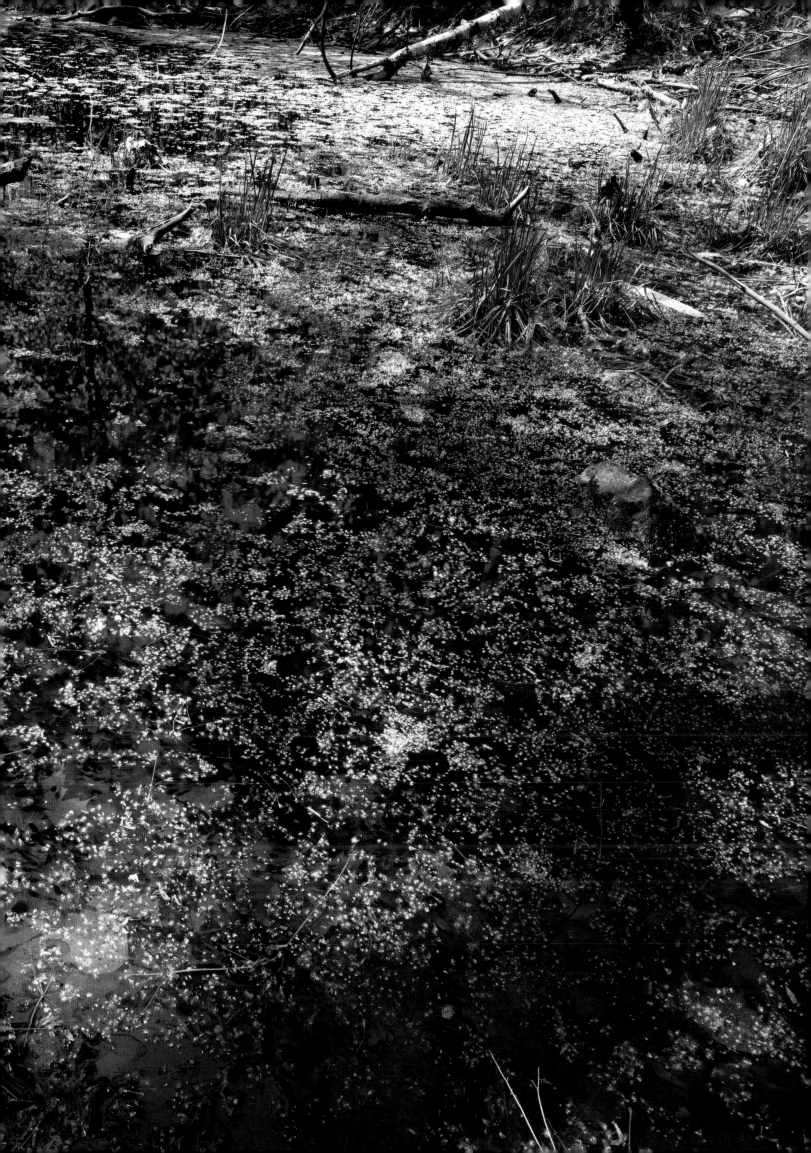

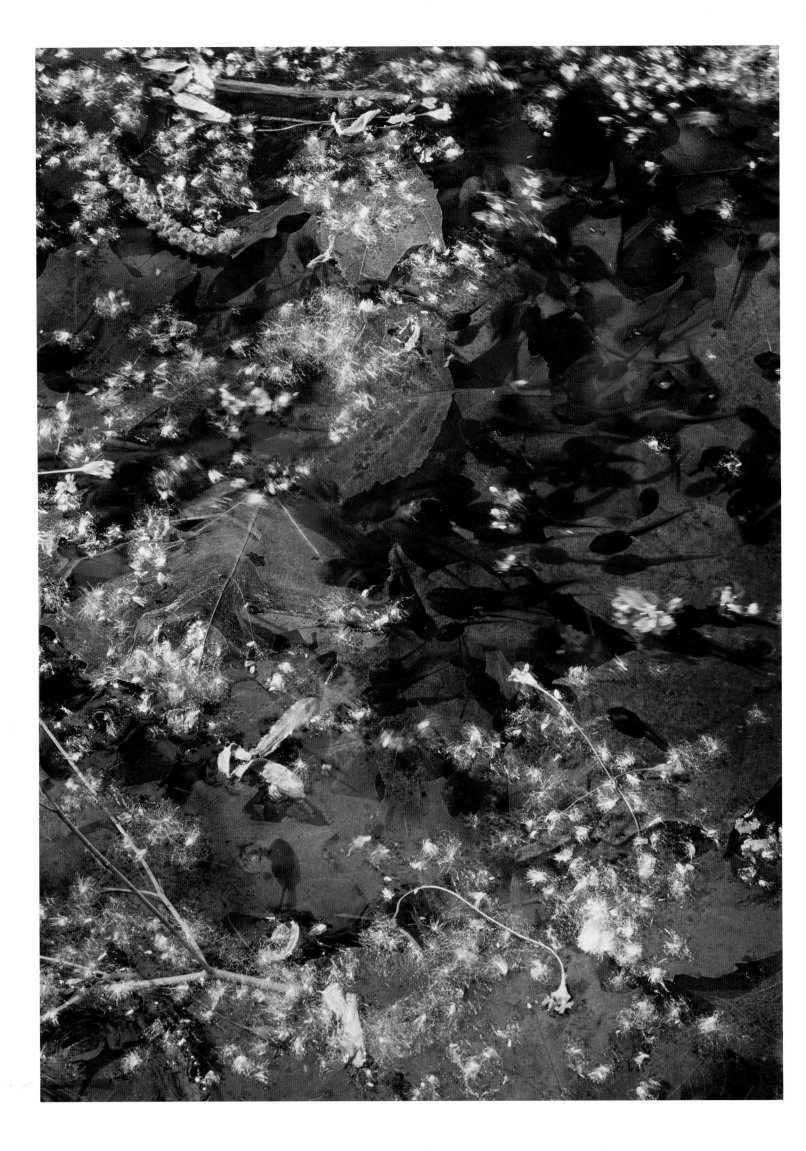

A Spring Race

April, in the words of T. S. Eliot, is the cruelest month, but in the Adirondacks, May is the most dreaded: the black flies arrive. (A friend, now deceased, often said she would return as a black fly in May to harass people.)

In May, under the veil of black flies, we have vernal ponds that seem to be, if not the primordial soup from which life sprang, then the cauldron of our continued existence.

These ponds have short but remarkable lives, existing only in the spring. (If only black flies had a similar fate.) They are formed in depressions in the earth when the snow melts and spring rains rest in small pockets of land with no drainage. I see them in farm fields in the Adirondacks and in many places in the woods. They are almost always gone by midsummer and certainly by late summer.

Detail of Vernal Pond (previous pages), on the northern shoulder of Giant Mountain

This one is high on the northern shoulder of Giant Mountain, just off the Spruce Hill Trail. There is life both underneath and on the surface of the water. Hundreds of tadpoles are swimming in the water, which is only inches deep. For these tadpoles to become frogs or toads (in this case, they are most likely wood frogs), they must do so before the pond dries up. In such a race to a life-or-death finish line, it helps that there is an absence of predators in vernal ponds, owing at least in part to the fact that fish do not live there.

On its surface, the pond holds clues to what lies above it: Wind and gravity have deposited delicate white bud scales and tiny yellow flowers from sugar maples and orange-brown male catkins from birch trees. In some parts of the Adirondacks, sugar maples are in decline, and scientists speculate that this is linked to acid rain. Birches survive well in higher altitudes such as this, but spruce and fir are typically the last band of trees before a summit's exposed bedrock.

◄ Detail of Vernal Pond

Lake Lila Sunset (62 | 63)

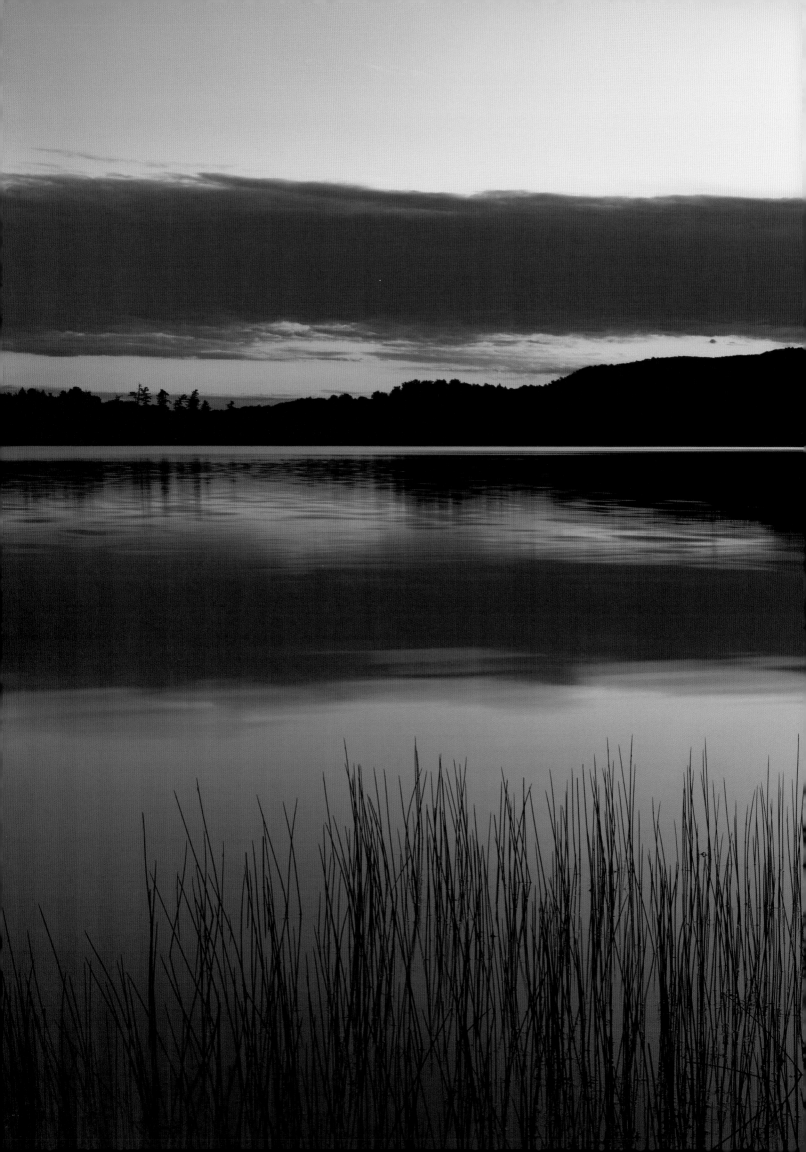

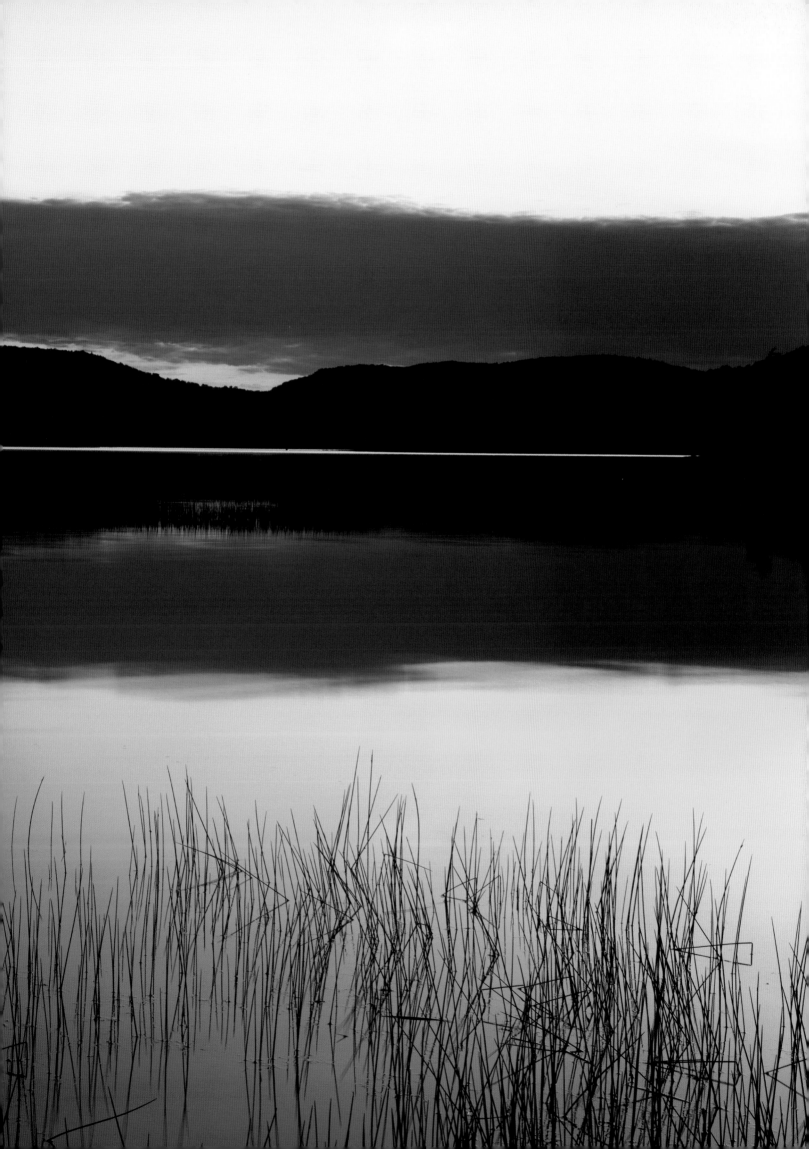

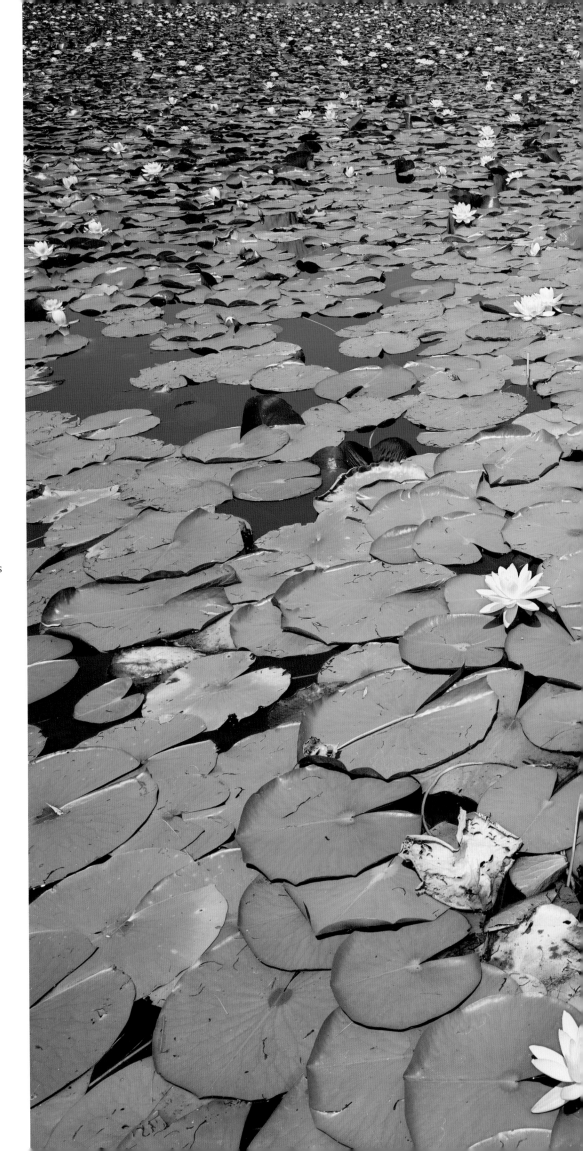

White Water Lilies

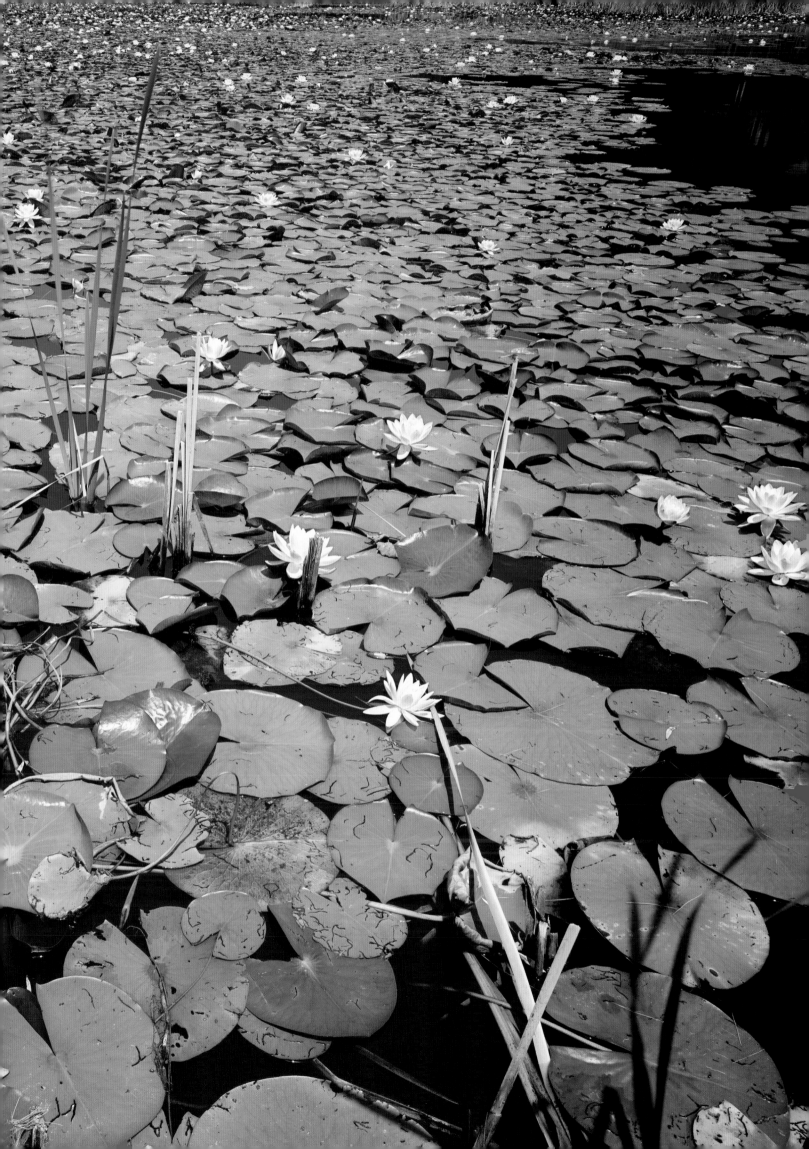

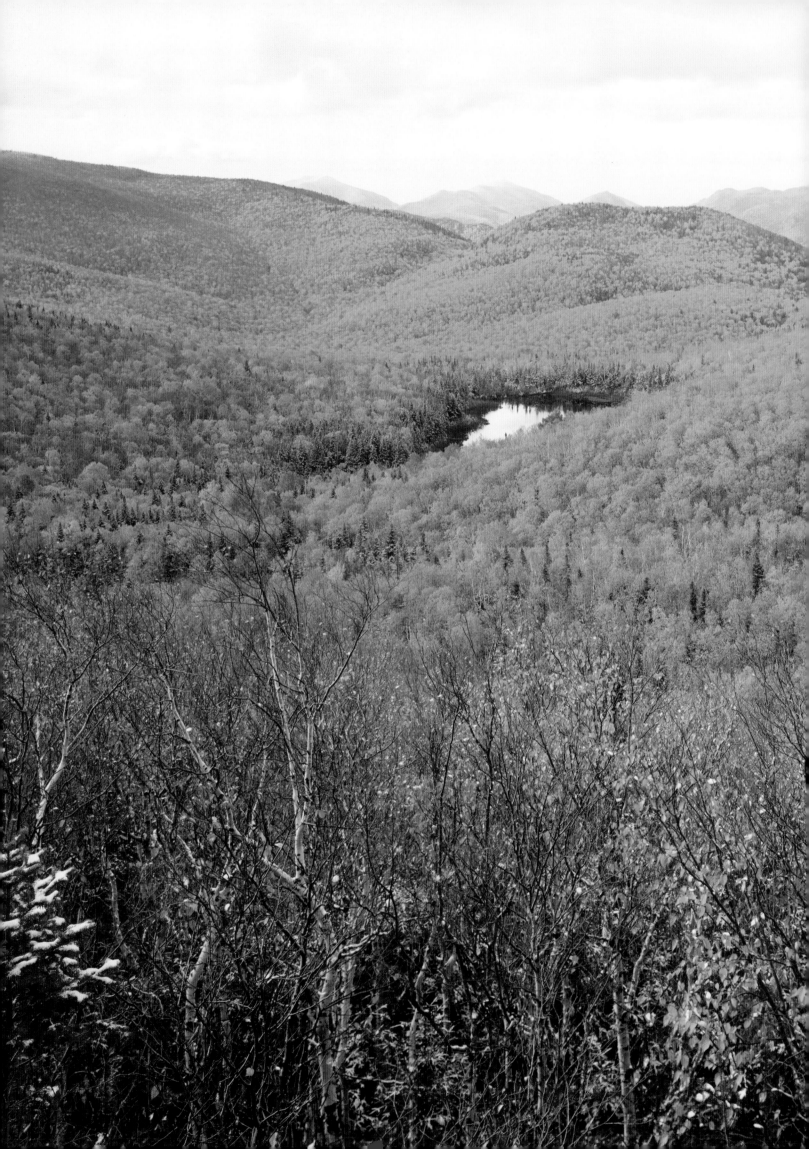

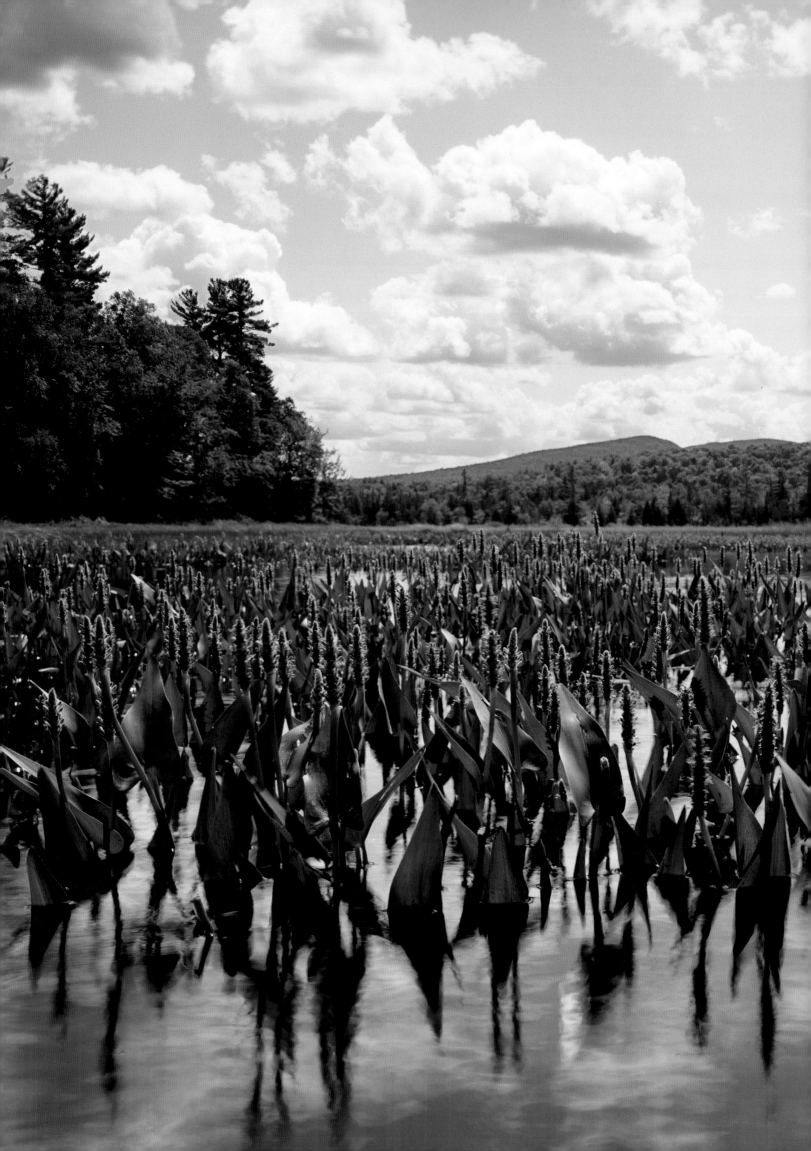

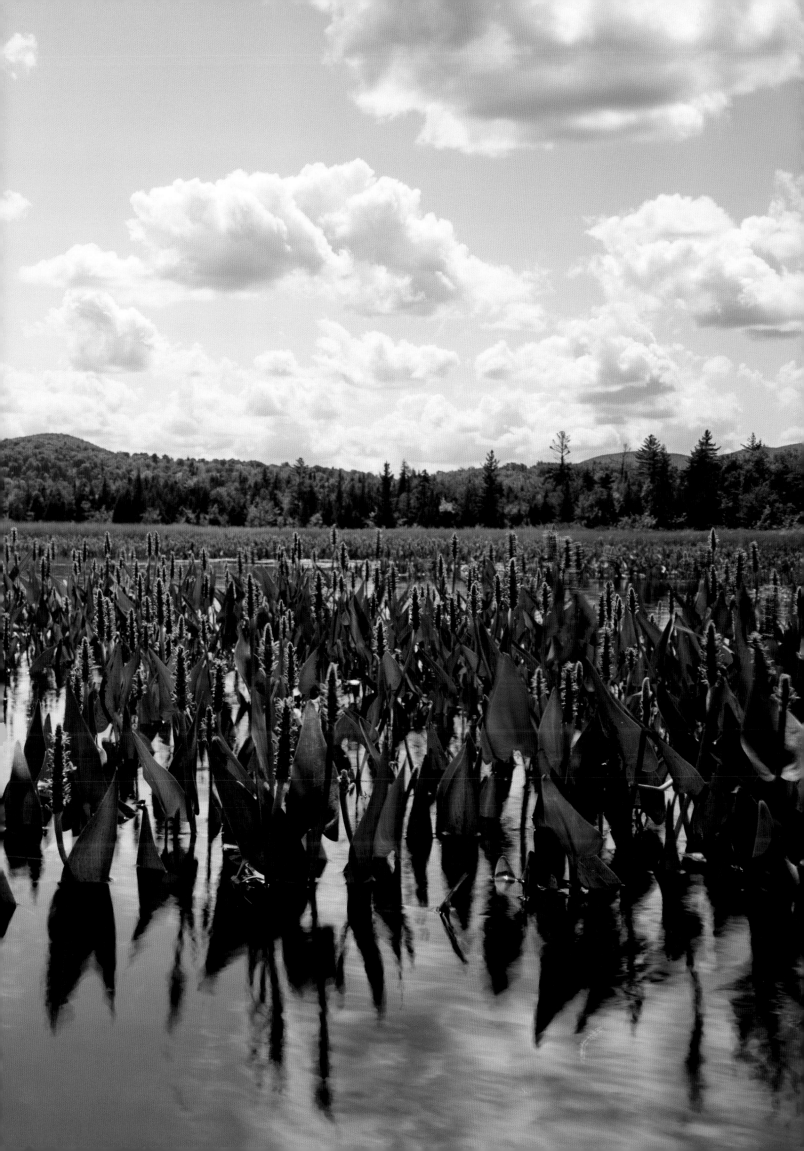

The Cult of the Landscape

Sometimes I think of the love of the Adirondacks as a cult, or almost a religion. There is a history of spiritual searching that is related to the landscape. It goes back at least to the time of Ralph Waldo Emerson. He and his philosopher friends spent time in the woods at Follensby Pond (previous pages). They stayed for a couple of weeks to explore their ideas in nature.

A notion prevails that being in the Adirondacks is the answer, indeed the cure, for everything. Reverend William H. H. Murray's guidebooks and writings in *Harper's* in the late nineteenth century described the Adirondacks as a spiritually rejuvenating place. The idea was further reinforced by Dr. Edward Livingston Trudeau, who built the most famous of the tuberculosis sanatoriums, promising the Adirondacks' fresh air as an antidote for even a deadly illness. I have certainly never tried to debunk the idea that this is a spiritually regenerative place.

I have used this landscape as a metaphor, and I have made efforts to infuse my images with elements other than the physical facts. For me, working too hard at adding levels of meaning is almost always doomed to failure. It's like looking for something that I've lost—if I look too hard for it, I can't find it.

Trying to understand how nature works is another way to listen to what the landscape is telling me. There is a very straightforward and rewarding pleasure in that. When people ask me what I do for a living, my standard one-liner is, "I photograph the nature of nature."

View from Nun-dagao Ridge (66 | 67)

Follensby Pond (68 | 69)

St. Regis River with Birch Bark ▶

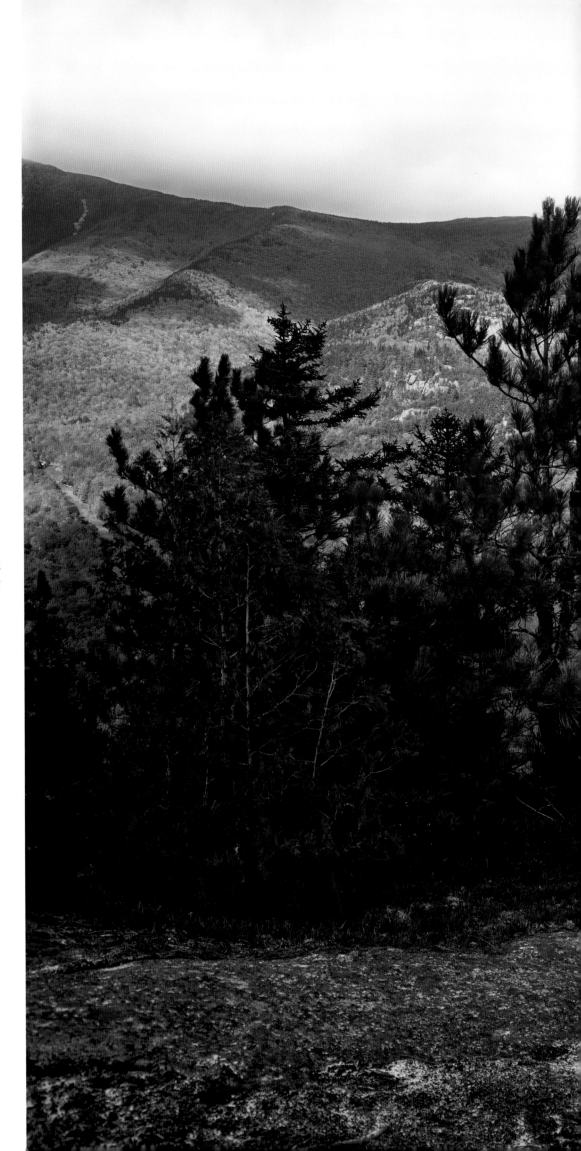

VIEW FROM HICKOCK
MOUNTAIN

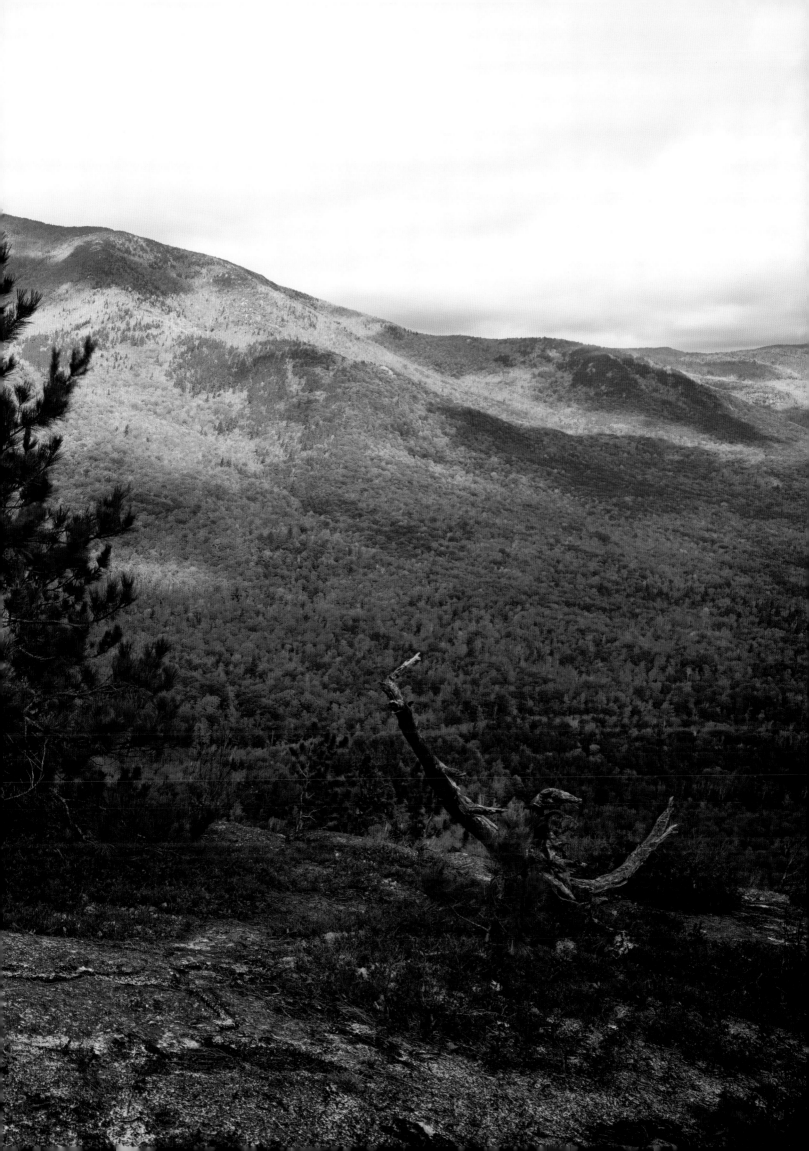

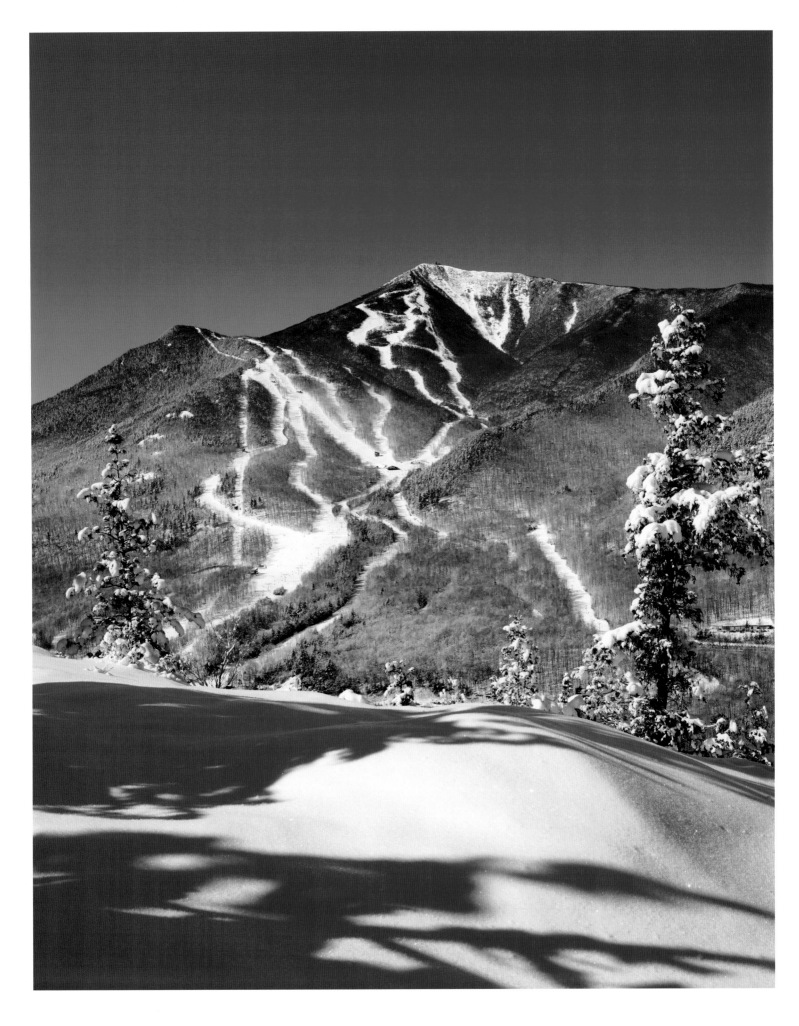

WHITEFACE SKI CENTER

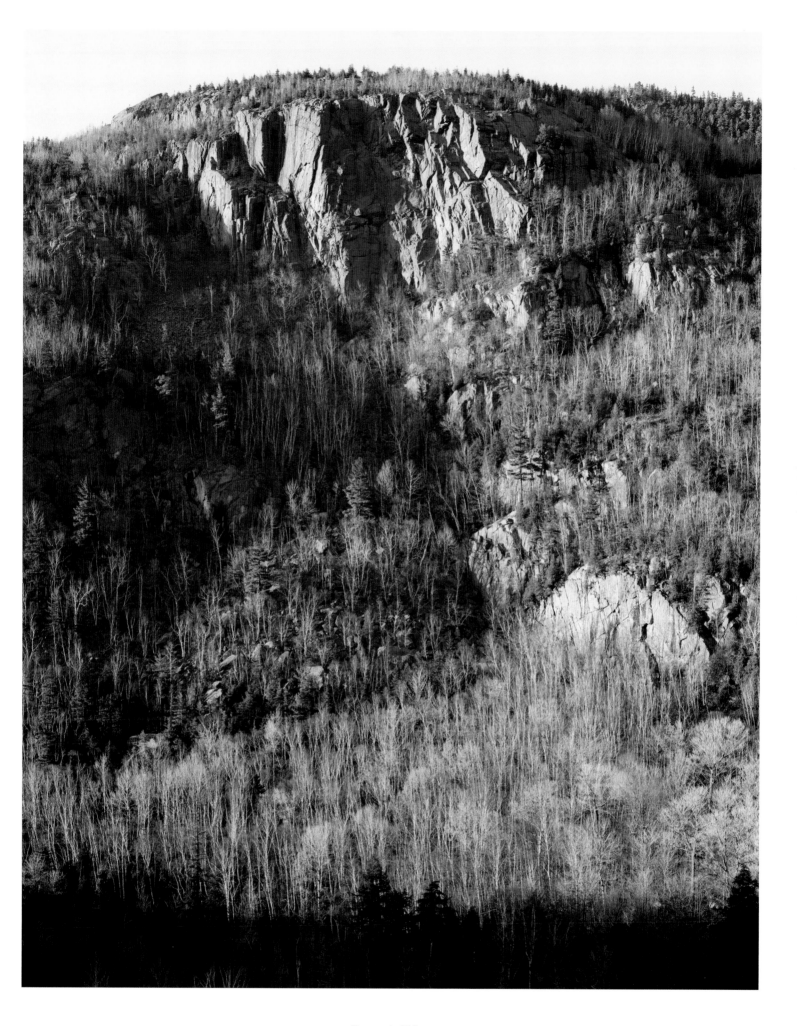

Spider's Web

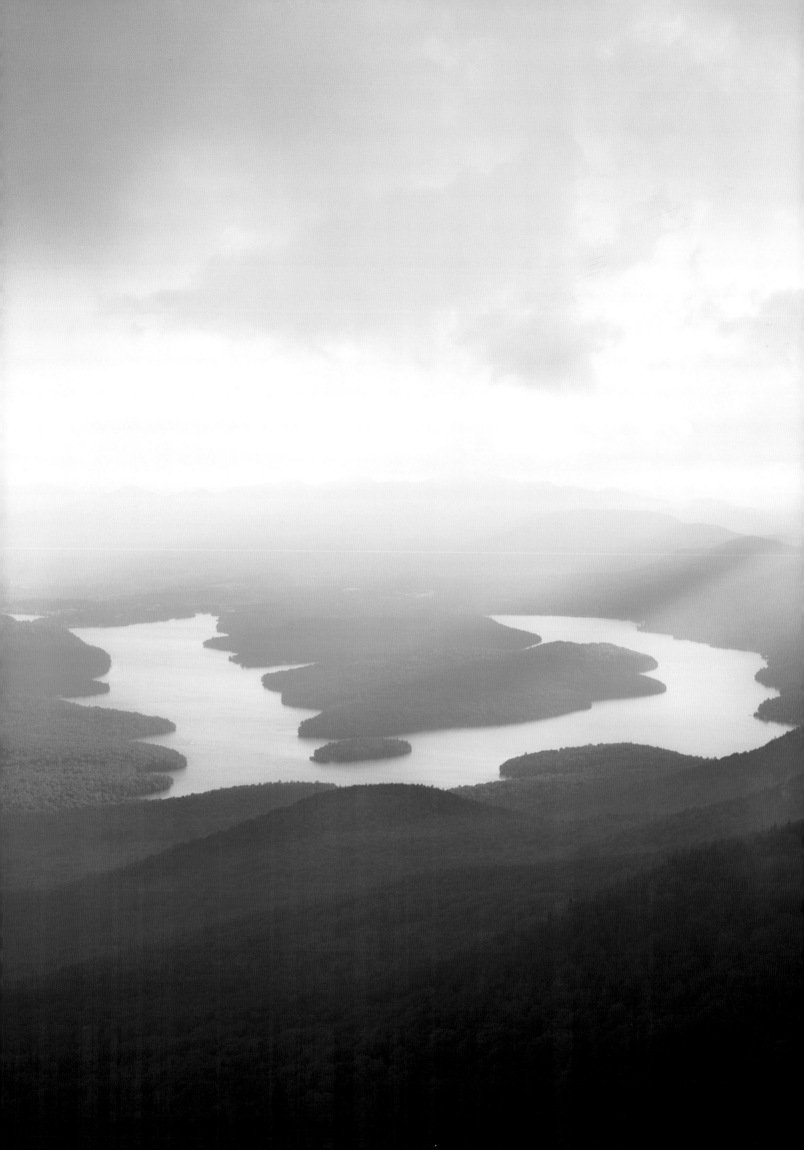

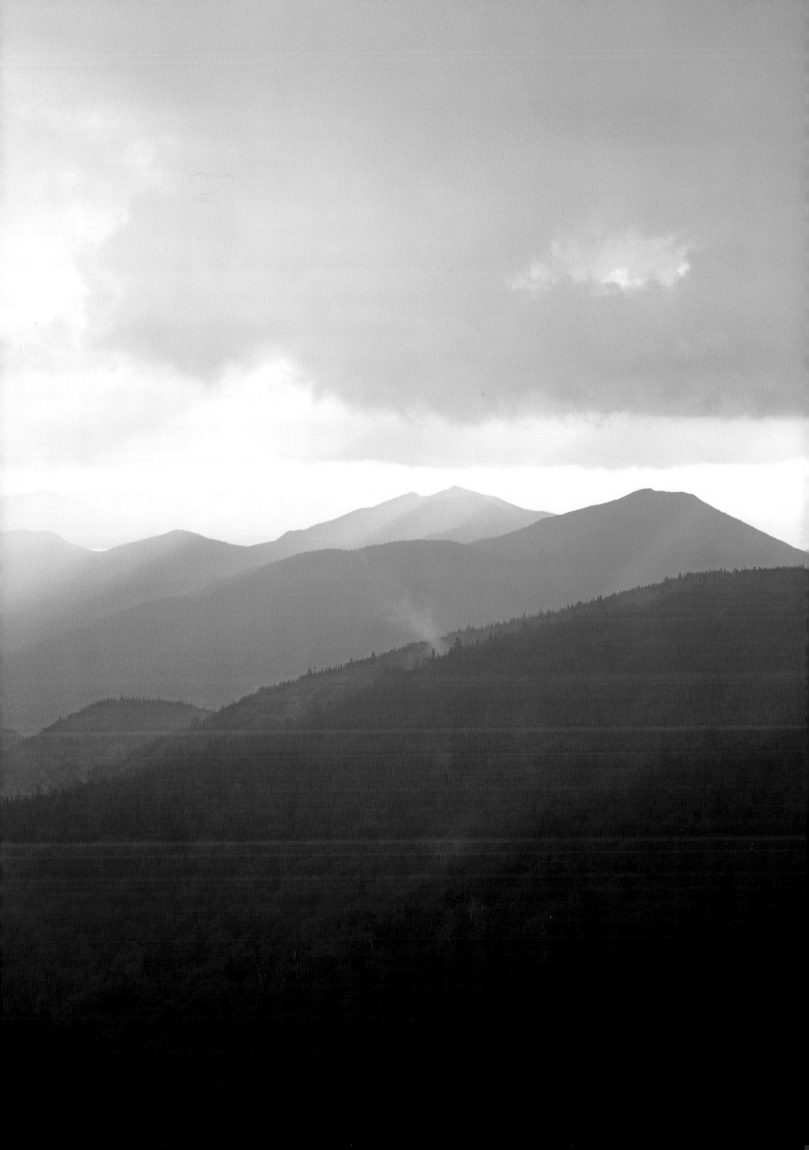

A Little Calcium Goes a Long Way

It is only fitting that the Adirondacks' most dramatic cliffs tower over its largest river. This remote location is perhaps best known to the many white-water paddlers who navigate the treacherous sixteen-mile Hudson River Gorge. Where the north-facing Blue Ledge causes the Hudson River to abruptly change direction, most paddlers focus their energies on "reading the water" rather than seeing the ledges' unique plant communities. These cliffs may harbor the greatest concentrations of northern limestone plant rarities anywhere in the northeastern United States. This is largely due to bands of calcium-rich marble that streak the cliff's mostly granite walls. These ledges are wet, loose, dirty, often icy, and dangerous.

Frequent avalanches and rock falls—sometimes caused by falling ice—help mix things up to create favorable conditions for plants, such as smooth woodsia (*Woodsia glabella*), a rare fern, to grow on the ledges themselves and in the rock debris below. Because the talus is almost always moist and has pockets of cool-air caves, plants such as purple saxifrage (*Saxifraga oppositifolia*) that are well adapted to its microclimate are called ice-cave flora.

Northern white cedar trees grow above the ledges. Where the soils are not particularly deep and the root systems are not substantial enough to hold the trees upright, they will sometimes grow downward, adding to the uniqueness of this location.

View from Whiteface (76 | 77)

The Blue Ledge ▸

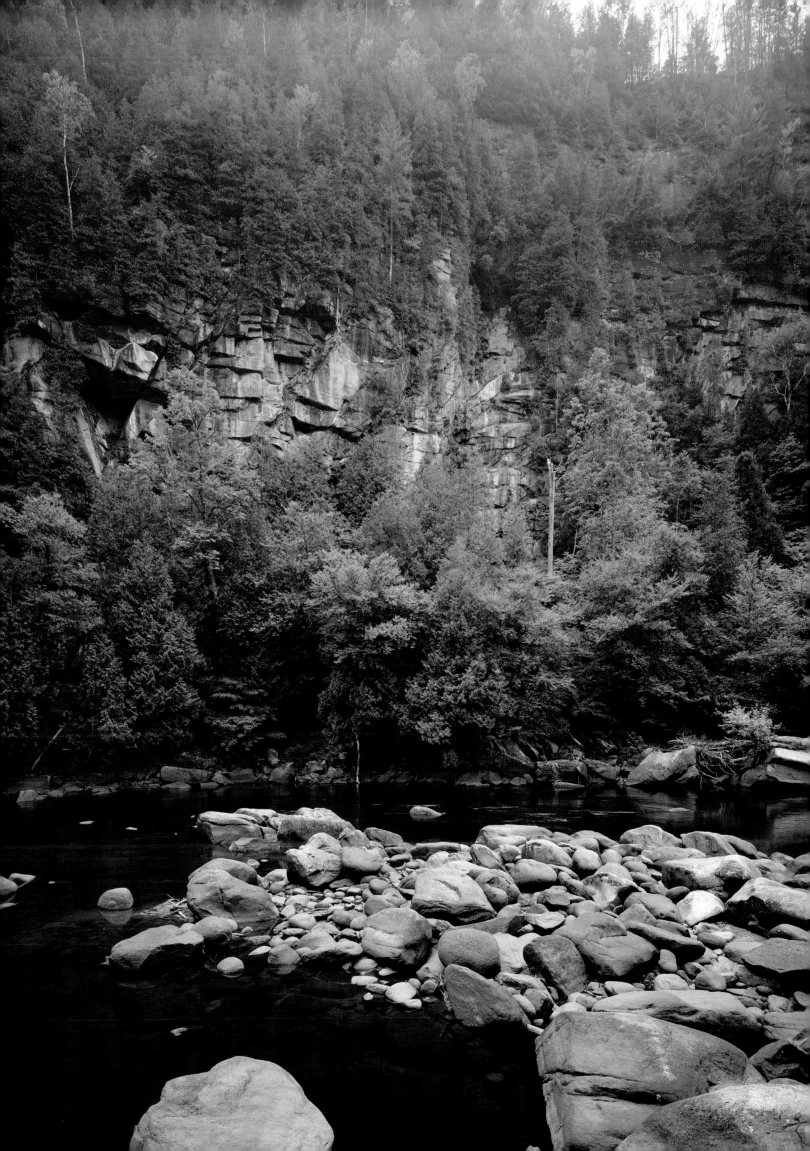

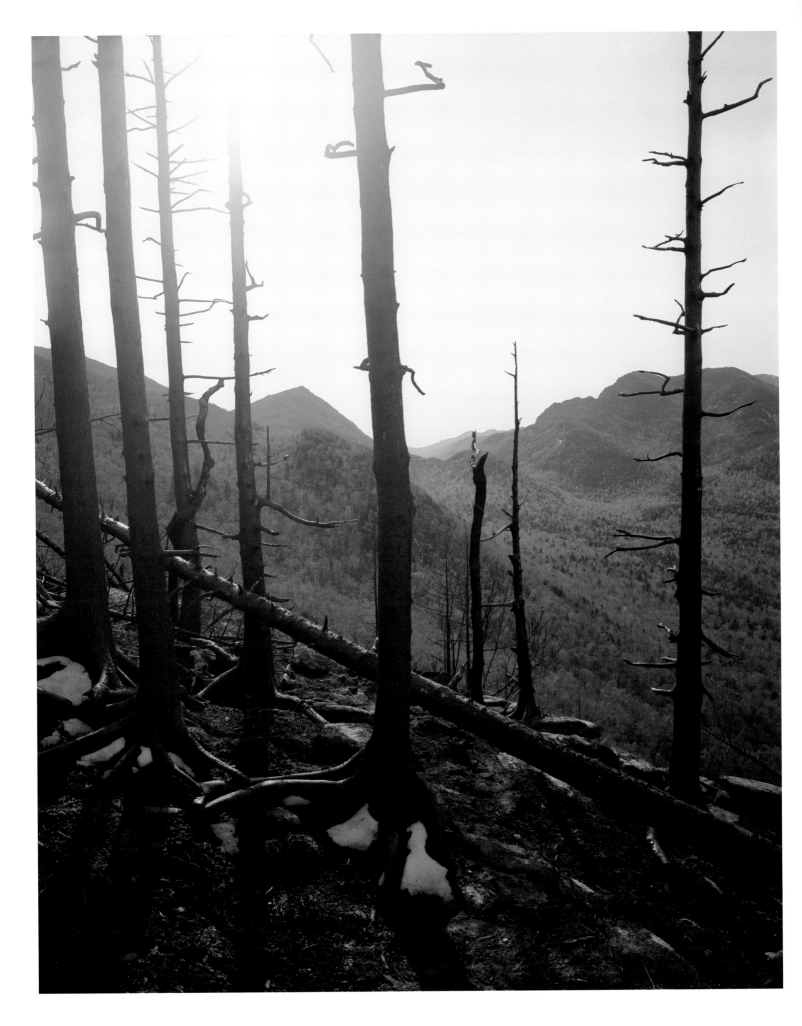

FIRE ON NOONMARK

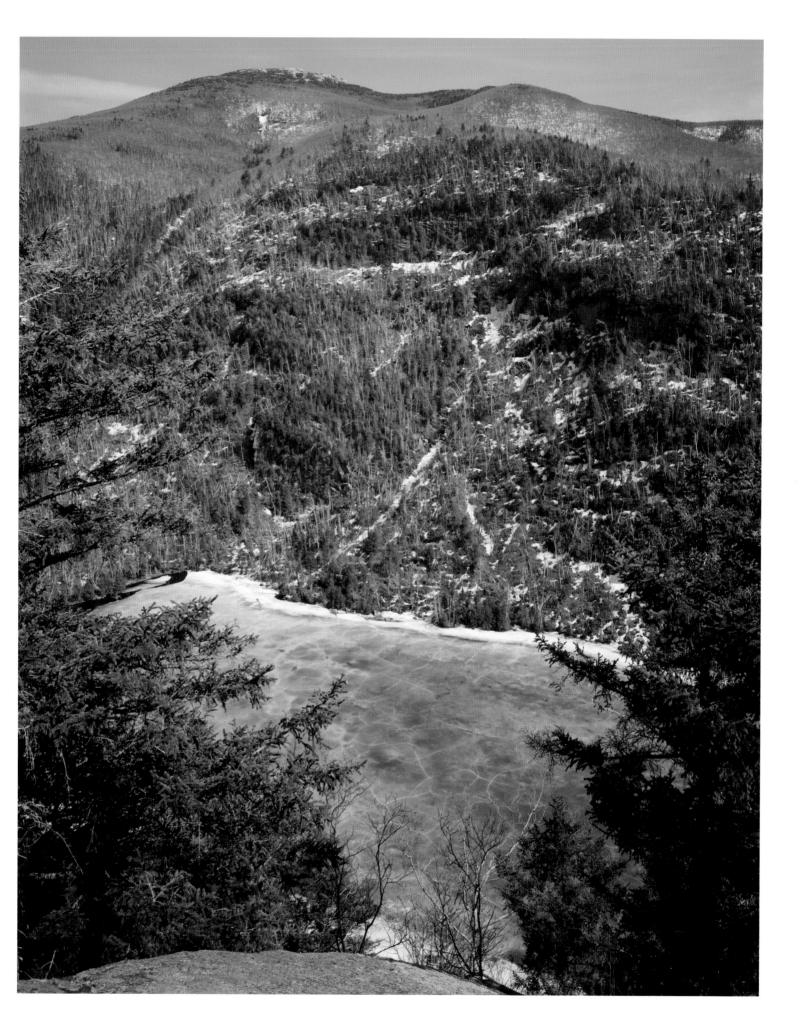

Ice Cracks on Upper Cascade

Cloudsplitter

Returning from an early-morning hike last October, I saw layers of fog across Little Beaver Valley. It seemed almost as if they were soft blankets draped by a heavenly mother across the valley. It is always exciting to become aware of phenomena that I have failed to see clearly before. Bolts of sunlight began streaming through a notch in the mountains, where Trout Pond lies in the east-northeast Jay Range. The light dramatically penetrated the fog and separated it into distinctive layers. Later that day I called an Adirondack Park biologist to ask him about it. He came over when the film was developed, took a look, and said "temperature inversion."

In mid-October the ground is often colder than the air, so the air closest to the ground becomes cooler than the air above it. Many times I have heard weather reporters say that we were having a temperature inversion—I understood the concept, but I had no idea that a photograph could illustrate it. As the cool air next to the ground is warmed, it rises and touches air that is still cool above it. The moisture precipitates out to form a layer of air free of moisture and thus clear. That's what gives the whole fog a layer-cake look. The way that the light came precisely through the notch to reveal the inversion recalls the geocentric architecture of ancient cultures like that of the ancient Greeks or of the American Southwest Anasazi tribes.

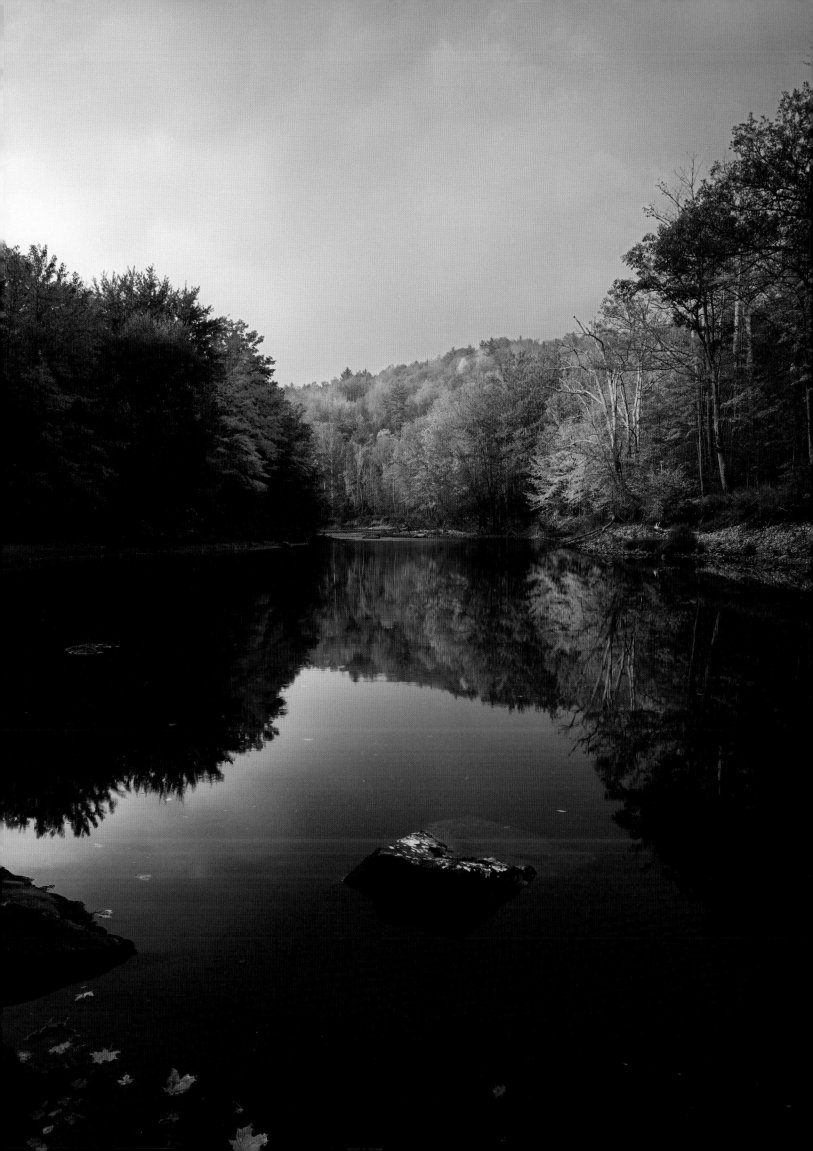

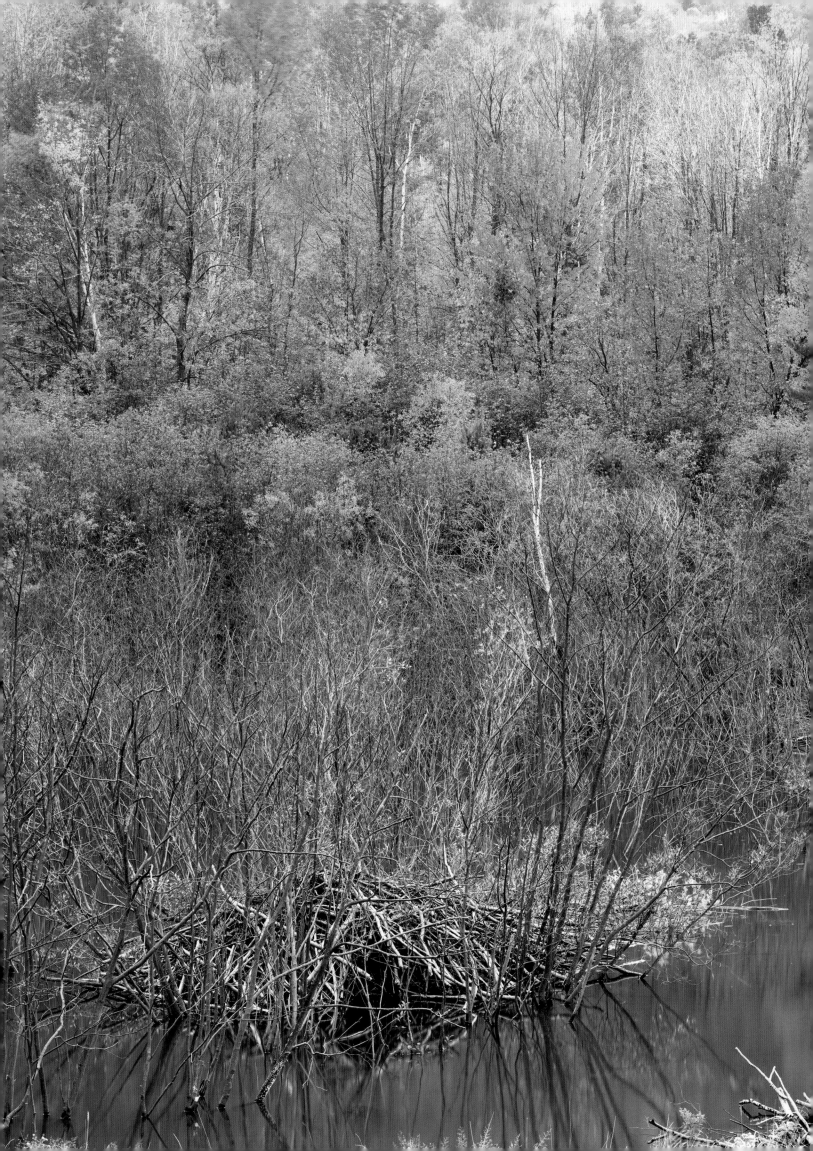

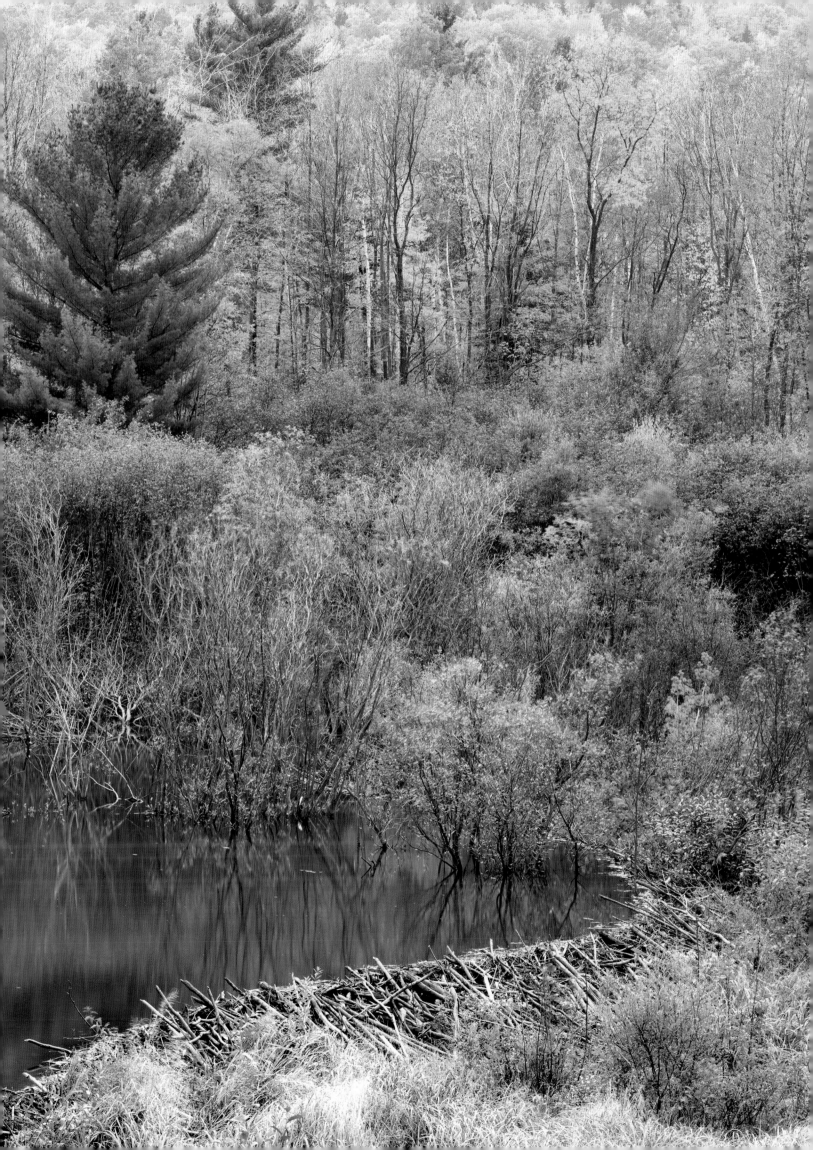

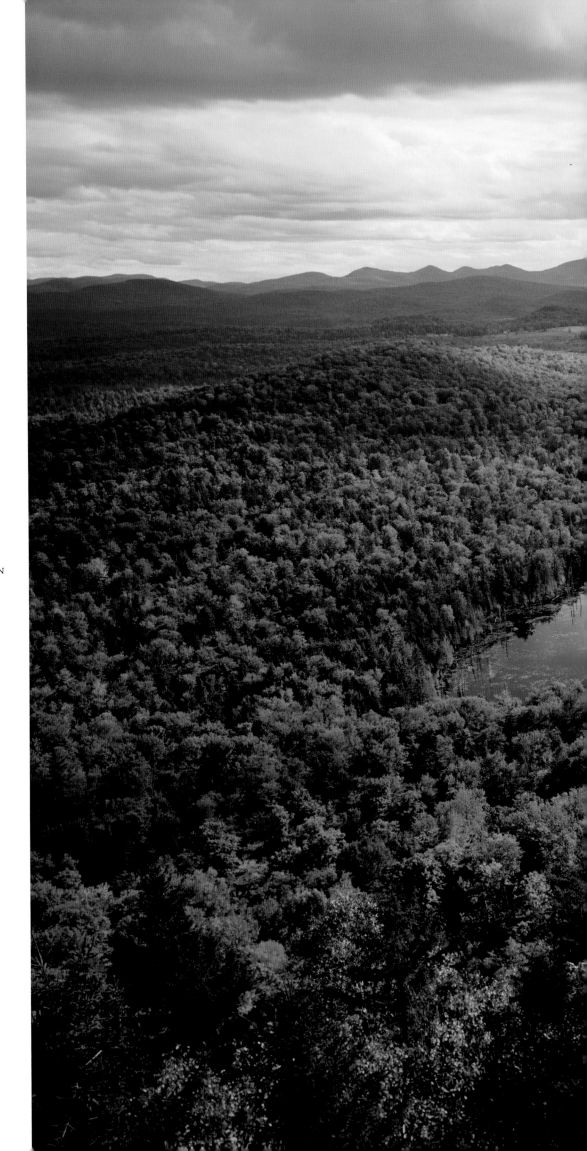

View from Peaked Mountain

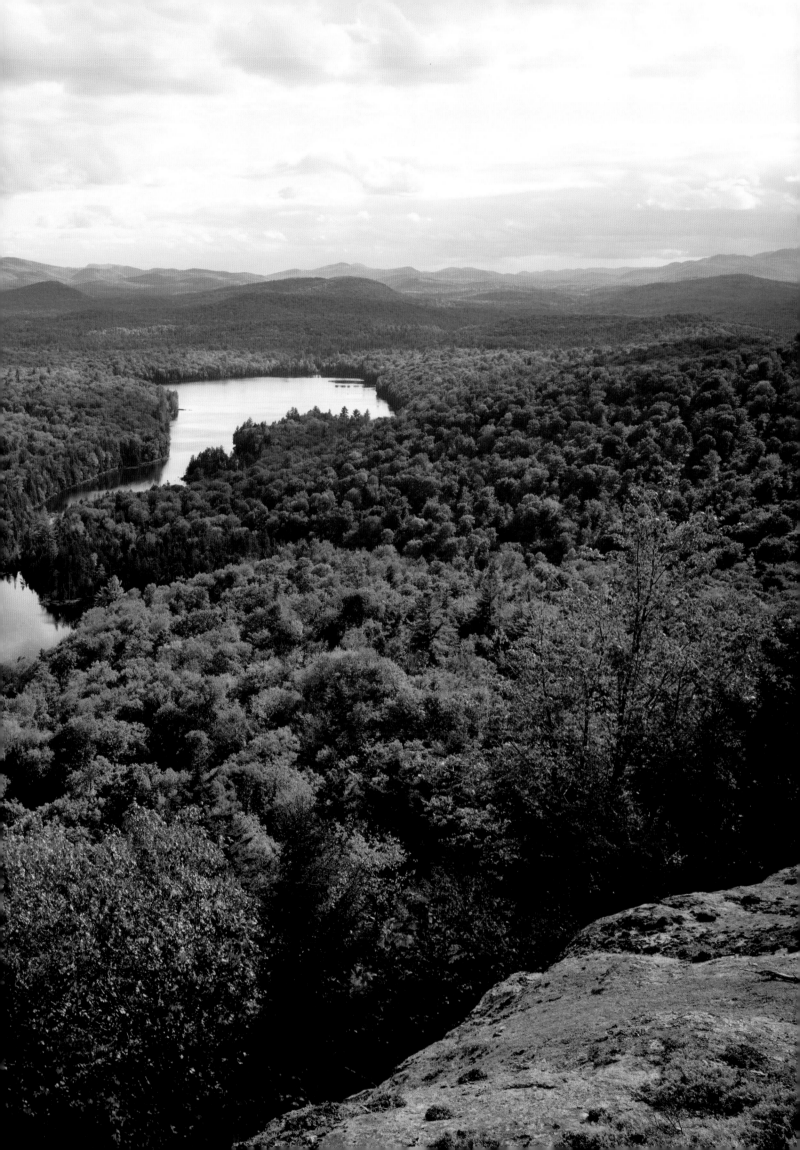

ANOTHER ADIRONDACK TALL TALE

There are a number of old private clubs in the Adirondacks— the Ausable Club, the Northwoods Club, and the League Club among them—that were established on vast tracts of land purchased from timber companies after clear-cutting or forest fires left them unprofitable. As a result, the lands were sheltered from unchecked development, and large forests remained unbroken and eventually revived to support a wide array of native plants and animals. The Northwoods Club is particularly noteworthy because it was the summer home, for seventeen years, of the American artist Winslow Homer.

Several years ago, a member of the club invited me down to "camp" for a couple of days. When I arrived, I ceremoniously signed the guest book as Homer had once done in the main lodge. I returned to camp many times to visit the property's ponds and to hike to the top of what Homer knew as Peaked Mountain, now listed on maps as Polaris Mountain. The view on the previous pages is from Peaked looking out over Split Rock Pond.

On one visit, my host, a fabulous fly fisherwoman, urged me to go out on Split Rock Pond and try my hand at the sport. I insisted that photography was so similar to fishing that I really had little interest. She would not hear of it, and I found myself being swept along by her enthusiasm. I must admit that I was worried that I would fall short of my reputation as being an expert on all things Adirondack.

We got into a classic Adirondack Guide Boat with spruce ribs and cedar planks. My "guide" wore a battered hat full of colorful hand-tied flies as she rowed me, the sport, to what she claimed was the right spot. As I was receiving a brief lesson in casting, a storm came up quickly and hard. Almost as soon as I had a rod in hand, it started to rain. Within moments thunder erupted, and the sky was charged with electricity. "This is unbelievable," I thought. It was straight out of a Homer storm scene, albeit more a coastal one than an Adirondack one. The boat heaved. I cast.

On my first toss of the line, a sixteen-inch rainbow trout grabbed the dark spruce fly on the end of my line, and, as lightning flashed all around me, I hauled in a fisherman's dream. When we got that sixteen-inch rainbow in the boat, she insisted that I cast again. This time a fourteen-incher went for the dark spruce. It was pure Homer. If I ever believed that one could enter another dimension or that the spirit of a person could inhabit a landscape, it was out there on Split Rock Pond that day. It was thrilling, and I was utterly transported. I hoped that it was a blessing from the great man.

SMALL FALLS NEAR THE HUDSON ▶

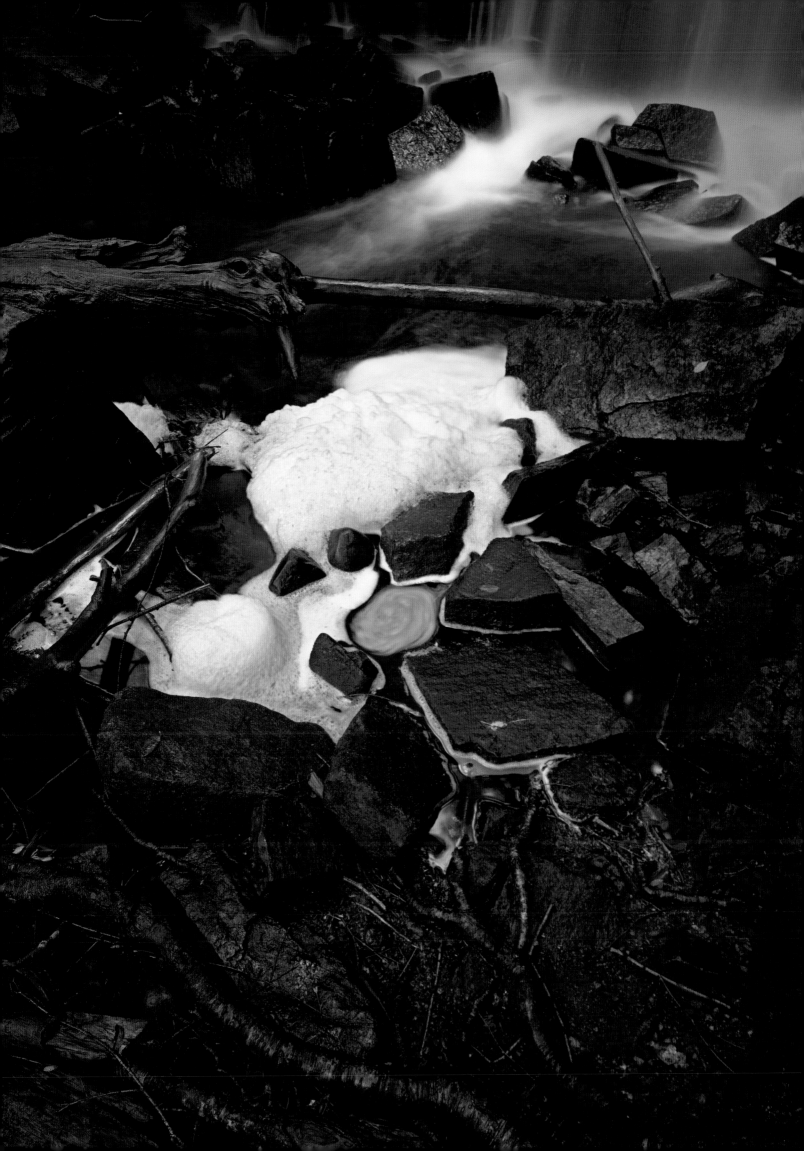

LICHEN ON PITCHOFF

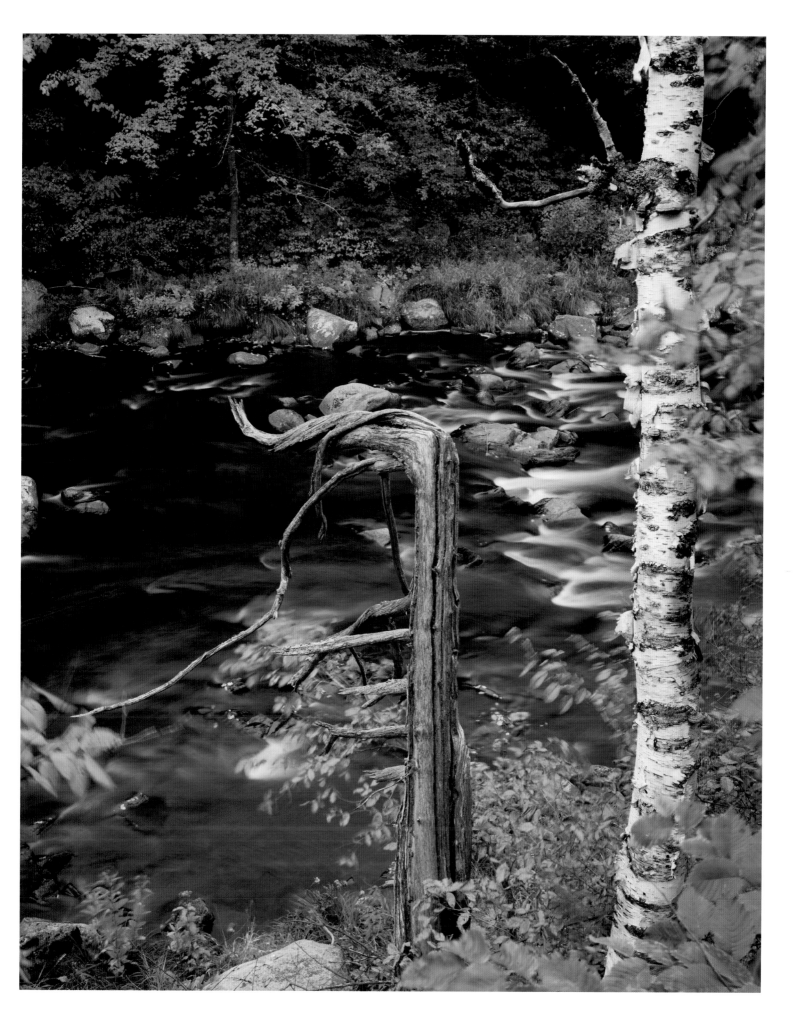

Dead Tree on the Ausable River

TUPPER LAKE SHORE

RIVER WITH IRISES

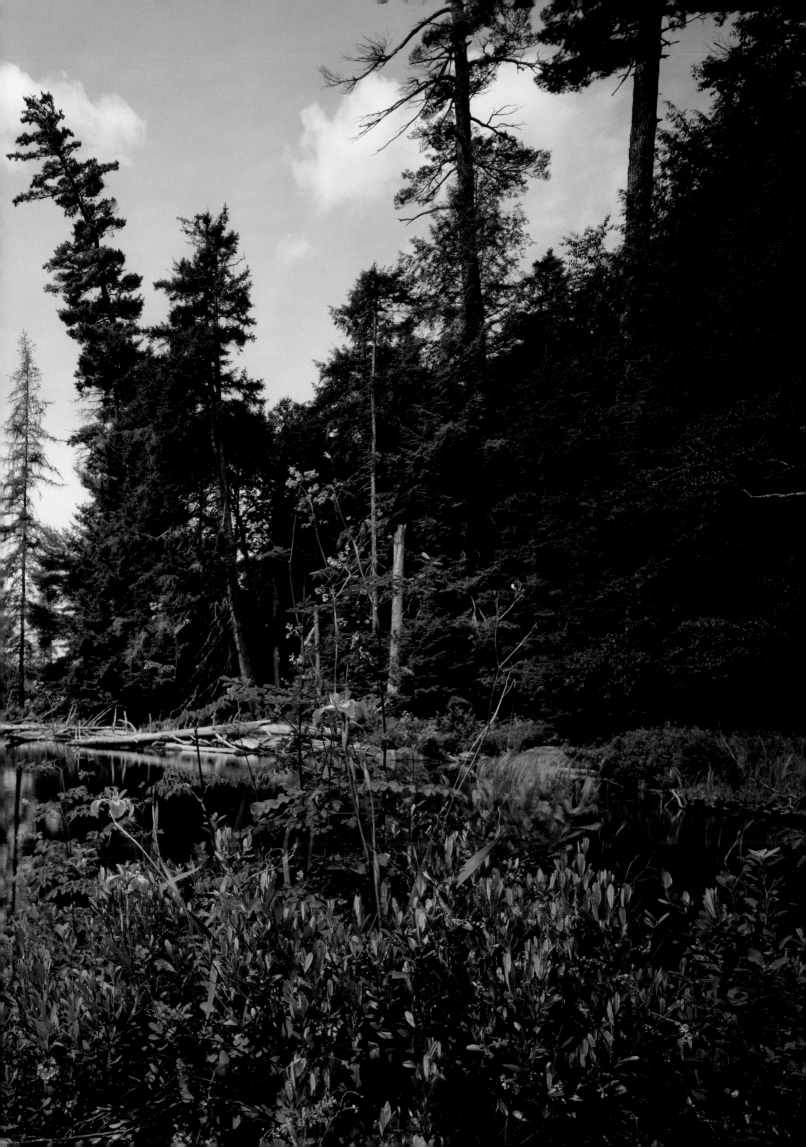

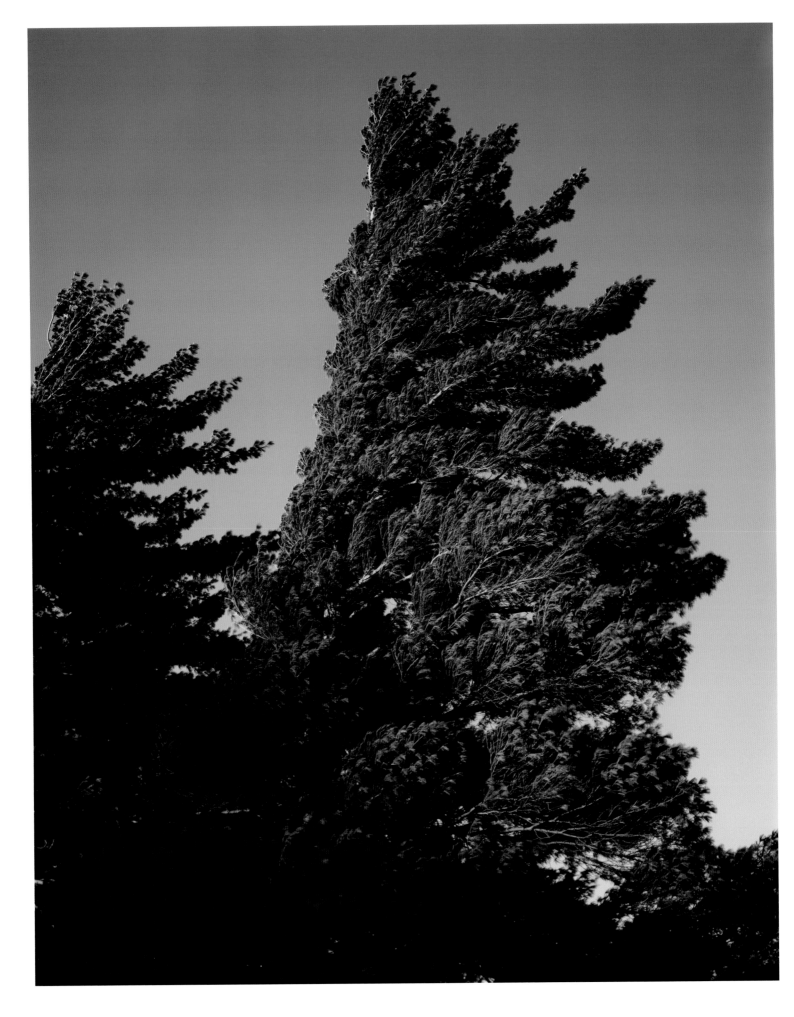

White Pine Flag

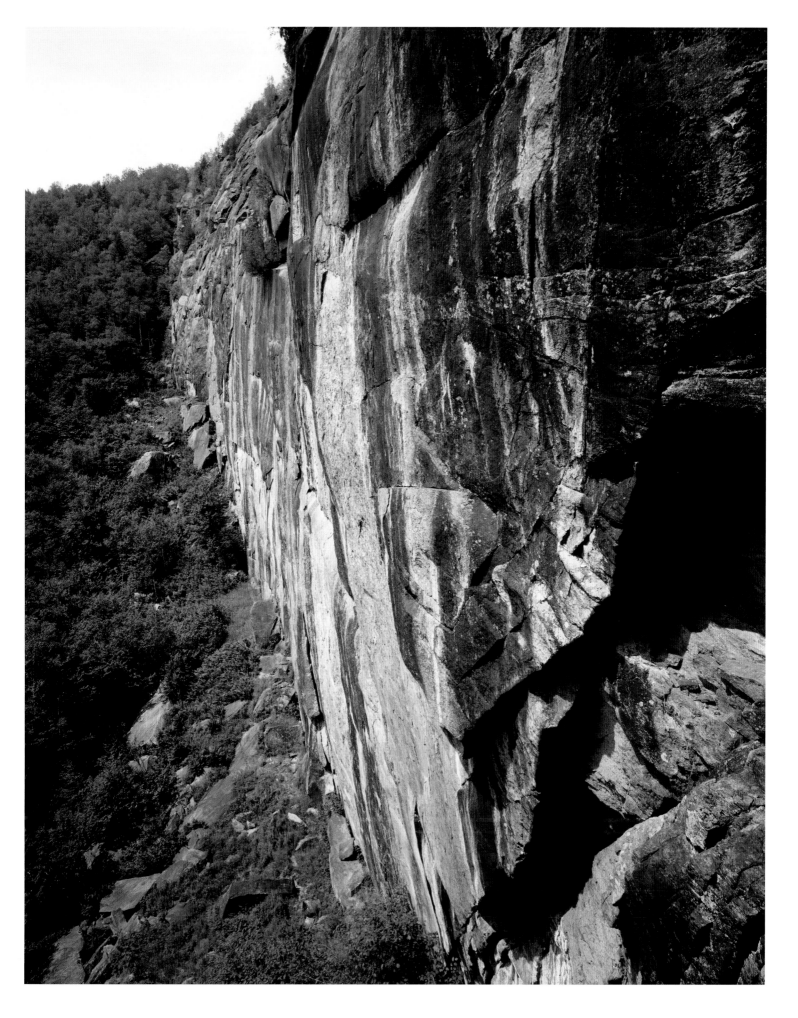

King Wall

GLASBY POND

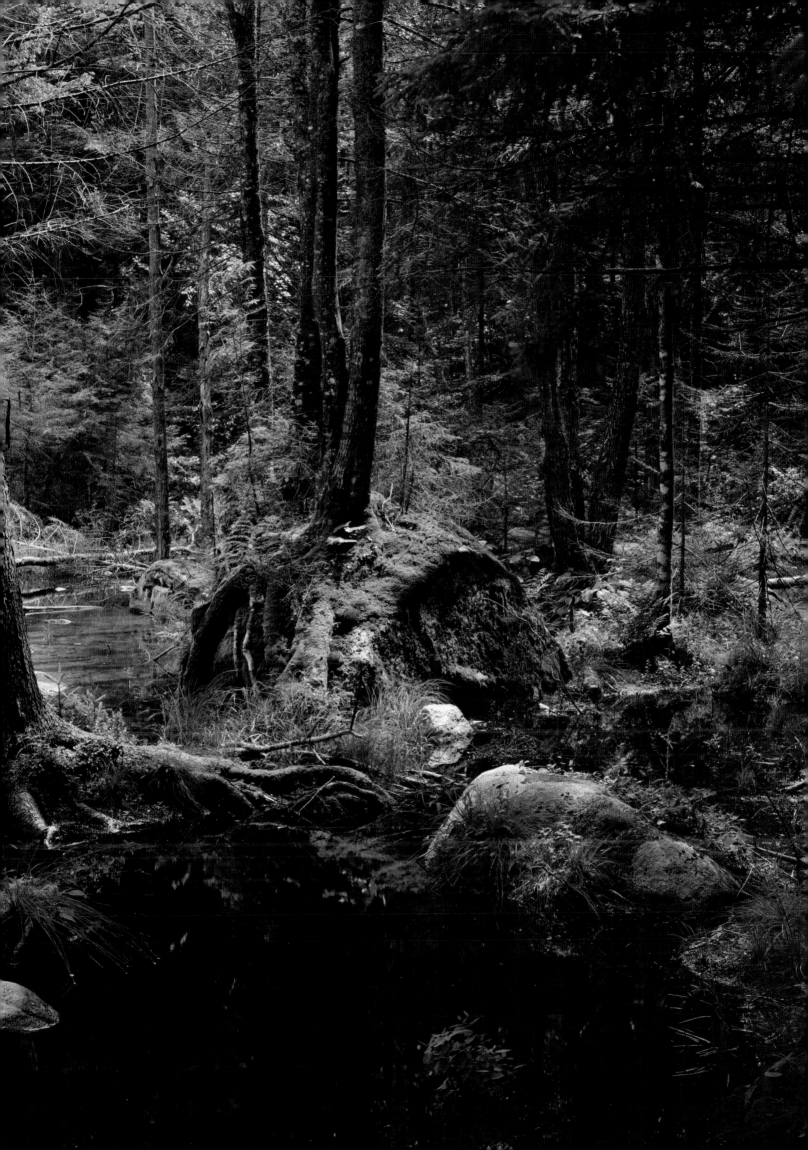

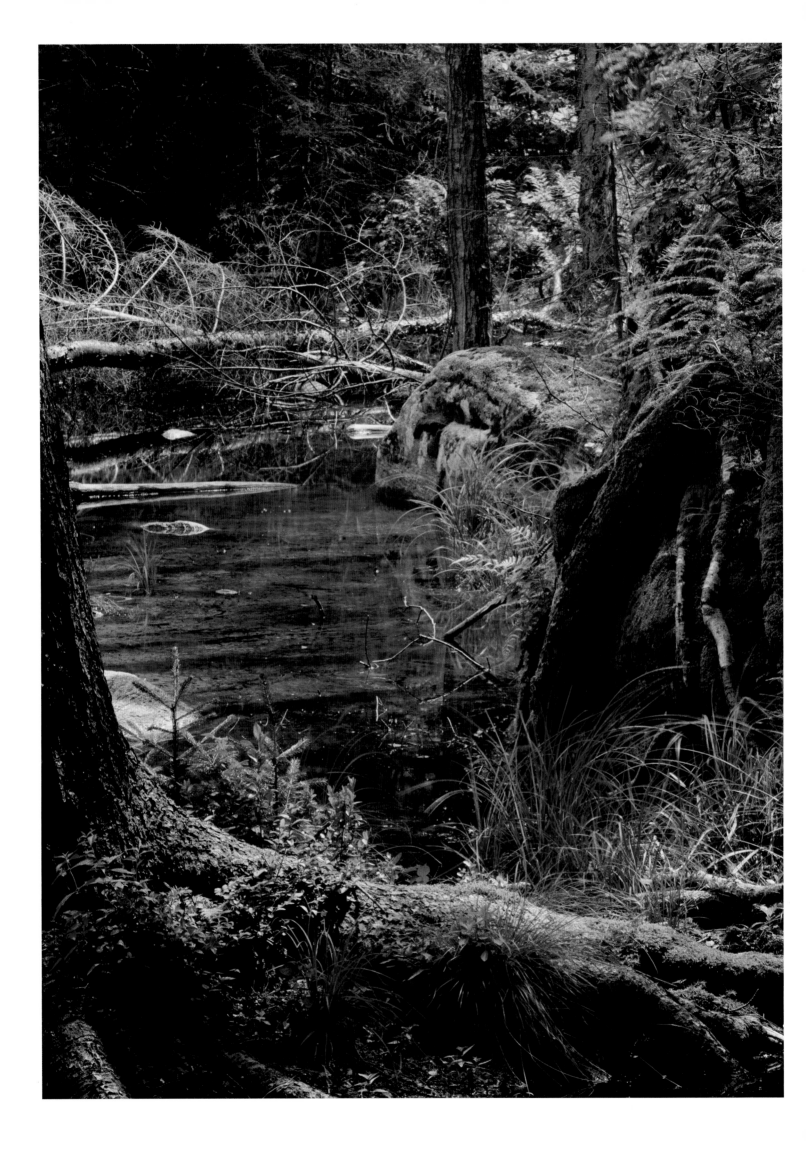

A Dynamic Landscape

Bob Marshall, an avid Adirondack explorer, founder of the Wilderness Society, and the person after whom a large Alaskan wilderness area is named, spent time at Glasby Pond when he was a forestry student at the New York State College of Forestry in Syracuse in 1922. He found the area heavily cut over and burned by wildfires that were fueled by the "slash" left from logging. The forest has since returned in a remarkable demonstration of nature's resilience when left to its own devices.

Detail of Glasby Pond (previous pages), the conversion of forest into wetland

Beavers, as an agent of nature, are changing the area in this photograph, just to the south of Glasby Pond (page 102), from forest to wetland. Floodwater from beaver dams is covering the forest floor and saturating the soils, causing forest plants and trees such as red maple, spruce, and hemlock to die off. As this happens, woodland trees, ferns, and shrubs are being replaced by wetland species such as horehound and sedges, as seen on the water's periphery. The hemlock and spruce saplings growing on stones and hummocks are profiting from the open canopy, but only time will tell if they grow to maturity or are killed by flooding. The fate of the mosses, which here are species of moss suited to the forest, also hangs in the balance.

This image also illustrates an uncommon and fortuitous opportunity for me as a photographer. While it is easy to photograph details and small environments within the forest, rarely do I have the space to back up with the camera to capture a forest's fullness. Typically the vegetation gets in the way, but in this instance, the beavers' work to flood the area gave me the room to make this photograph that captures a wide portion of the interior of a forest.

◄ Detail of Glasby Pond

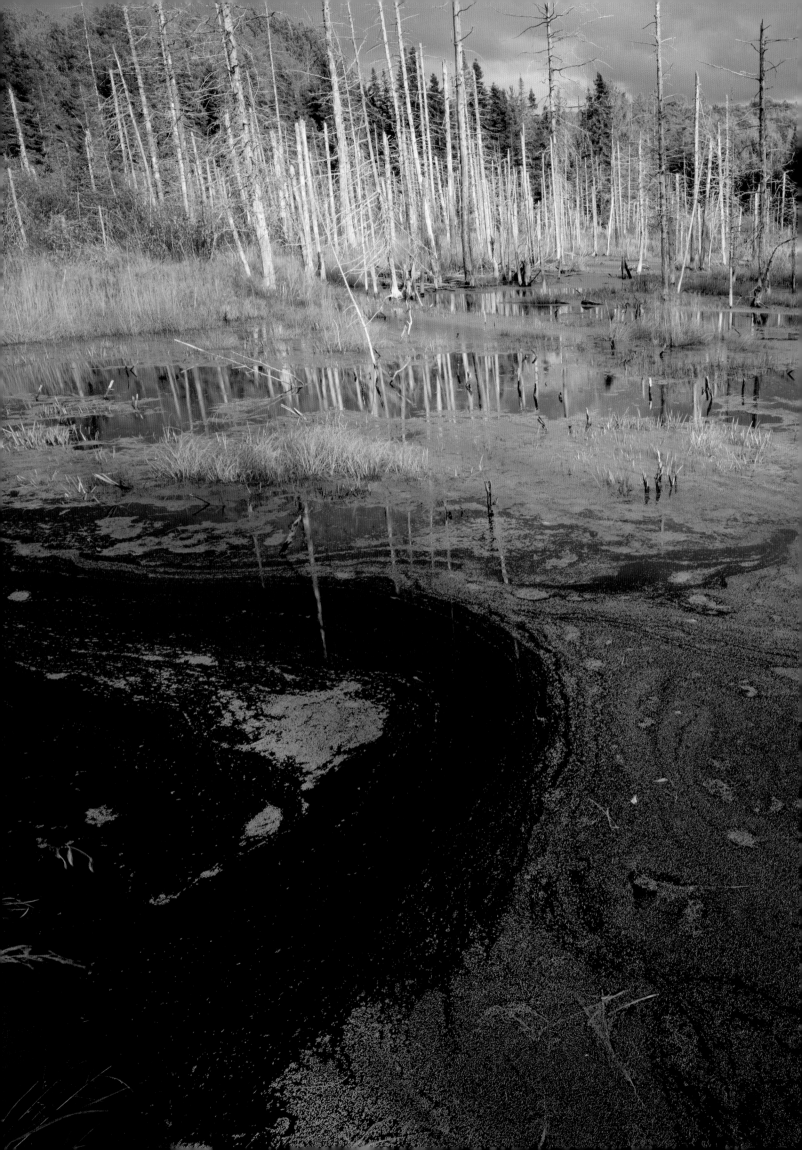

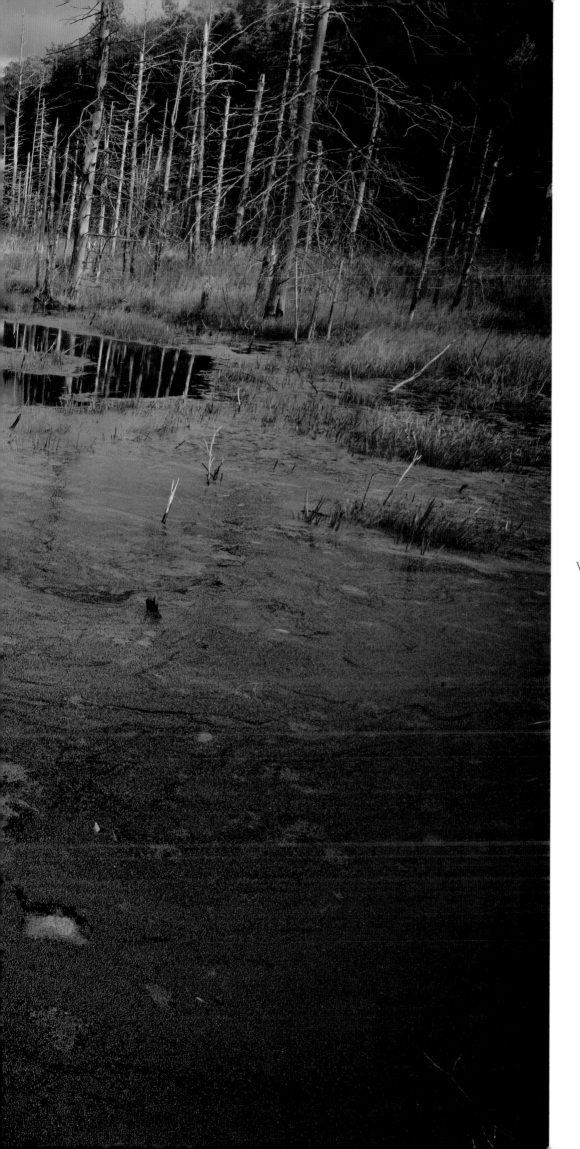

West Pine Pond Outlet

The Natural Engineers

To think that beavers were once almost extirpated from the Adirondacks is sometimes hard to believe. At the turn of the twentieth century, the heyday of the fur trade, beaver pelts were a valuable commodity. After almost being trapped into nonexistence, beavers have since made a comeback, and it appears they are here to stay.

Whereas beavers are just beginning to make their mark near Glasby Pond (page 102), they are in full effect at West Pine Pond, a place that seems to have been flooded many times. The mixture of plants seen in this image help tell the story of a changing landscape.

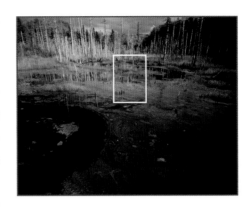

Detail of West Pine Pond Outlet (previous pages), a newly flooded pond

The bleached-white timber in the middle of the pond has been dead many years. That these dead trees are relatively uniform in size suggests that they might have originated together, perhaps when an older pond drained. At that time, too, other forest plants, such as the partial ring of shrubs around the pond, would have taken root.

It is hard to determine when the forest began to phase out, but it must have been quite some time ago since many wetland species, such as duckweed and bur reeds, are here now. Their presence indicates that the pond is extremely fertile. The abundance of bulrushes, a flood-tolerant plant, also points to a history of flooding. At the water's edge, on the far side of the marsh, are alders, which like to keep their feet wet. Where the ground is higher and less moist, they give way to spruce, pine, and hardwoods.

Detail of West Pine Pond Outlet ▶

Adirondack Loj Road (110 | 111)

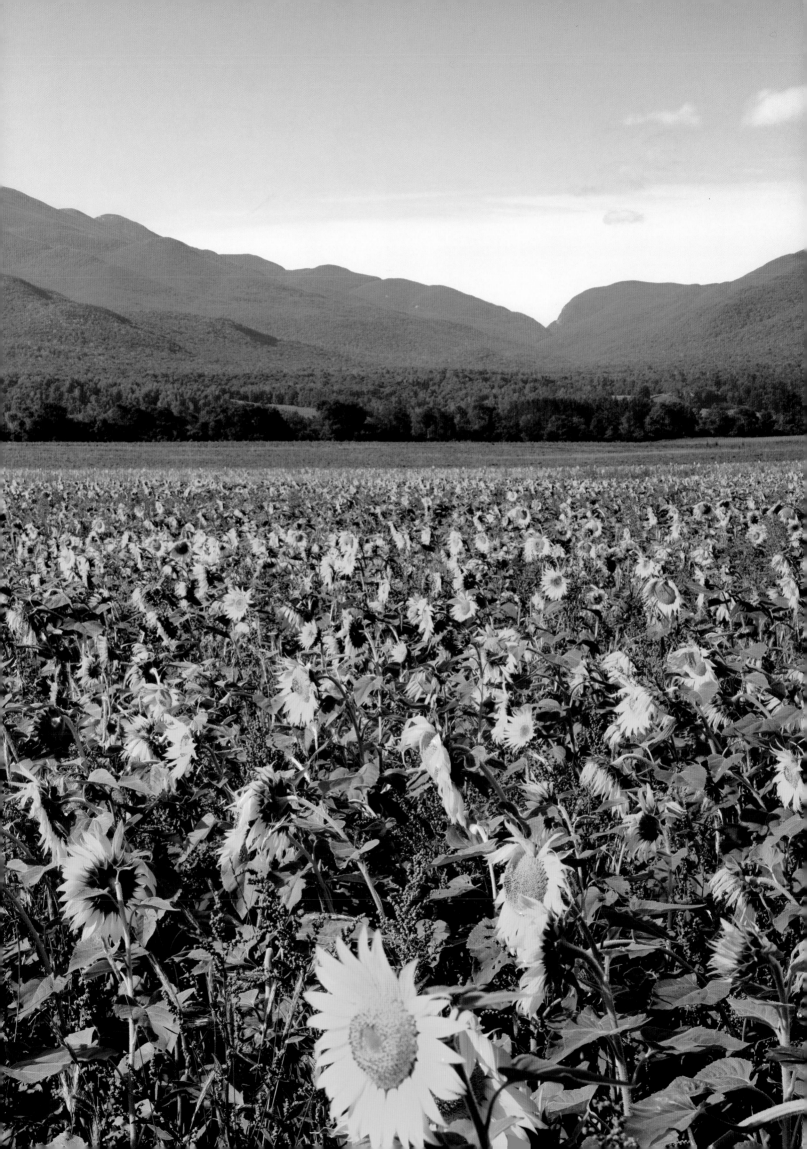

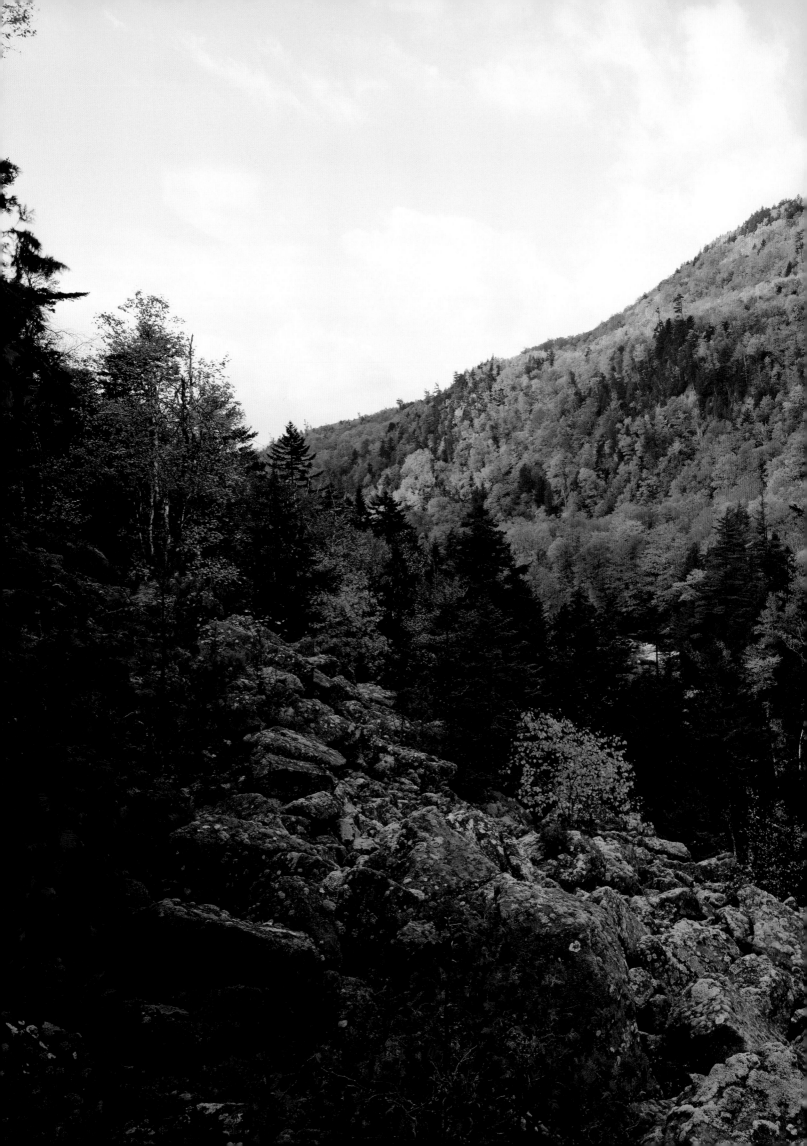

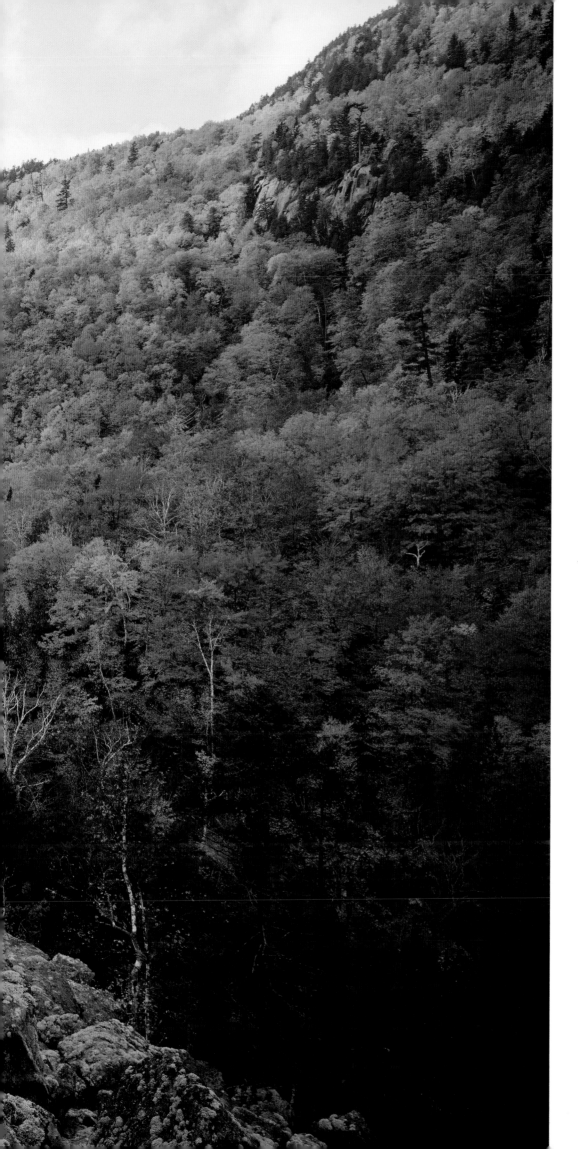

Wilmington Notch

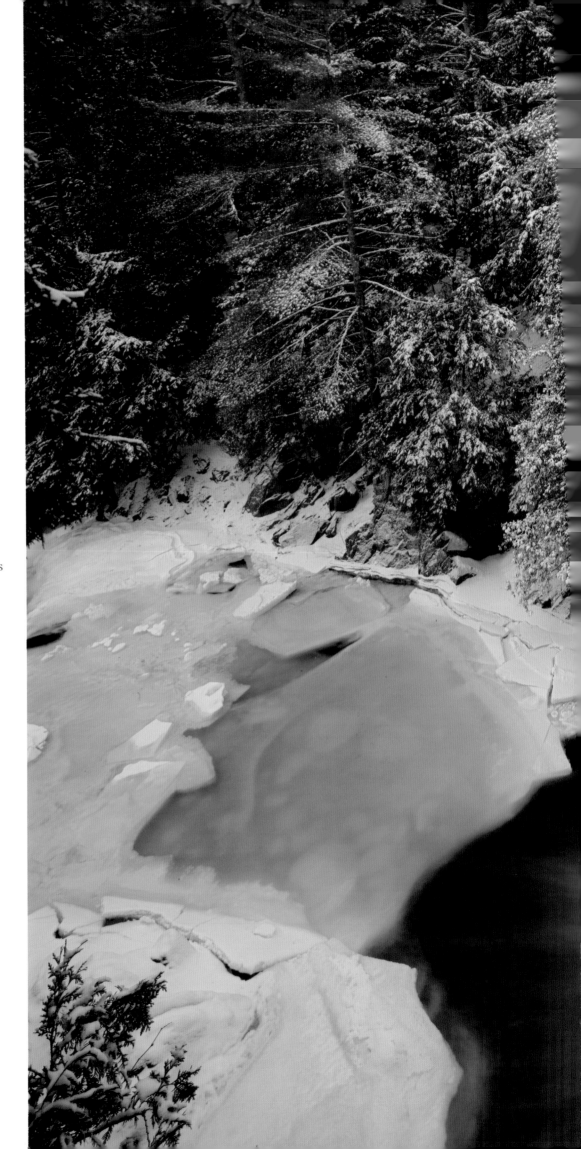

Split Rock Falls

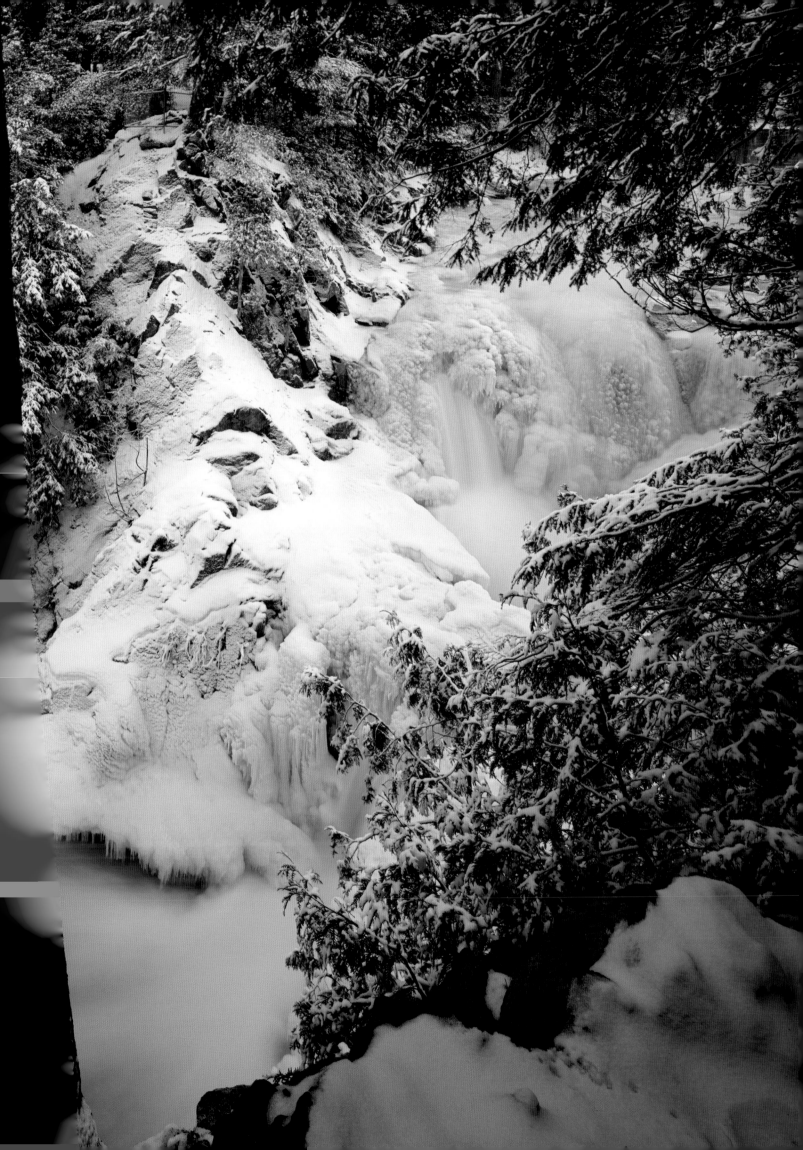

Spring Debris

Wolfjaw Brook

LAYERS OF TIME

This is one my favorite photographs because it shows an unusual set of nature's colors and captures several interesting geologic formations and ideas. The name "Orebed Brook" says a lot about it. In the lower right-hand corner the orange-red is recognizable as iron oxide. Some of the earliest exploration of the Adirondacks was made in an effort to find veins of valuable iron ores.

This spot is very close to the top of Gothics mountain on the Johns Brook Valley slope. It is perhaps only a half a mile below the system of cables inserted and embedded in the rock to help climbers to the top of Gothics. Because it is high and extremely remote, mining never occurred here. It is sad to think that this remarkable spot could have been destroyed for a few years of iron deposits.

As I have mentioned, these mountains are composed almost entirely of anorthosite, an igneous rock formed deep in the earth under tremendous pressure and heat. One of the subcategories of anorthosite is feldspar, and a subcategory of that is labradorite, which sometimes displays an unusual iridescence, called "labradoresence." I believe the unusual blue-green in the photograph is evidence of film recording labradoresence as best it can. The mosses that grow on these mineral rich rocks seem to be illustrating the old principle that you are what you eat—because they have absorbed that unique color.

The photograph was made with a two-second exposure, so if anything moved in that two seconds when the shutter of the camera was open, its path was recorded. The spiral or hooked white shapes in the small pool of water, resembling the tracings of atomic particles in milliseconds after collision in an accelerator, show the movement of the naturally occurring foam on the surface. Below the foam is another, quite different, visual representation of time. The vertical striation of the rock was created under intense pressure twelve to nineteen miles below the earth's surface, forming ribbons of quartz and feldspar.

Thus, we have a snapshot of time in seconds, overlapping a picture of time in millions of years. Staring at this piece of ground, or the photograph of it, makes me think about where we stand in the universe and in time.

OREBED BROOK ▶
GUIDE BOATS (120 | 121)

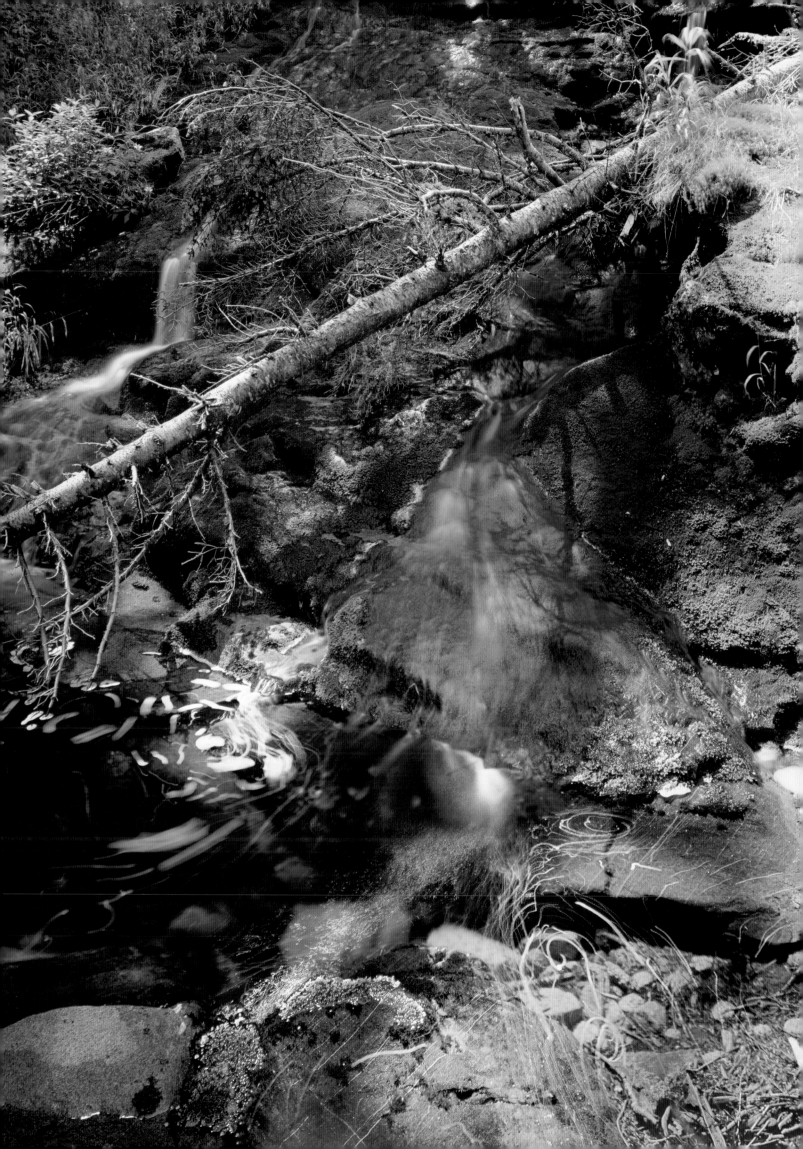

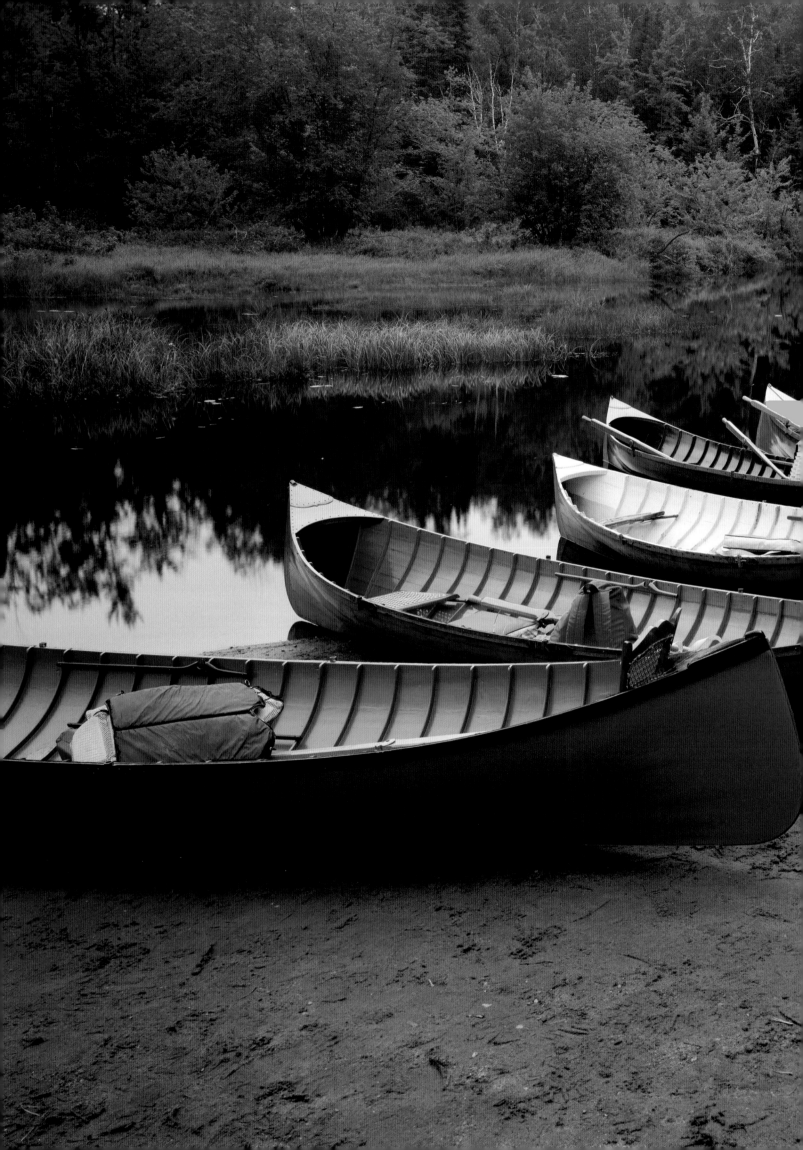

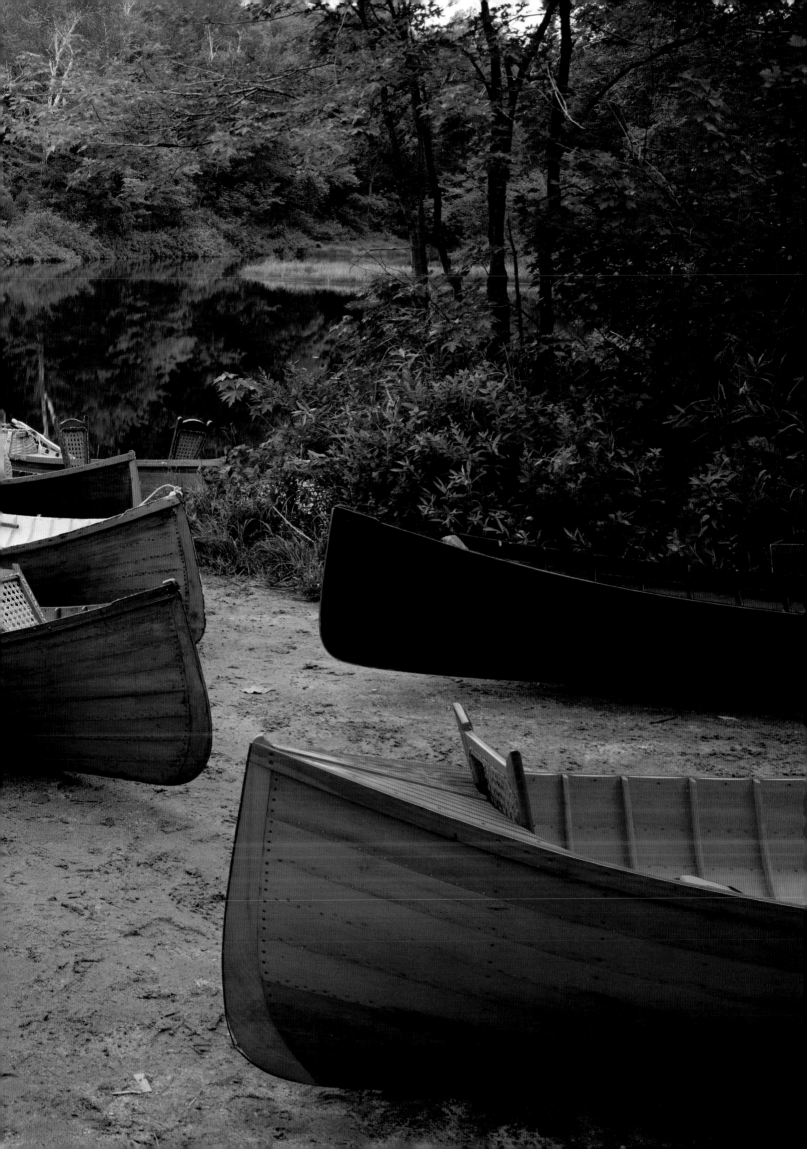

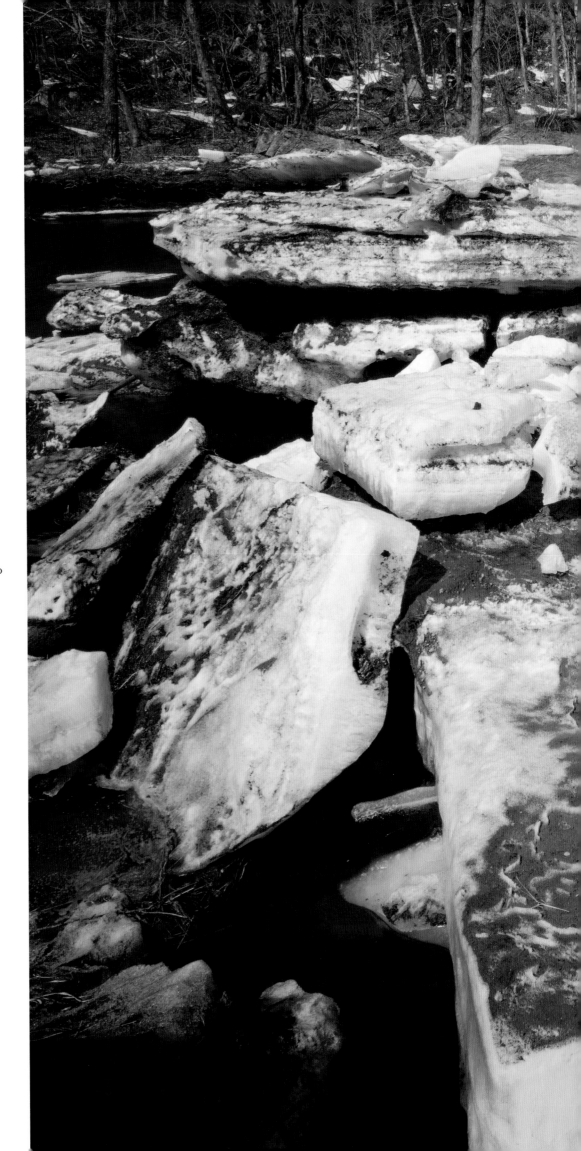

ICE AND MUD

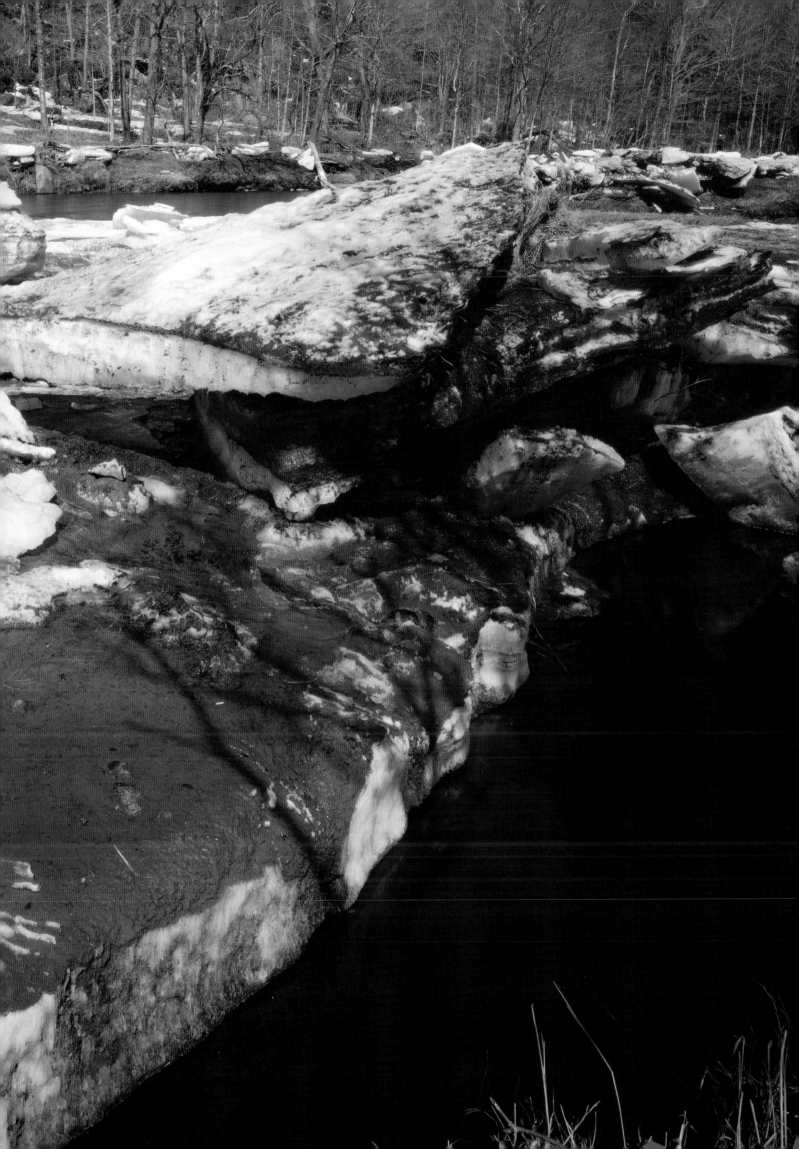

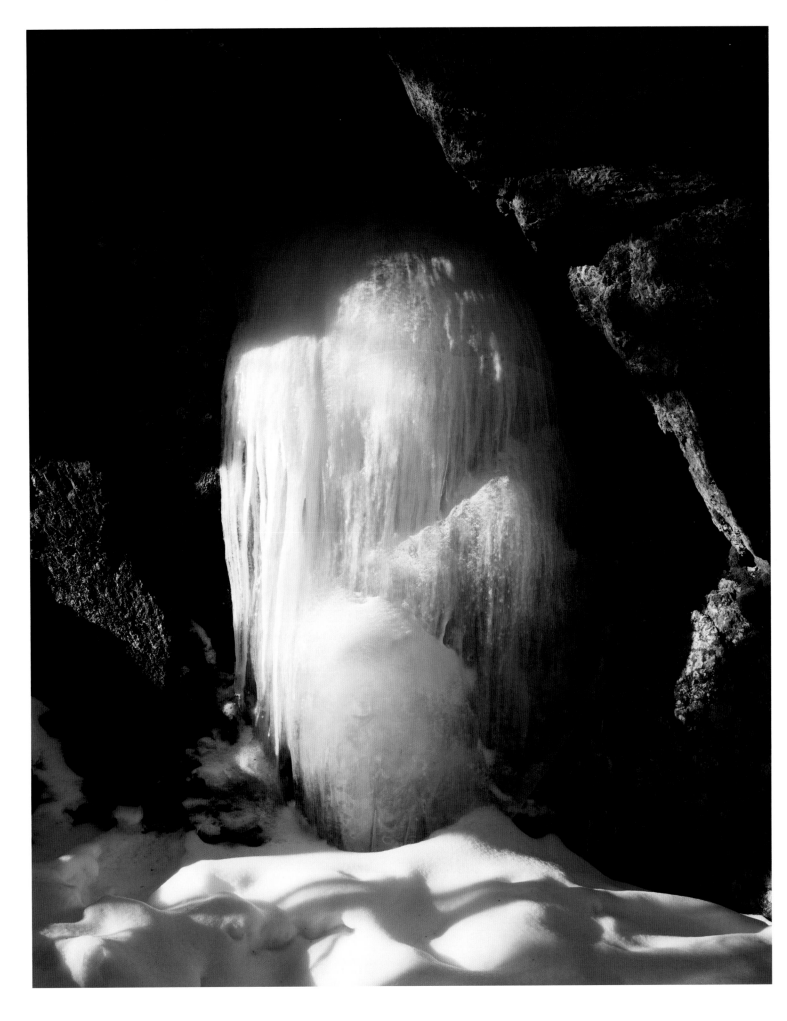

Ice Flow at Avalanche Pass

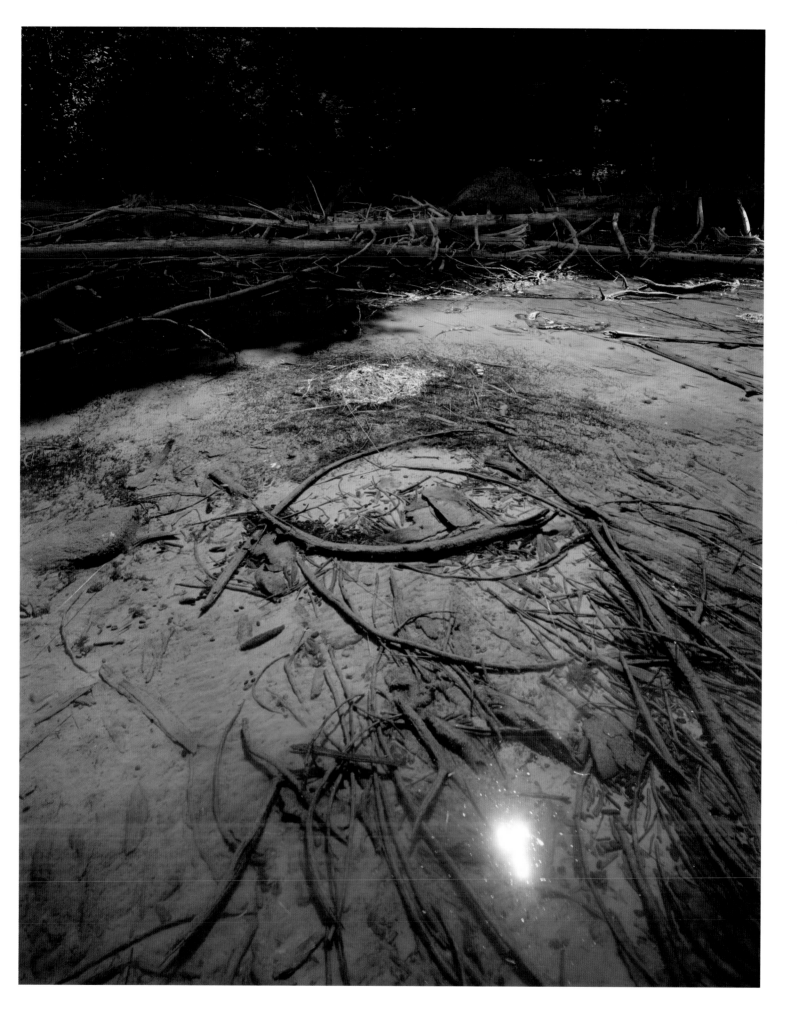

Edge of Pond

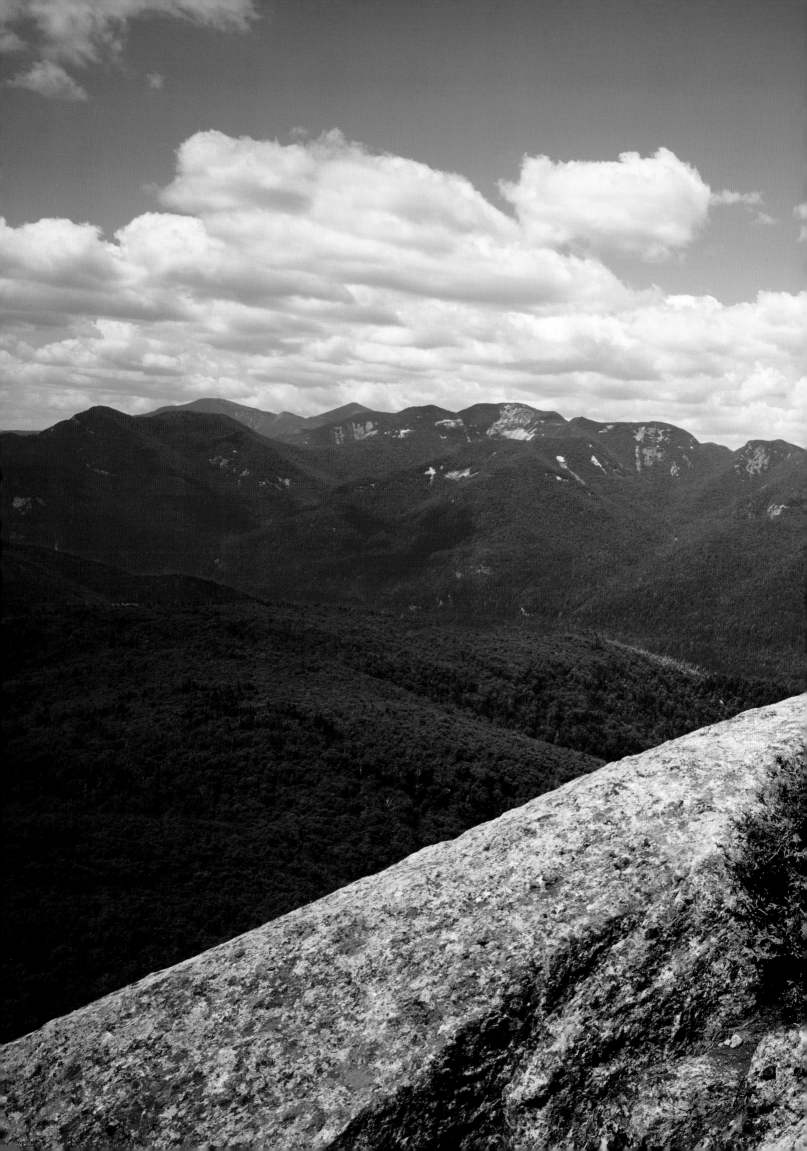

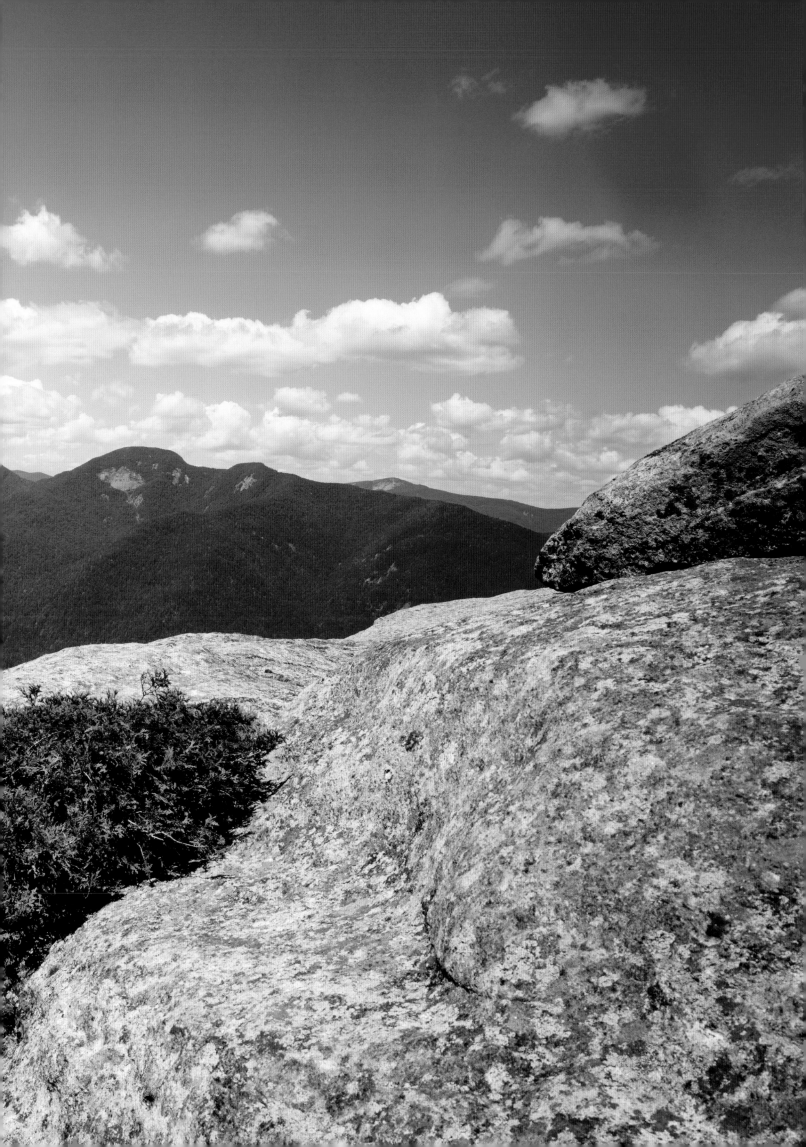

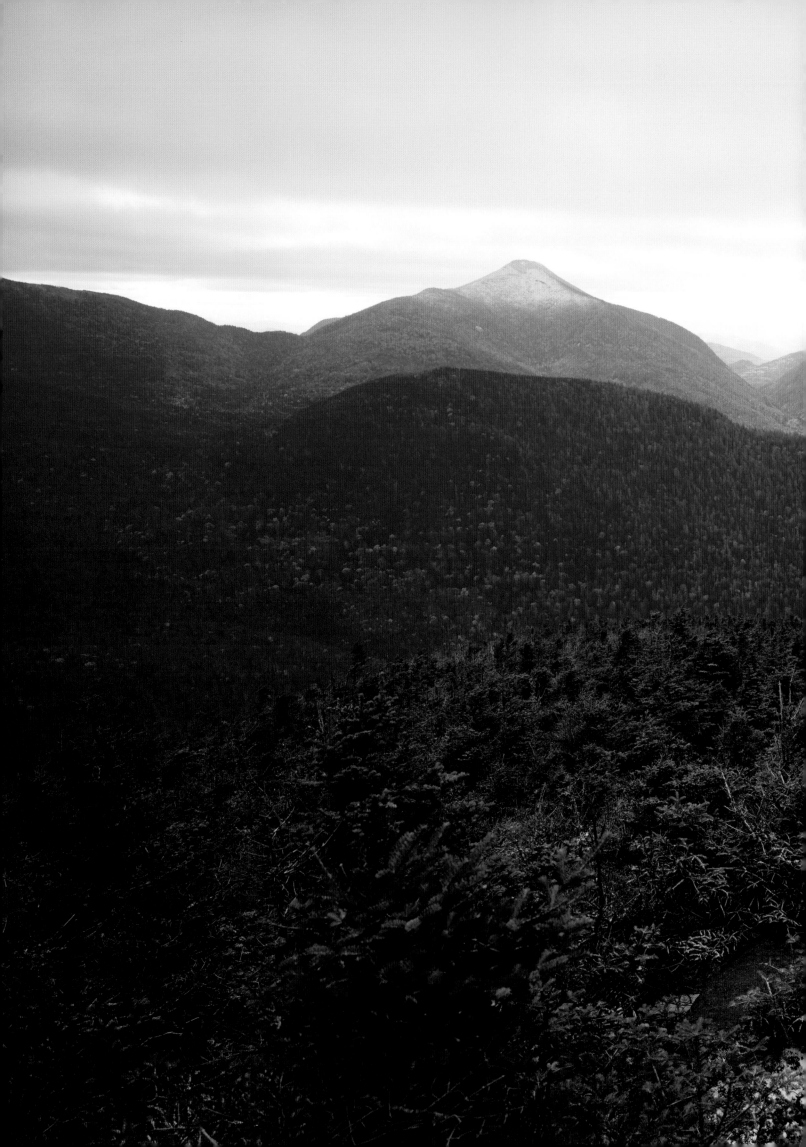

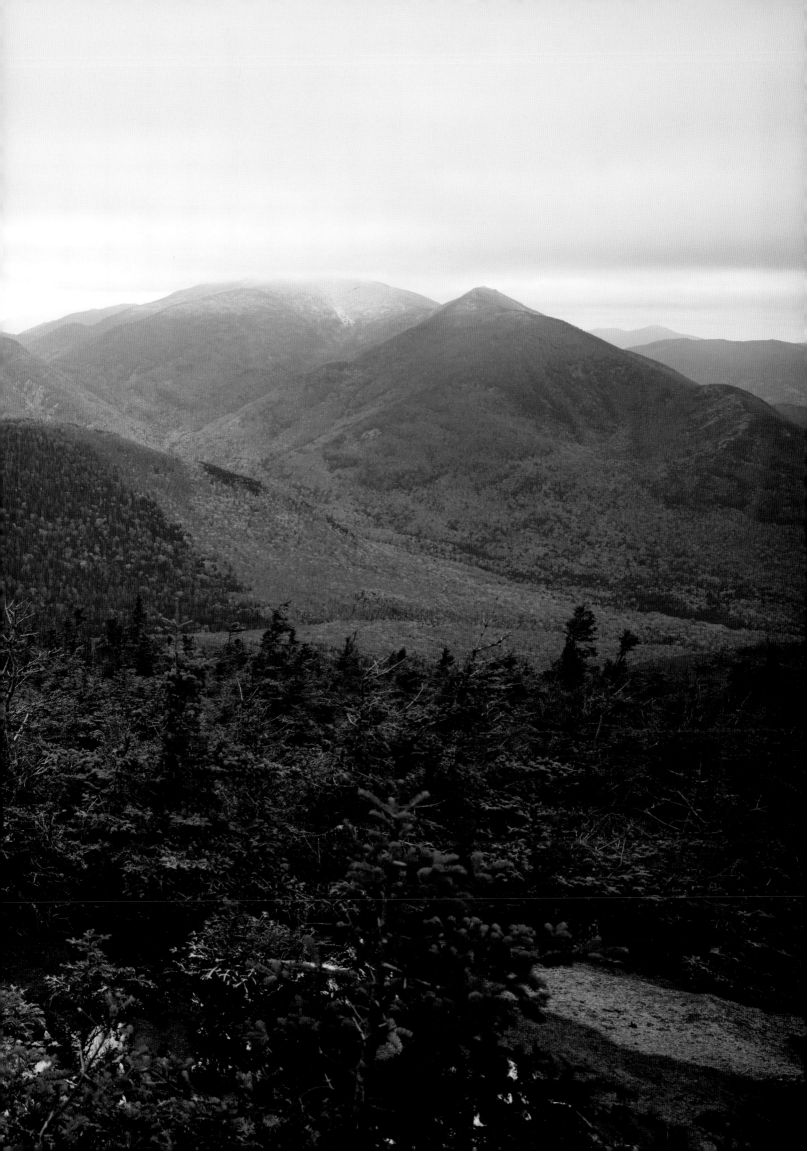

A Living Fabric

"Algonquin Peaks in Storm" (previous pages) shows in the foreground a small patch of mountainous spruce and fir forest that is likely old growth, escaping the lumberman's ax and the fires of the early 1900s. Balsam fir and red spruce make up the dominant forest type on the higher mountain slopes. Northern hardwood forests, comprised of sugar maple, yellow birch, and American beech, cover the mid-level slopes and hills of the Adirondacks.

These dominant forest types are largely intact—or unbroken—within the Adirondacks, forming the fabric that holds the landscape together. Woven into this fabric are ponds, bogs, trees, plants, microbes, and other natural features that work together in a delicate balance to support everything that lives in the forest. Like an insurance policy against disaster, the intact forests of the Adirondacks are big enough to absorb large-scale disturbances such as fire, logging, and high-wind blowdowns. Any reduction in size of these vast intact stretches of forest would certainly lessen their resilience and ability to absorb disturbances.

The orange-colored deciduous trees on the right-hand side of "Algonquin Peaks in Storm" show an area of human impact on the forest. "Algonquin from Mt. Jo" (opposite) shows the same human impact. Birch trees and other northern hardwoods are growing in an area that was likely disturbed by fire or logging. Birch, known as a "pioneer" species, is often the first to grow after a disturbance. It is not possible to see from this distance, but young balsam fir and red spruce trees are growing under the maturing birch—a patient and continually unfolding response to the changes on the landscape.

VIEW FROM NOONMARK WITH BUSH (126 | 127)

ALGONQUIN PEAKS IN STORM (128 | 129)

ALGONQUIN FROM MT. JO ▶

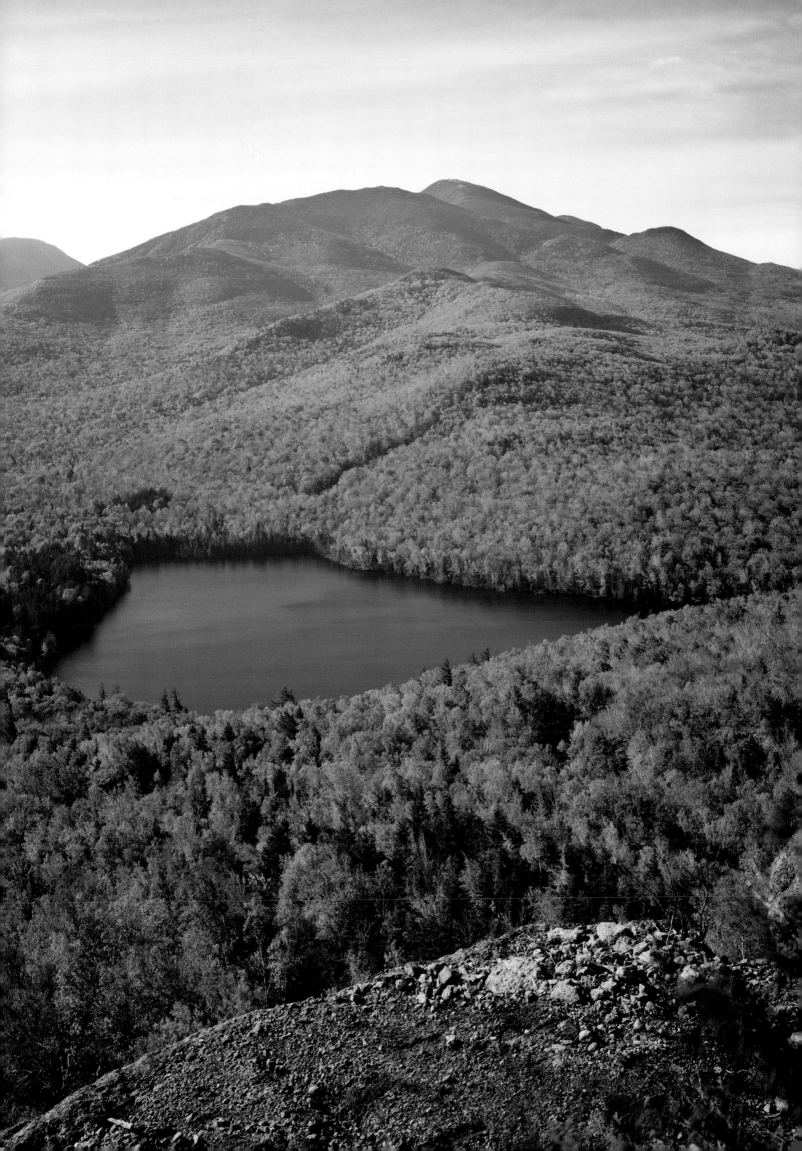

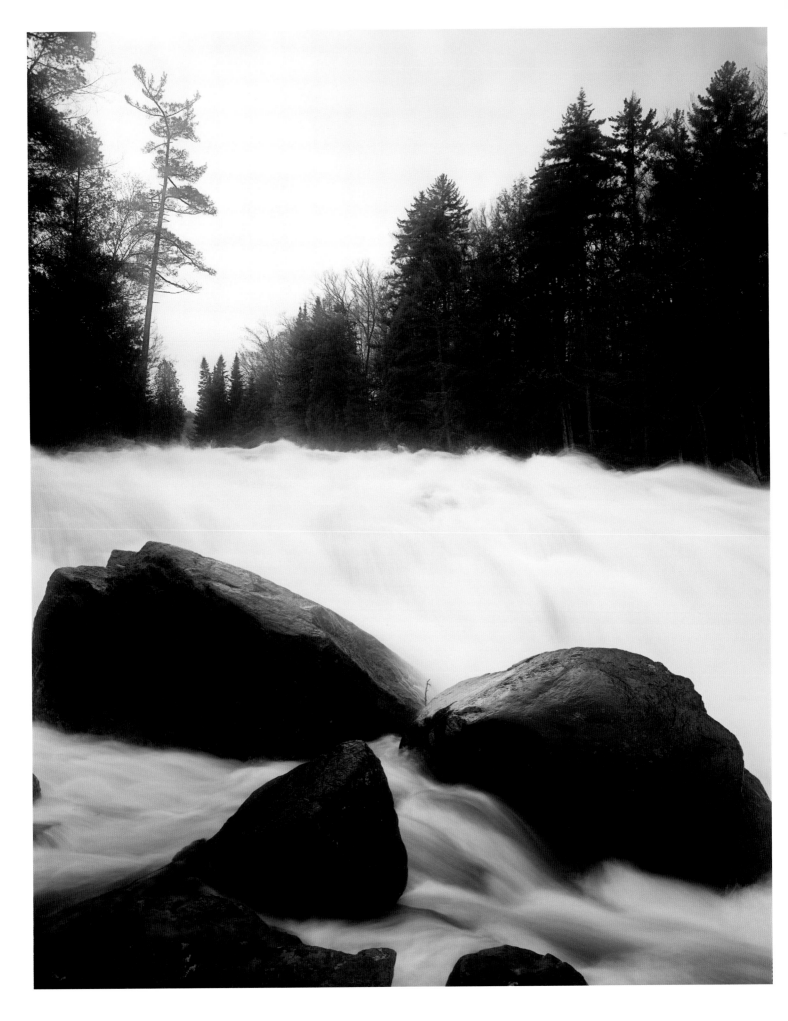

Buttermilk Falls

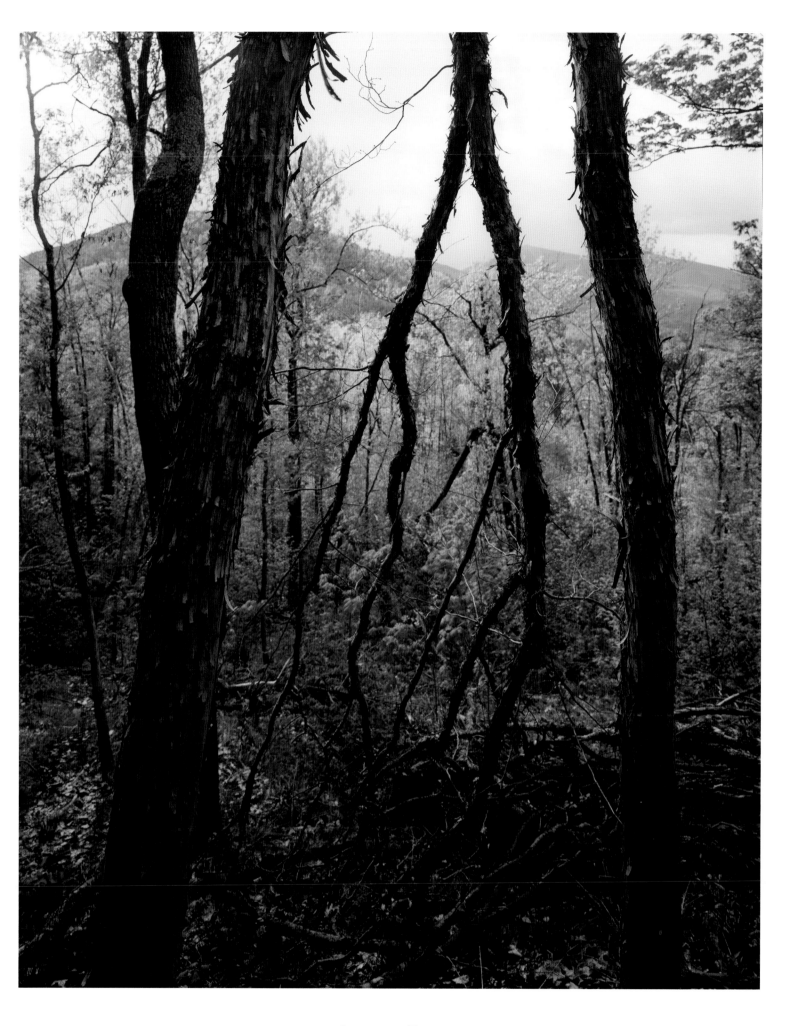

Ironwood Trees

Shadbush

REMAINS OF OTTER'S LUNCH

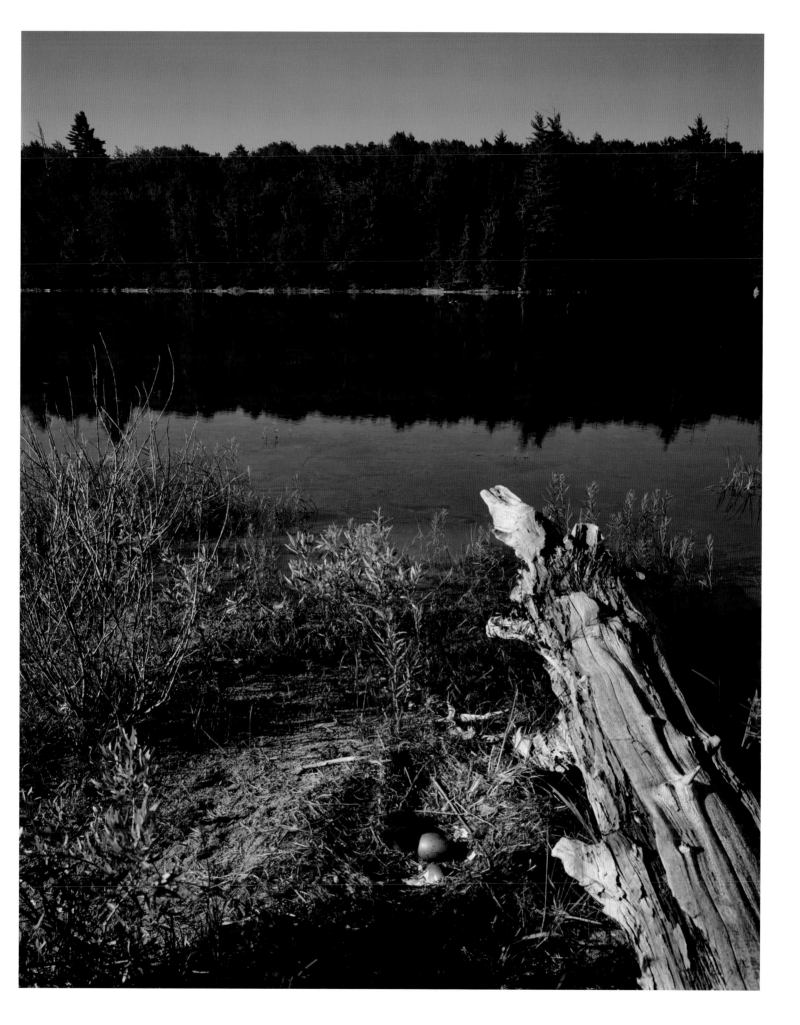

Loon Nest

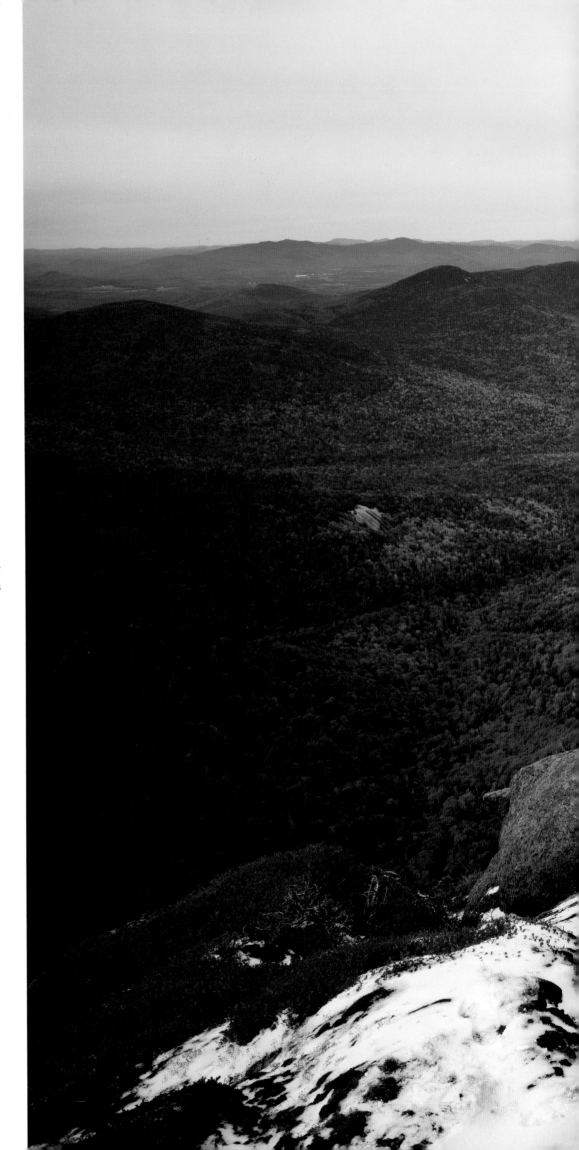

View of Johns Brook Valley
from Gothics

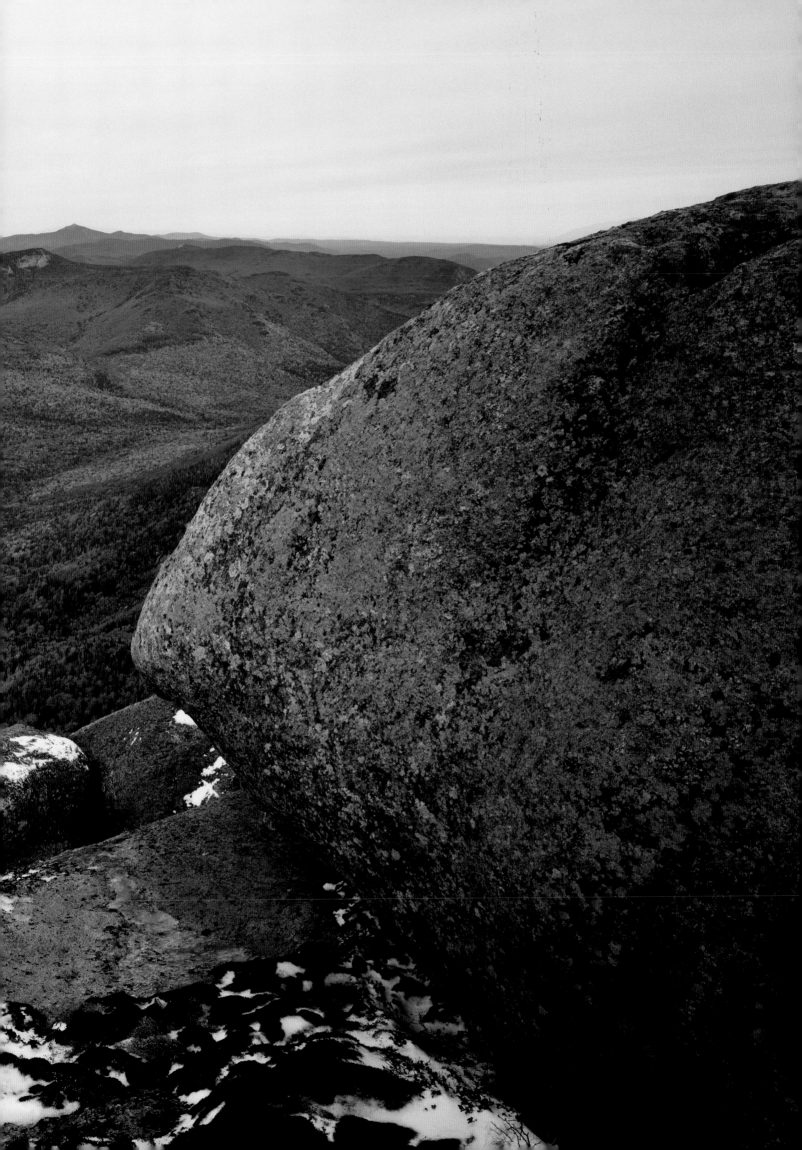

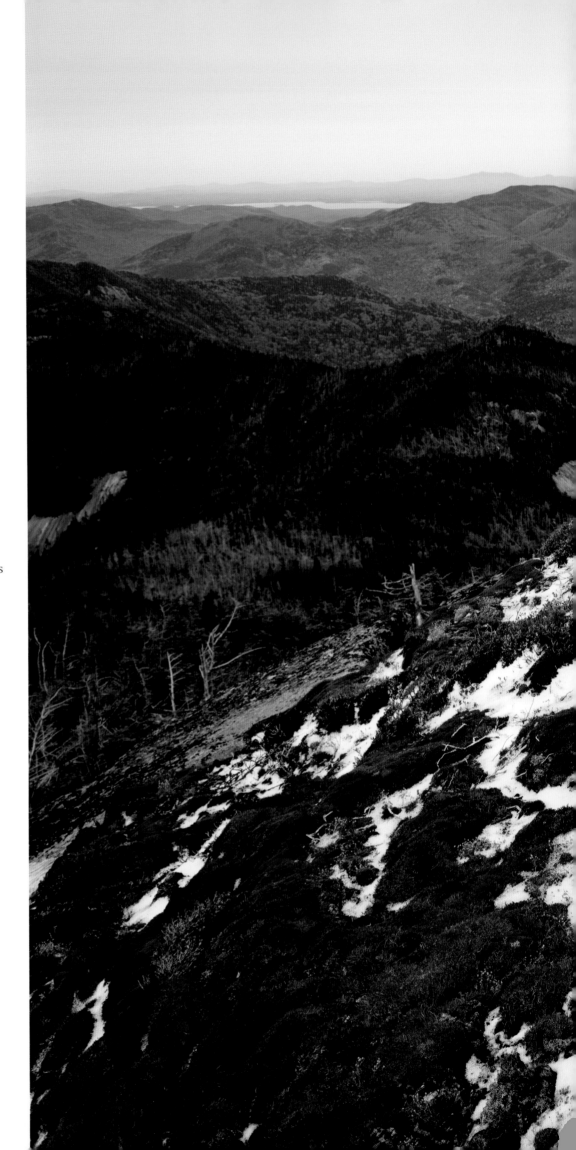

View of Giant from Gothics

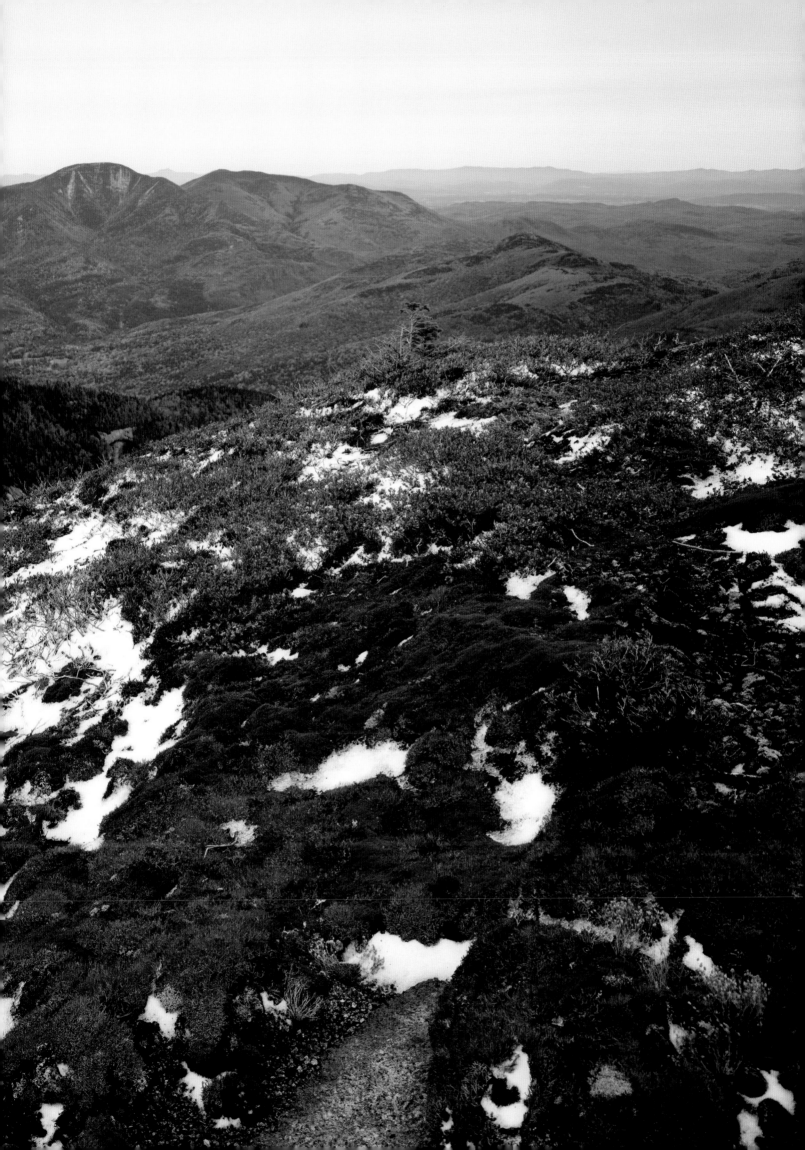

A Rarefied Existence

The foreground of "View of Giant from Gothics" (previous pages) shows the lower edge of alpine tundra. The tundra environment is a highly evolved group of plants, or in scientific parlance, a co-evolved community. There are fewer than eighty-five acres of it in New York State—all of it above tree line in the Adirondacks. It is not easy to survive in this environment; the plants that grow here are remnants of the last Ice Age. Bearberry willow, Lapland rosebay, and other alpine plants are well adapted to cold temperatures, harsh winds, direct sunlight, and nutrient-poor soils.

These plants grow in dense, mixed mats of vegetation that represent one of the Adirondacks' most precious habitats. The snow pack in winter plays an important role in protecting alpine tundra. It provides shelter in the winter and moisture in the spring, allowing the tiny plants to flourish in the summer.

In addition to alpine plant species, mosses and lichens are also found on the summits. The wonderfully colored lichens on the rock in "View of Johns Brook Valley from Gothics" (page 138) are a mix of algae and fungi that are interdependent, gaining strength and support from each other. Not symbiotic in the scientific sense, these separate species seem here to be tougher together than they could be alone.

Protecting alpine habitat is an ongoing conservation success story worth mentioning. Since 1990 the Adirondack Nature Conservancy and its partners have encouraged hikers to step on the rocks of the summits rather than the thin soils that support delicate vegetation. Naturalist educators are posted on the highest peaks as "summit stewards," helping hikers gain an appreciation of the flora and teaching them to tread lightly. They also survey and keep records of the location and status of alpine meadows, stabilize eroded areas with rocks, and monitor for reestablishment of native species. Because of these efforts, many summits look better now than they did twenty or thirty years ago.

Near the Summit of Little Porter ►
Between Kiwassa and Oseetah Lakes (144 | 145)

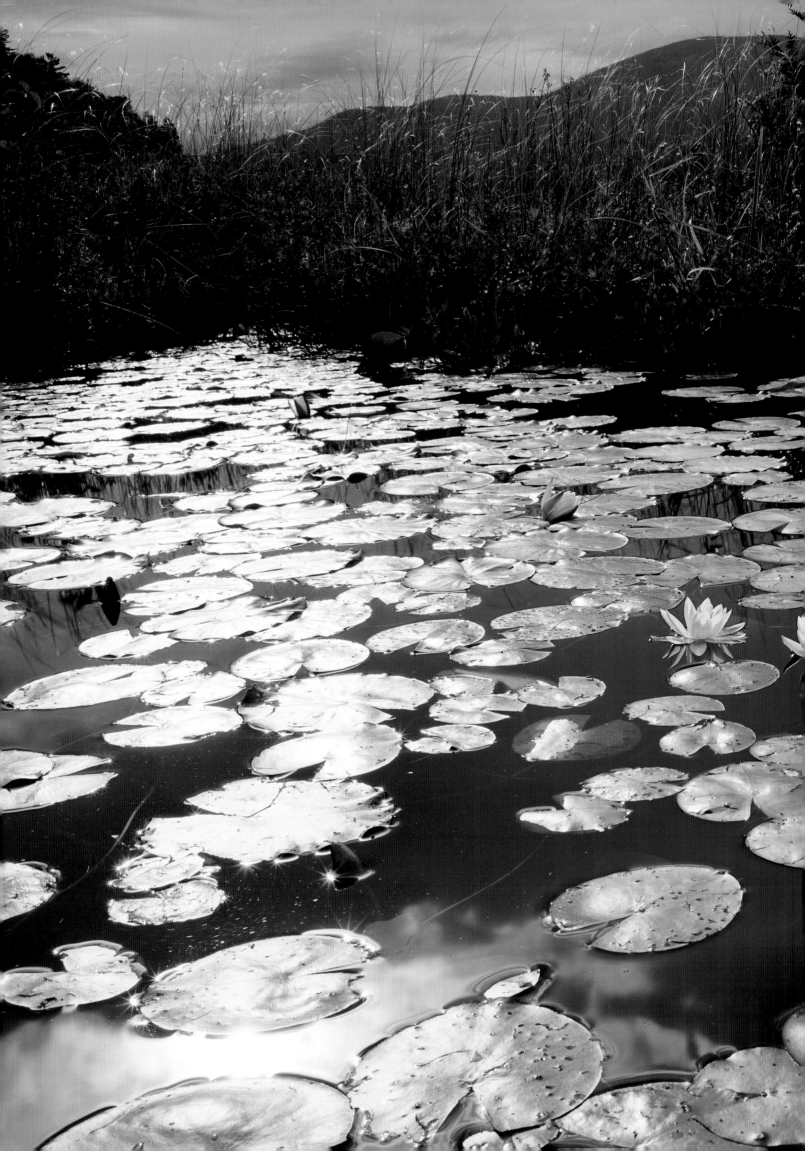

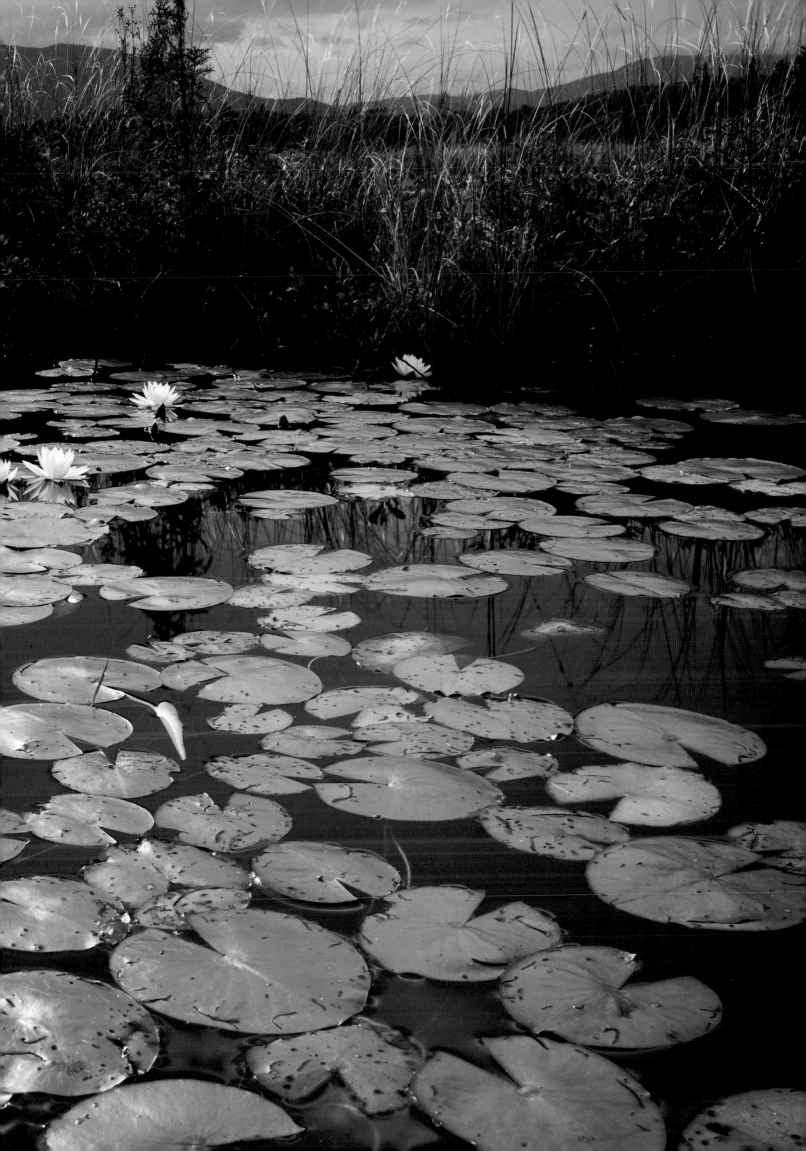

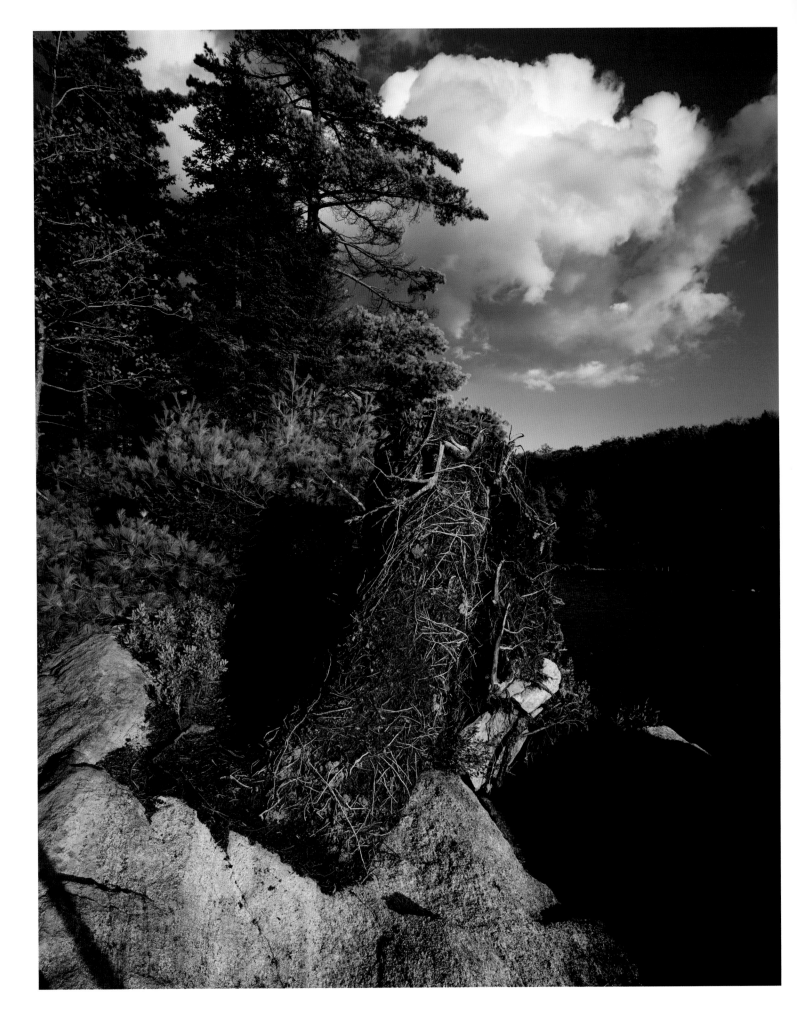

On Utowana

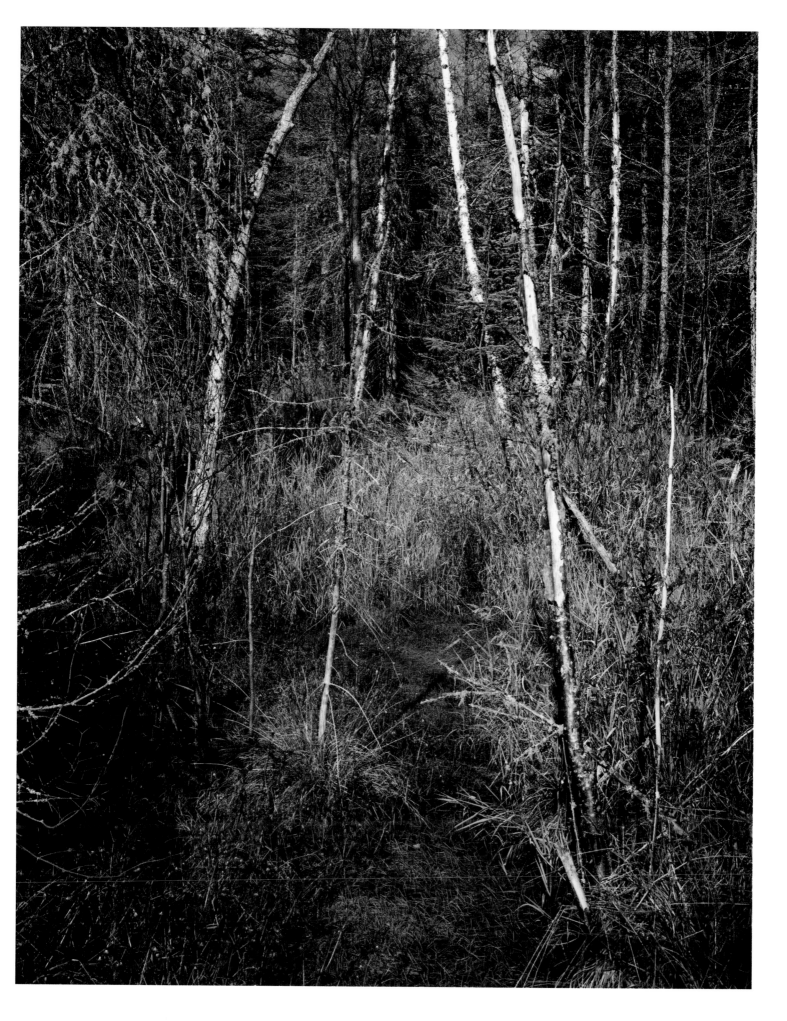

Near Tahawas

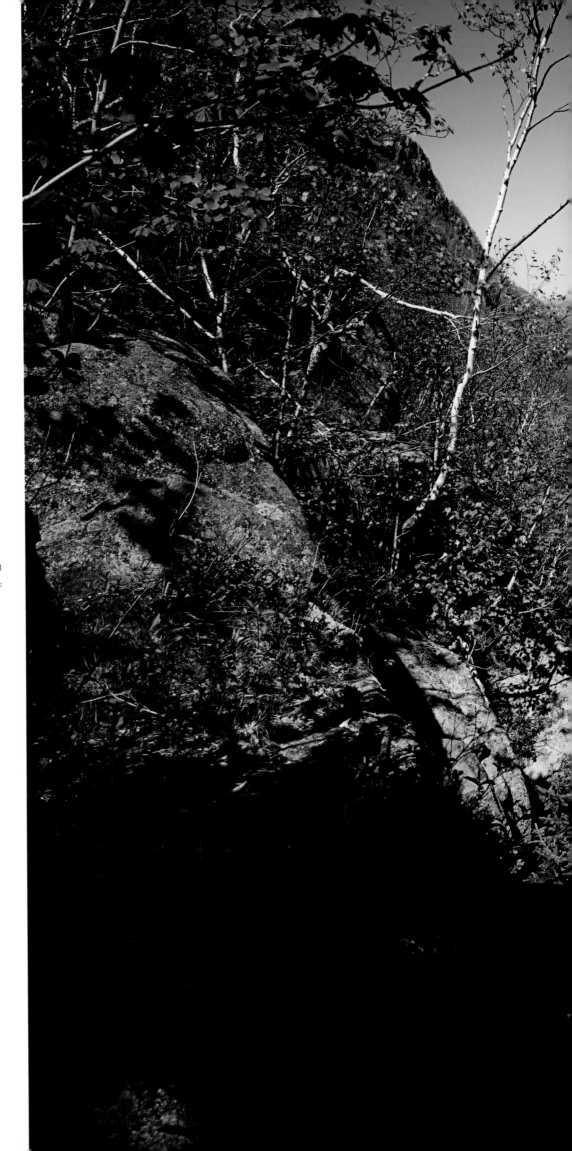

Lower Cascade Lake from
Pitchoff

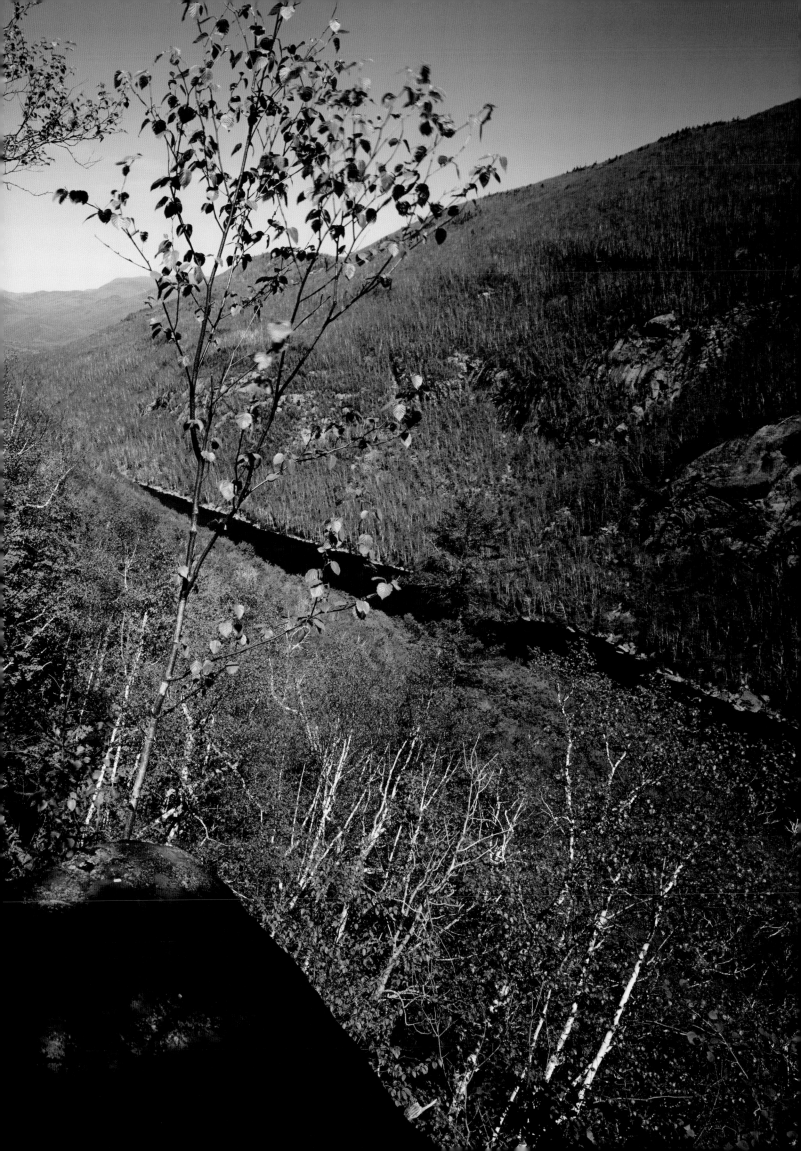

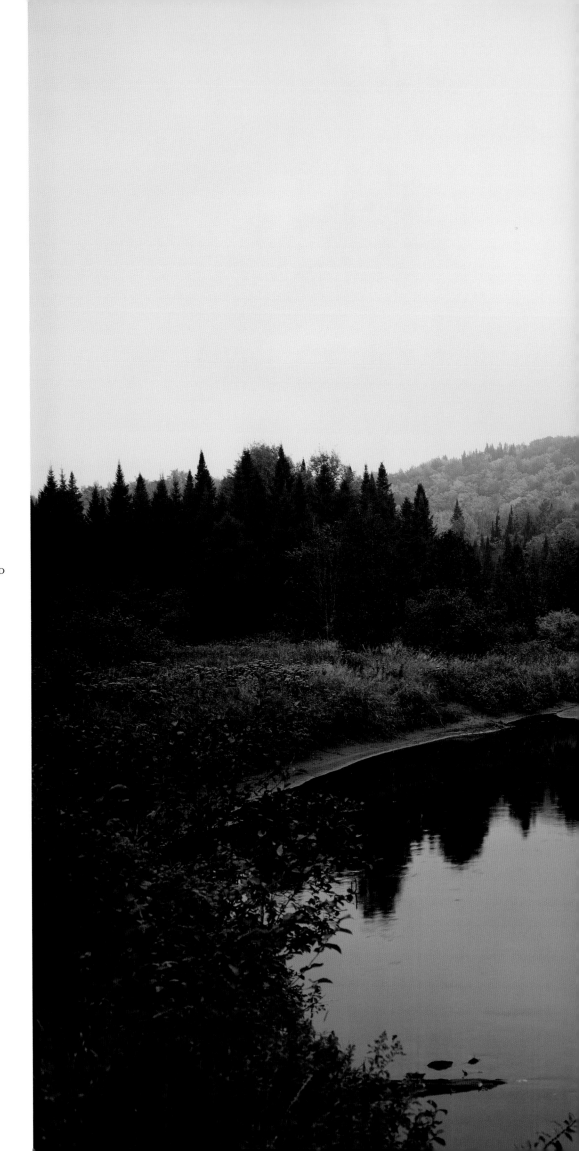

River Road, Lake Placid

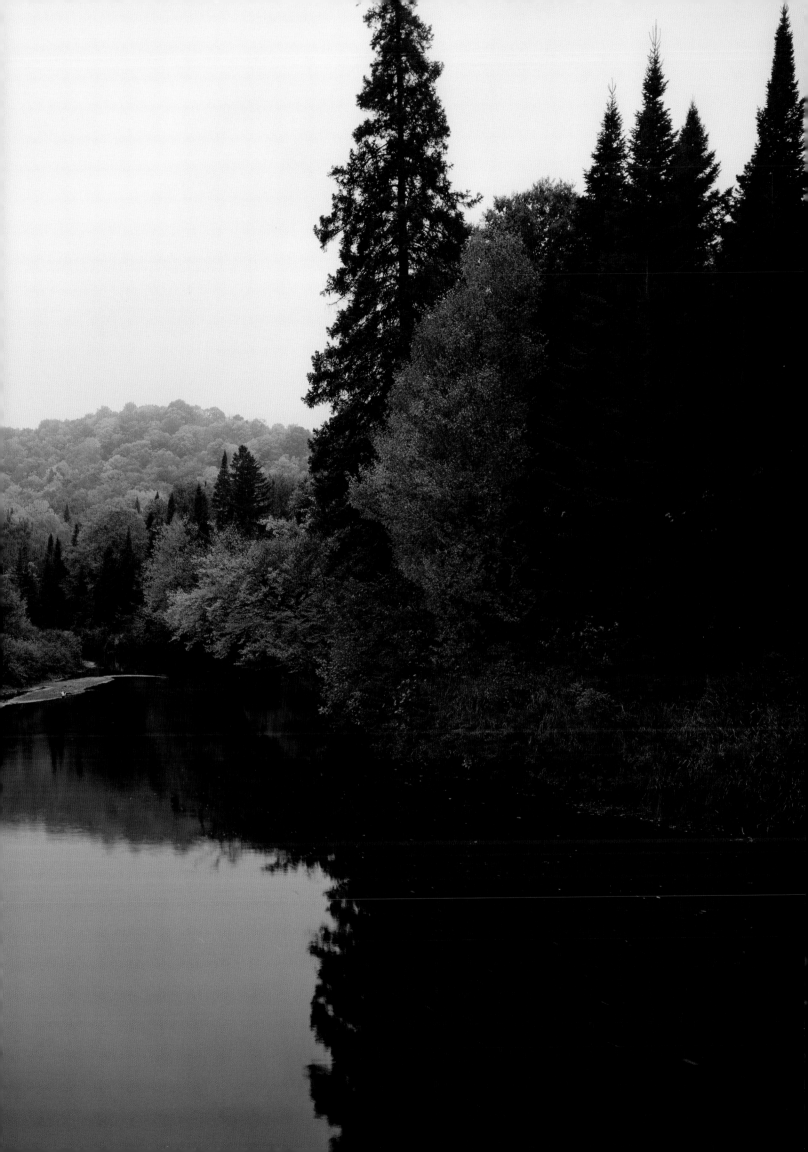

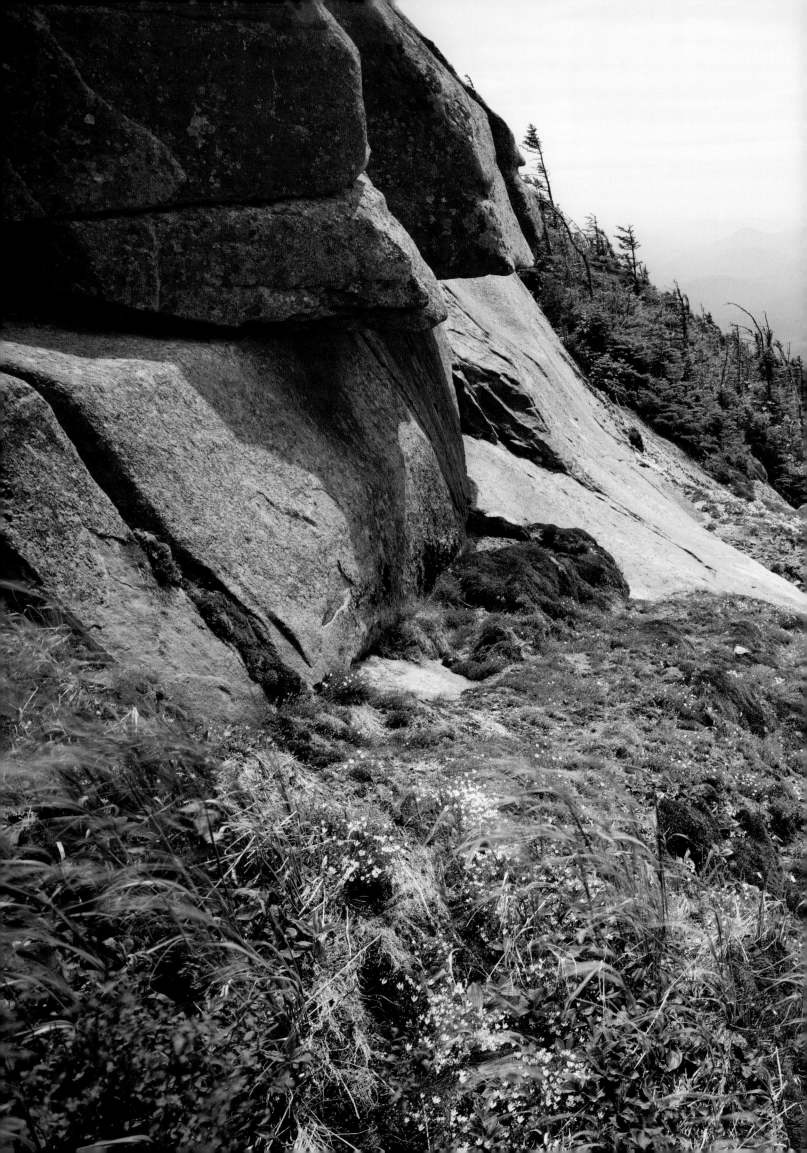

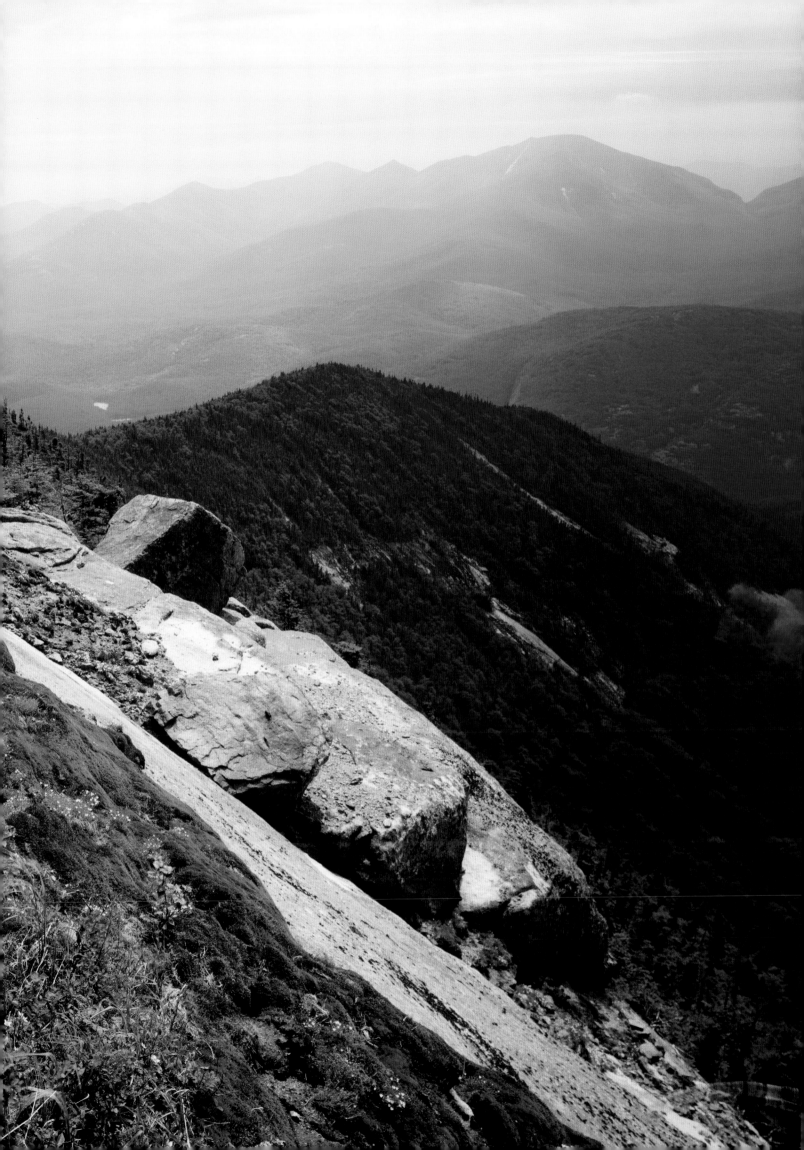

Getting a Grip on the Slides

The previous photograph was made in the krumholz zone, perhaps 200 feet below the summit of Giant mountain, known to old-timers as "Giant of the Valley." In the photograph, mountain sandwort is in bloom; several other herbs are present, including dicranum, polytrichum, and pohlia, and the barely unrolled leaves of clintonia and bunchberry—all subsisting in what's known as a slide environment.

Slides are places where the soil and plants have lost their grip and slid down the mountainside, leaving only exposed bedrock. Nature adapts to slides the way it does to most natural disturbances—after the initial wave of damage subsides comes regeneration. There is new light, moisture, turned soil, and freshly broken bits of rock to provide nutrients. Colonizing plant species, such as the abundant sandwort in this image, grow on the slide's edges and in the sheltered places where soil accumulates. The mats of vegetation may look something like tundra (page 140), but the plants and processes here are different. Tundra soils, limited to sheltered areas on summits, are very slow to form and poor in nutrients. Hence, tundra plants are slow growing and necessarily adaptive.

Cliff-face plants, on the other hand, grow on loose bits of stone and sand, which can contain more nutrients to produce lusher vegetation. The species that grow in this environment are quite dependent on disturbance. With spiderlike stems and roots capable of trapping and gathering soil particles, they are faster growing than tundra plants because they have an outside source of nutrients. But they play a dangerous game; they must live among water channels where soil and nutrients concentrate, but not in the strongest flows where they would be washed away by water or stripped away by ice. In true Darwinian fashion, most of these plants form clumps and can regenerate from fragments, allowing them to take root—rather than be destroyed—after being moved by ice. Adaptation does have its limits, though. Plants that grow on the edges of slides are always vulnerable to gravity and other forces. It is possible that the plants in this image did not exist here the year before, at least not in their current configuration.

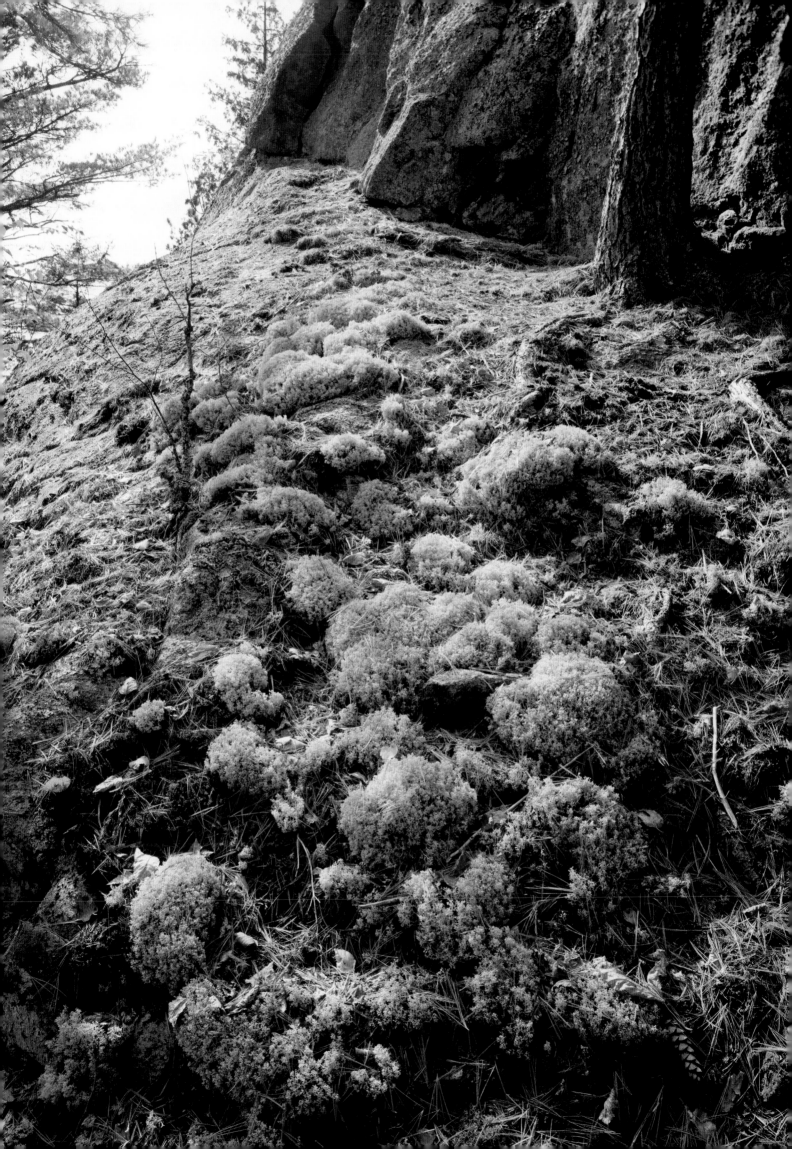

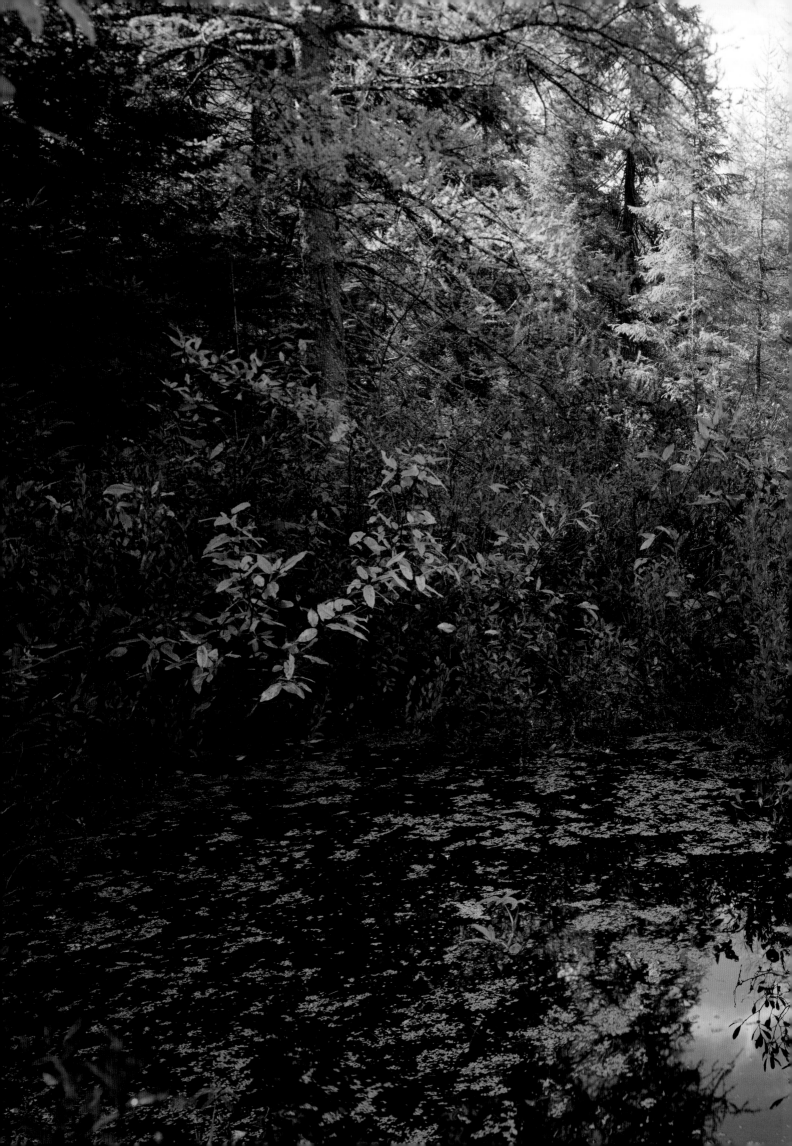

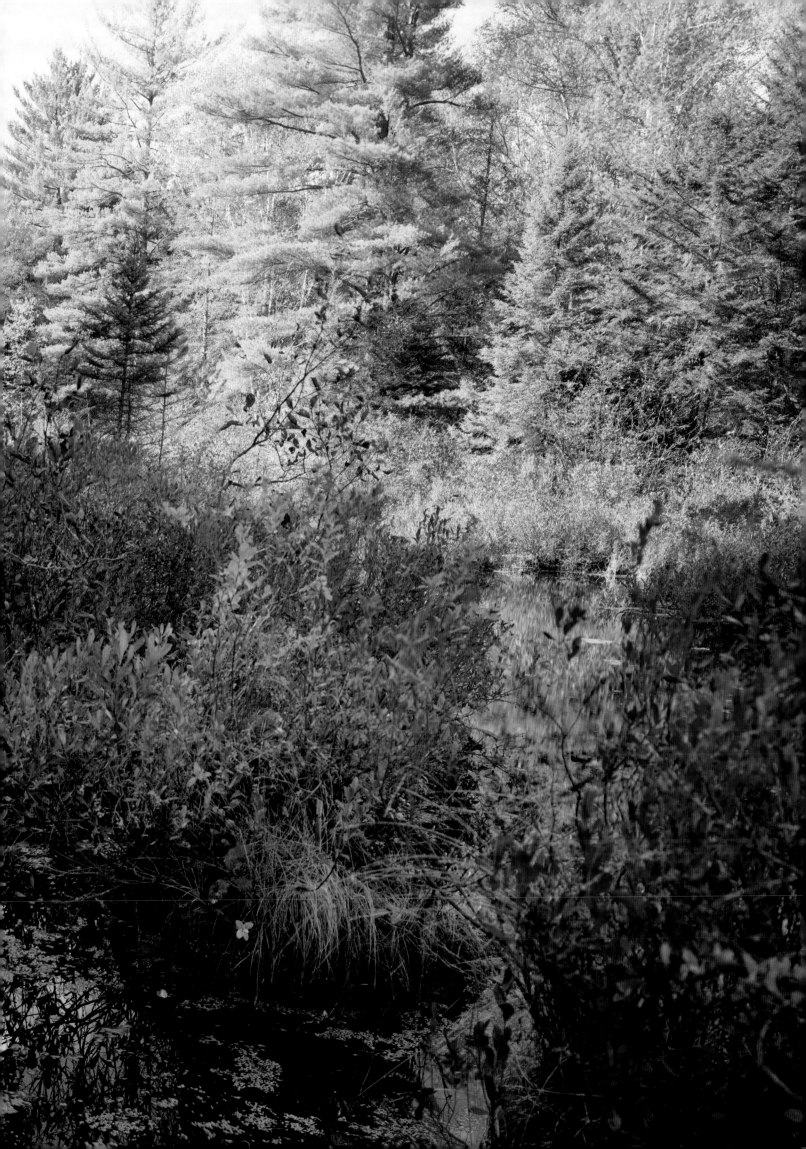

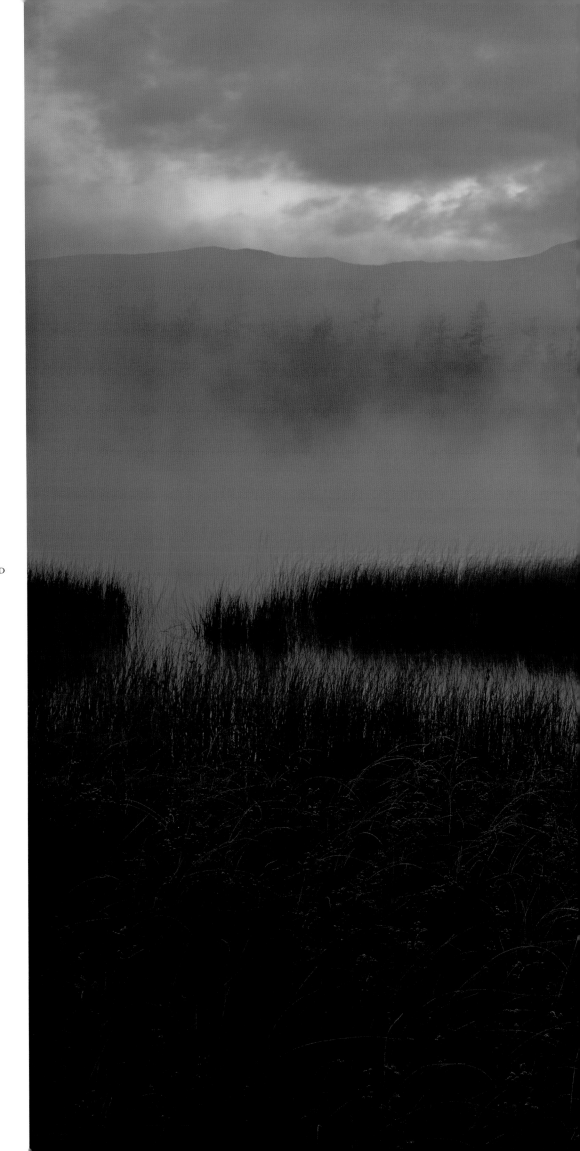

Whiteface from Connery Pond

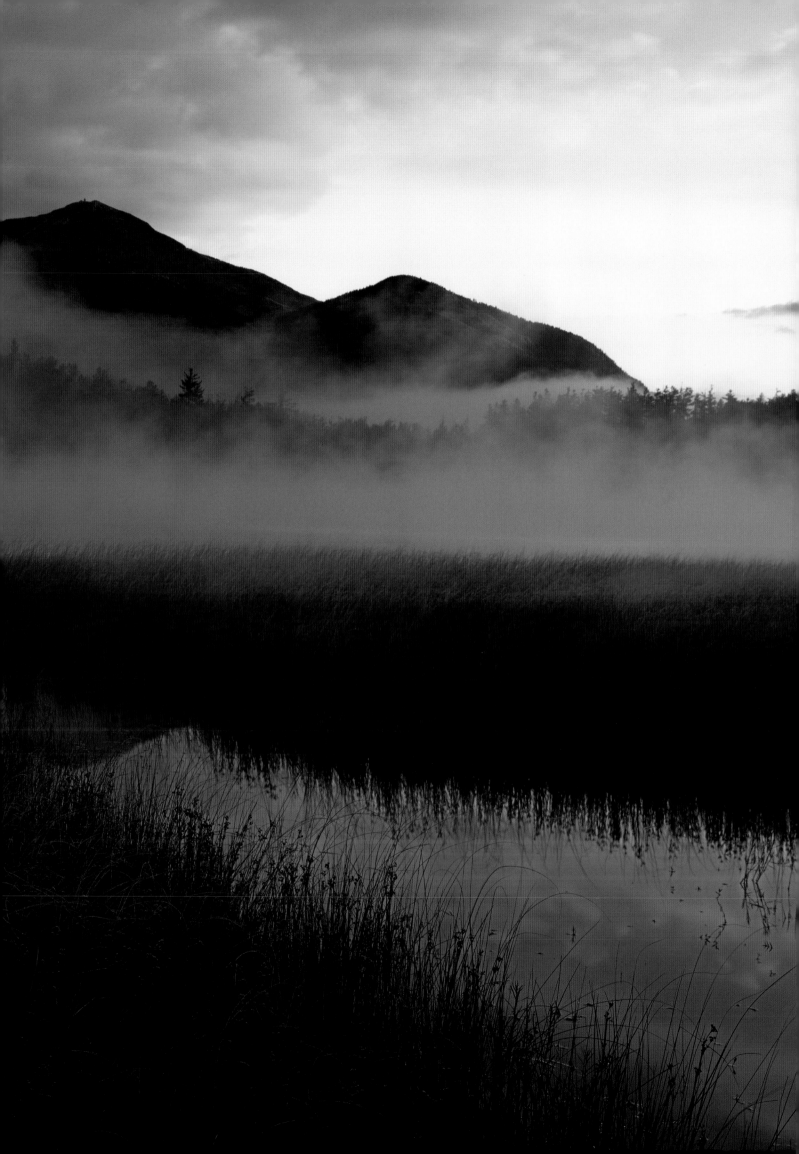

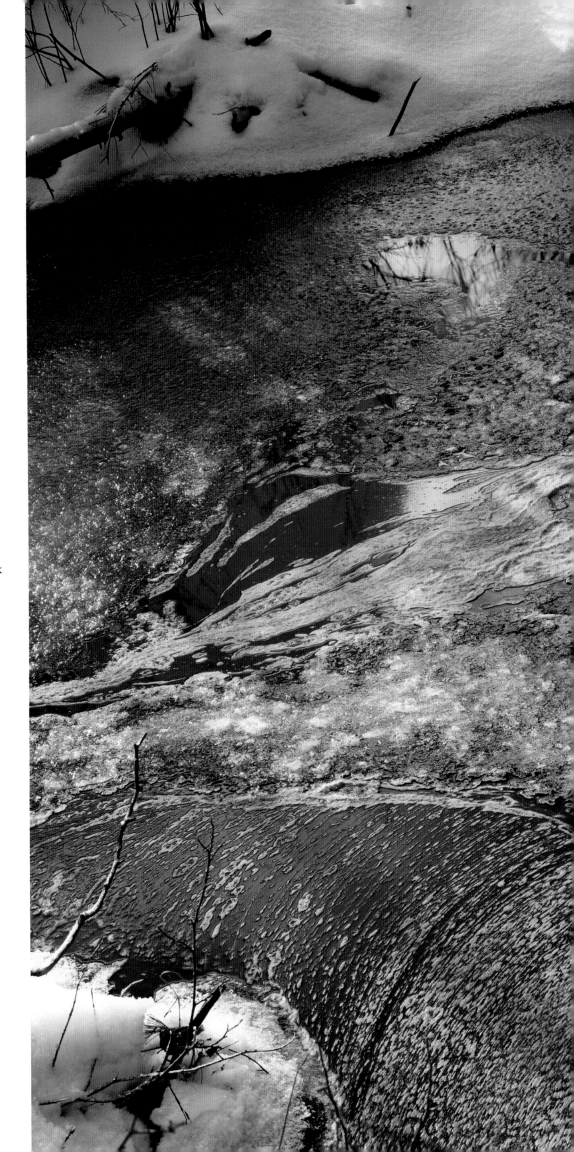

French Brook

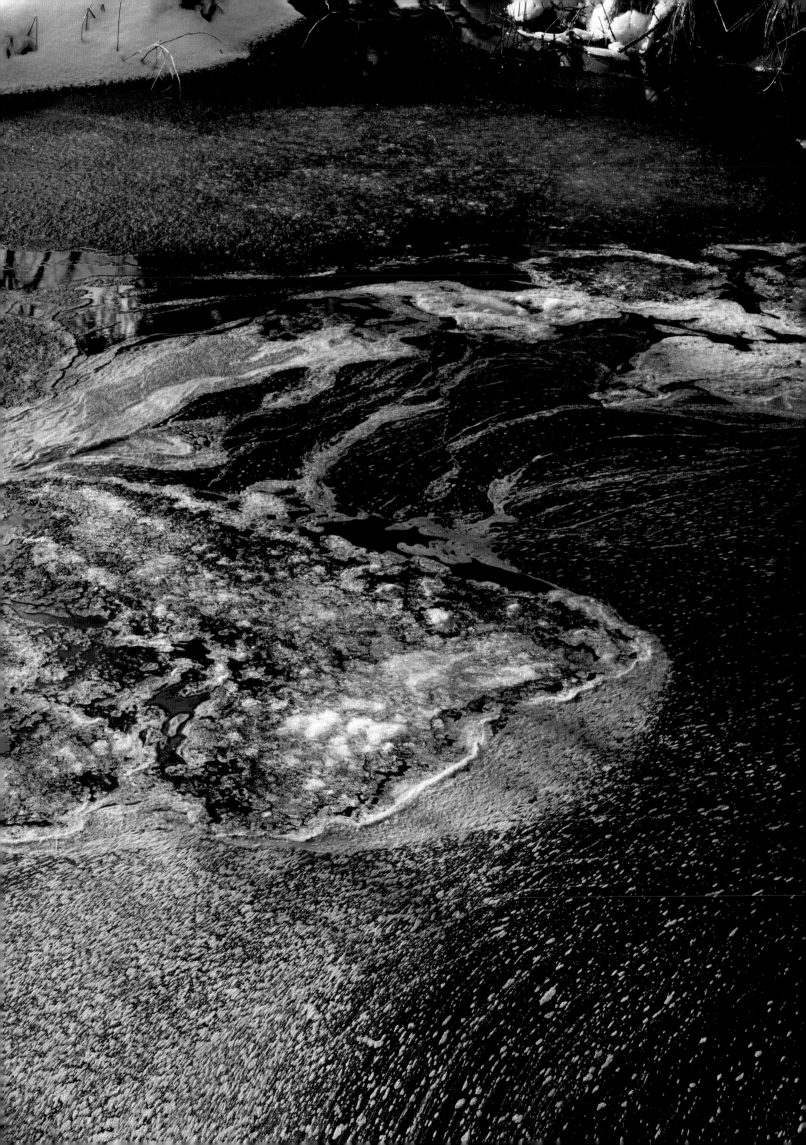

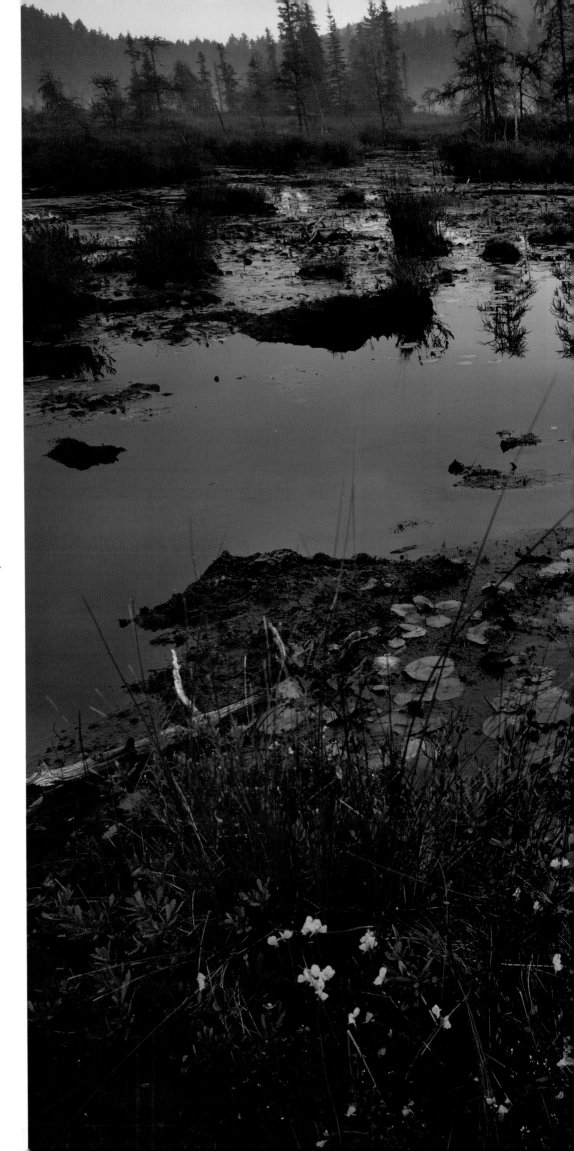

WELLER POND OUTLET

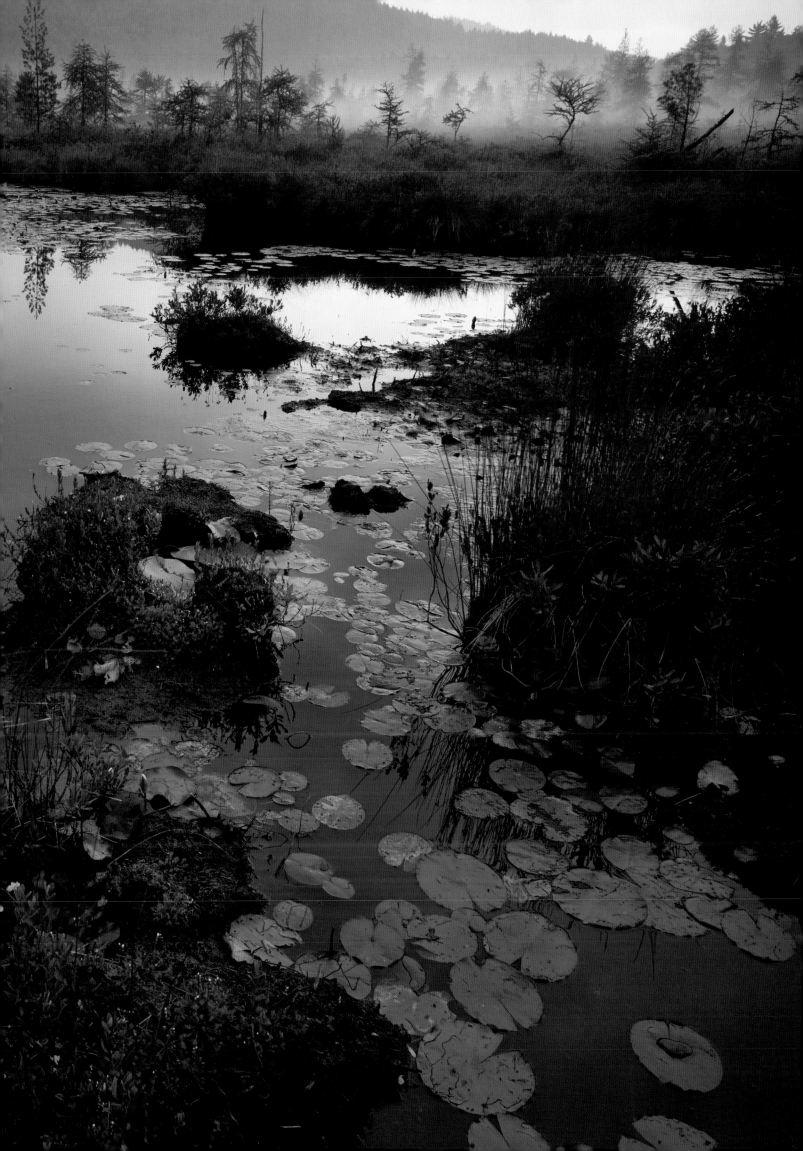

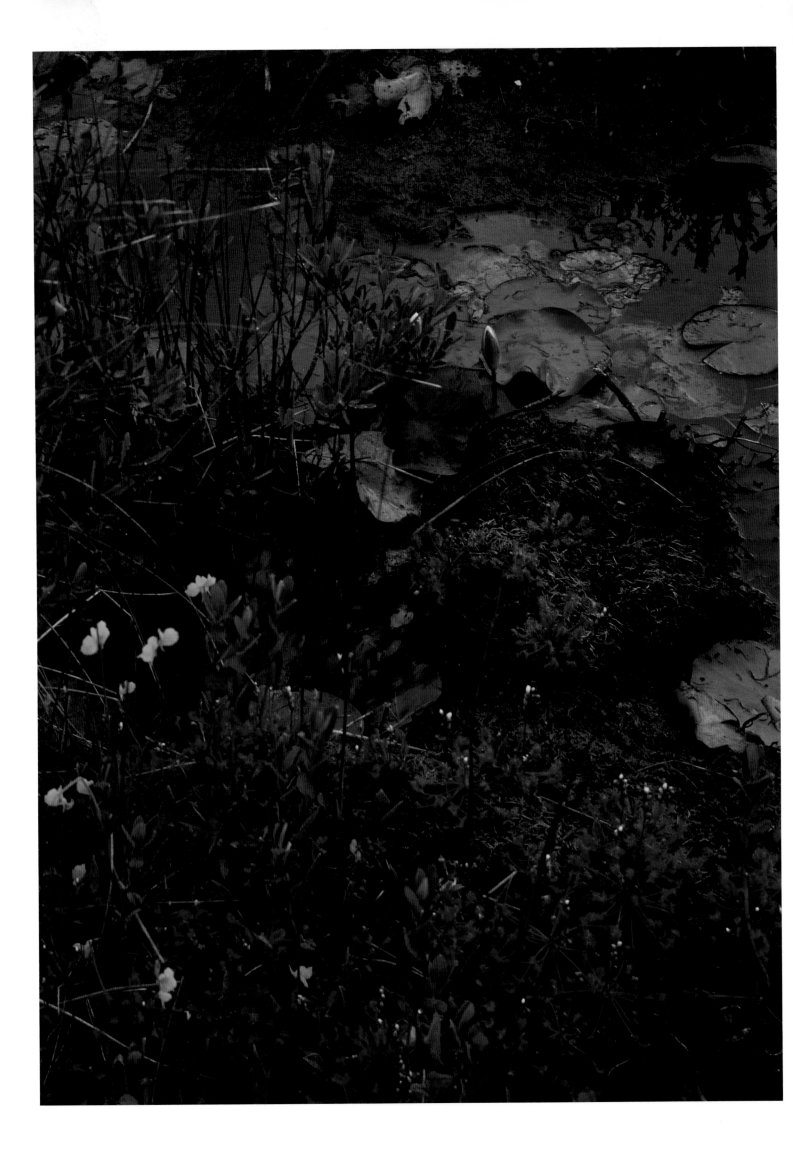

Our Walden Pond

"Wanted: Some invalid who is not improving and would like to go into the Woods for the Summer." So read an advertisement placed in a local paper by Fred M. Rice, a robust Saranac Lake woodsman, guide, and boatbuilder. The year was 1931, and Fred was looking for a man who would pay him to be his guide. Instead, the ad was answered by Martha Reben, a bedridden tuberculosis patient with little money, who saw this as possibly her only hope for survival. The fragile invalid certainly did not look like someone capable of roughing it in the woods, but Fred agreed to accept her as a client. He eventually took her to the rather remote Weller Pond. There, with Fred's encouragement, Martha learned to appreciate the pleasures of long walks. Within a year, she was able to live alone at the pond for a few weeks at a time, and she began keeping a journal. After nearly ten years at Weller Pond, she completed *The Healing Woods*, her now-classic Adirondack book that celebrated the pond in much the same way Thoreau immortalized Walden.

Detail of Weller Pond Outlet (previous pages), an Adirondack wetland

Two pictures in this book were made alongside Weller Pond. The first appears on page 6, and the second, on the preceding pages, was made in the slough going into the pond from Middle Saranac Lake, on an early morning in late August. Nights at that time of year are cool, and a mist that rises off of the water in the morning is almost always assured.

Many classic bog species can be seen on the floating hummocks and islands in the photograph "Weller Pond Outlet" (previous pages). In the acidic world of a bog, plants have adapted in unusual ways to obtain nutrients. Some, such as leatherleaf, have waxy leaves that stay green longer than other shrubs, enabling them to photosynthesize earlier in the spring and later into the fall. The most impressive adaptation, however, is found in the infamous carnivorous plants that "eat" insects, small amphibians, and aquatic organisms such as mosquito larvae. These plants capture prey in order to obtain nitrogen and other nutrients that are released when the prey decays. Two carnivorous species can be seen in this image: sundew (the low red plant) and bladderwort (with the yellow flower, in the foreground).

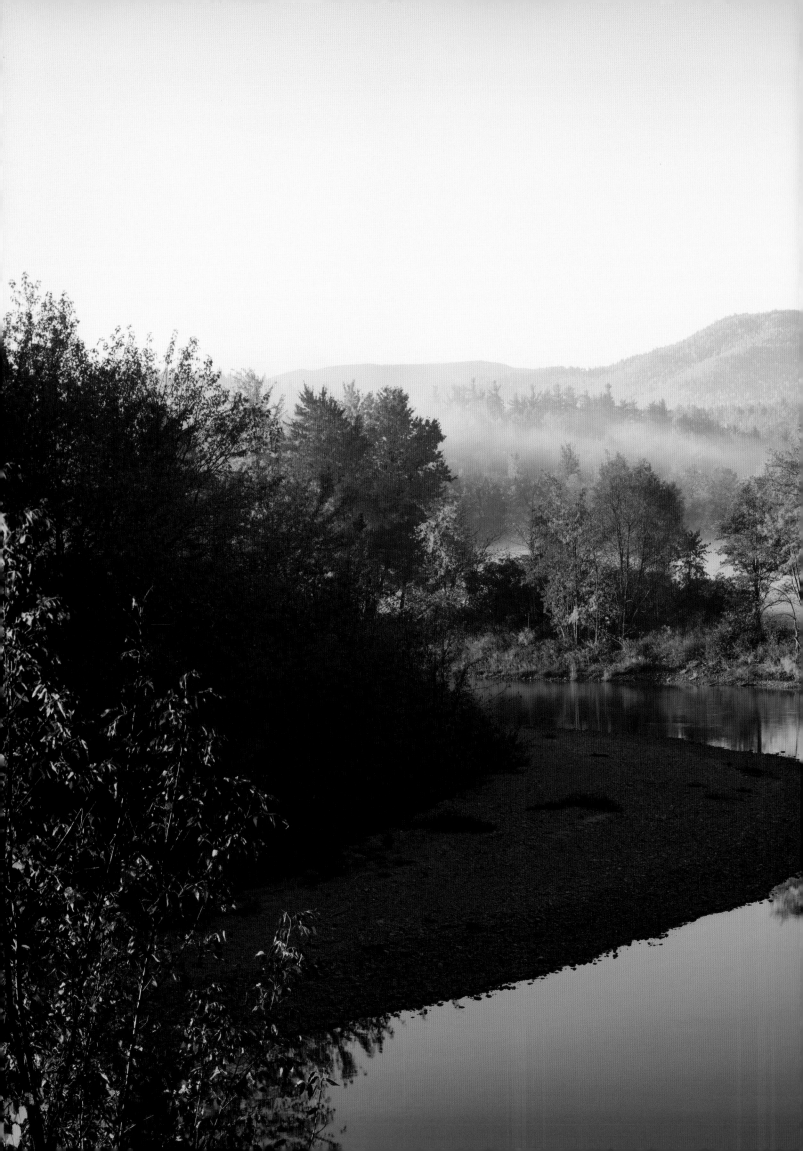

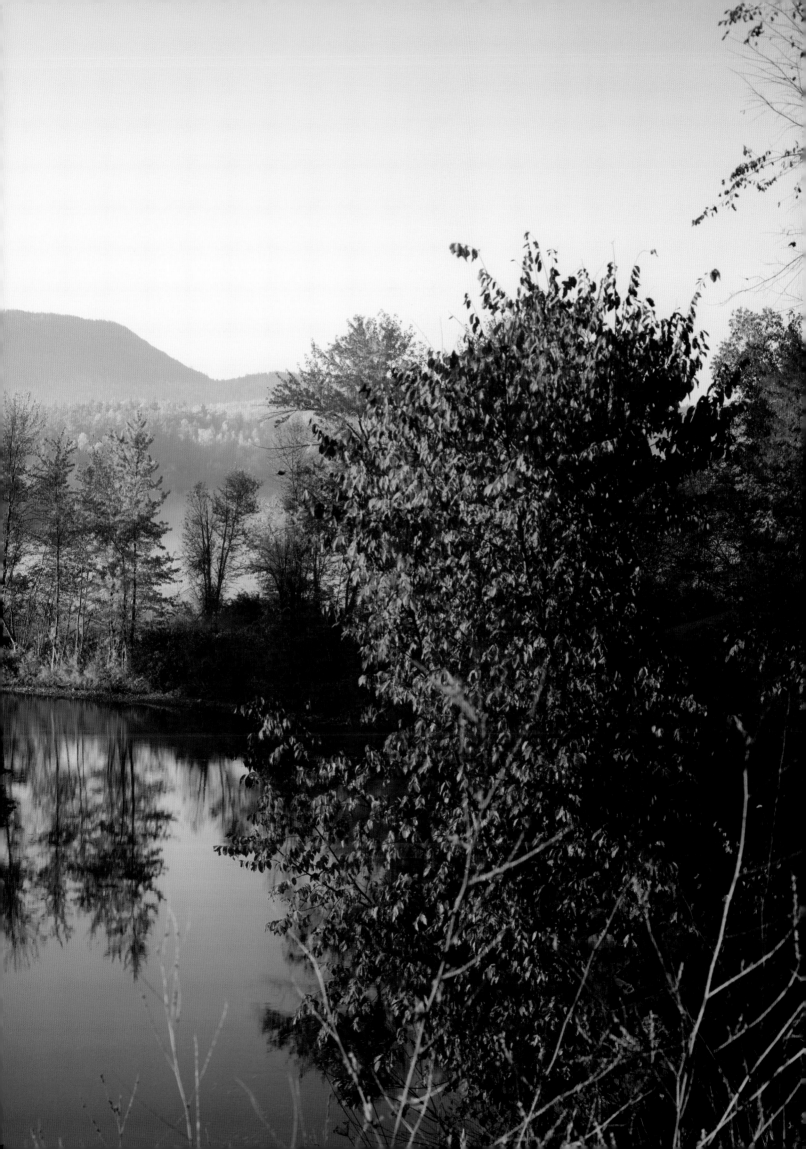

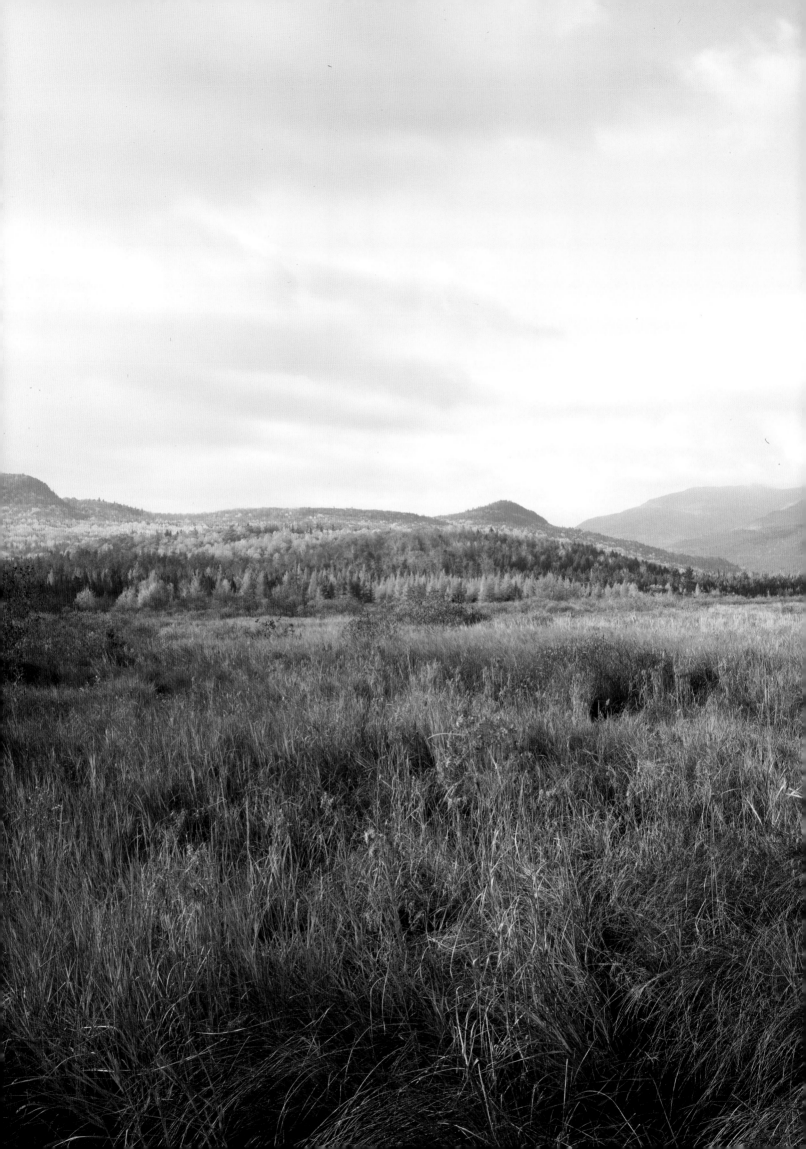

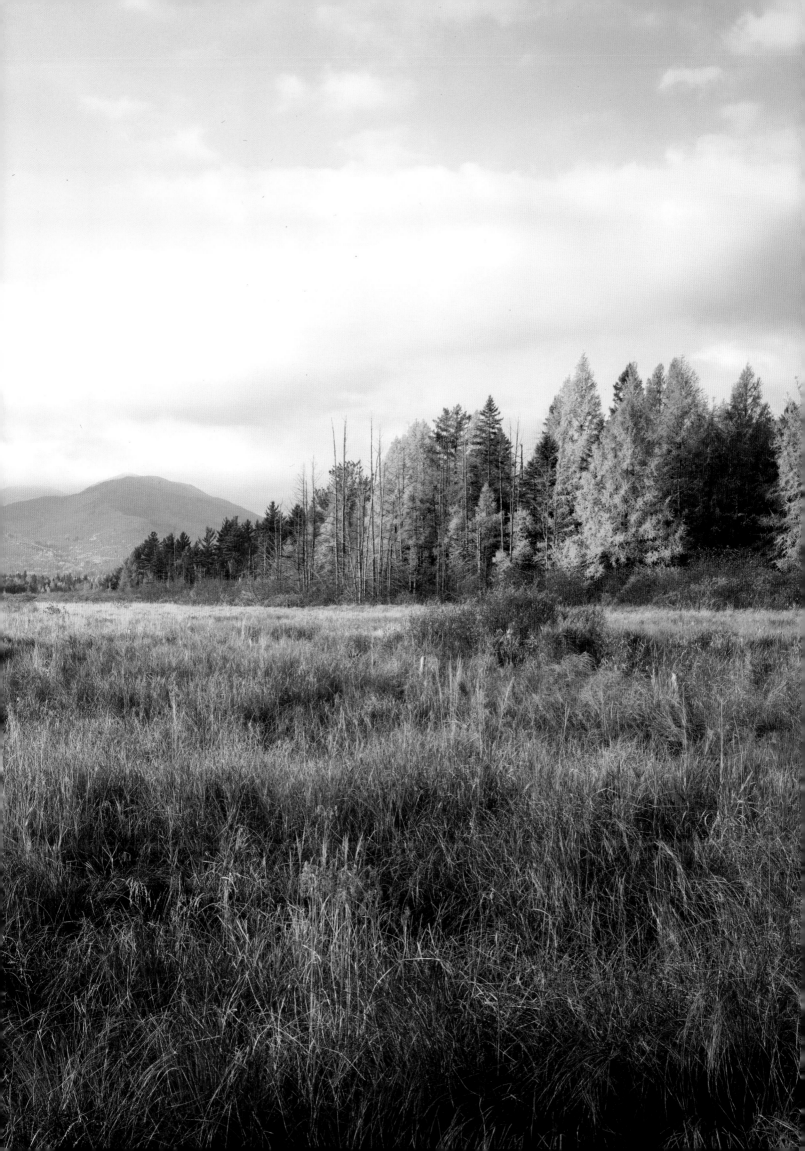

A Natural Connectivity

There is a persistent conception of nature as a test for the self. Surviving on one's own in the wilderness for a few days proves one's mettle, the thinking goes. Like many young people, I approached nature this way as a teenager; it was a means of affirming my manhood. But today I no longer look at nature in this light.

Twelve years ago, my daughter Esmé was in an automobile accident that left her disabled. After that I began to question my values, particularly my attachment to this idea of nature as a test. I clearly loved my daughter, with her disability and her dependence on others, just as much as I had before her accident. But I knew living unaided in the wilderness was not going to be an option for her, although she would have to face survival tasks that would be much tougher.

Whereas once I saw nature as a means by which a person could measure one's independence, the lesson nature seems to be teaching me now is one of interdependence. The connectivity of everything, especially in nature, seems to be speaking loudly and clearly now. And it is speaking to my better self, or at least to a more mature and wiser self. Just as Esmé depends on others to do many things that most people take for granted, so, too, do species in the wild depend on each other for their survival. There is an immeasurable and implicit beauty in this interdependence.

This photograph, taken at Handsome Pond, shows a stand of bunchberry shrubs that are benefitting from the decaying matter that surrounding trees have produced. This lovely spot lies within a 16,000-acre tract of land on which International Paper donated a special recreation easement to New York State. Not only will the land be preserved, but as part of the transaction the land will be set aside to provide wilderness experience opportunities for disabled persons. Under this arrangement, Paul Smith's College will develop a universally accessible recreation program to assist people with disabilities using this new park.

I applaud International Paper's initiative in making a portion of the Adirondack Park accessible to everyone while also keeping the forest products industry—a quintessential Adirondack vocation—alive. In the same month that Governor George Pataki announced this project, he also announced that the state will purchase conservation easements on an additional 255,000 acres of IP land and will purchase outright 2,000 acres to add to the Forest Preserve. (IP holdings represent nearly 10% of the total private land in the Adirondack Park.) This is the largest land protection transaction in the history of the park. Partnerships like this between the forest industry, the state, and conservation interests demonstrate a necessary interdependence, one that is critically important for the future of the Adirondacks.

Handsome Pond ▶

Marion River Lily Pads (172 | 173)

Haystack from Upper Ausable Lake (174 | 175)

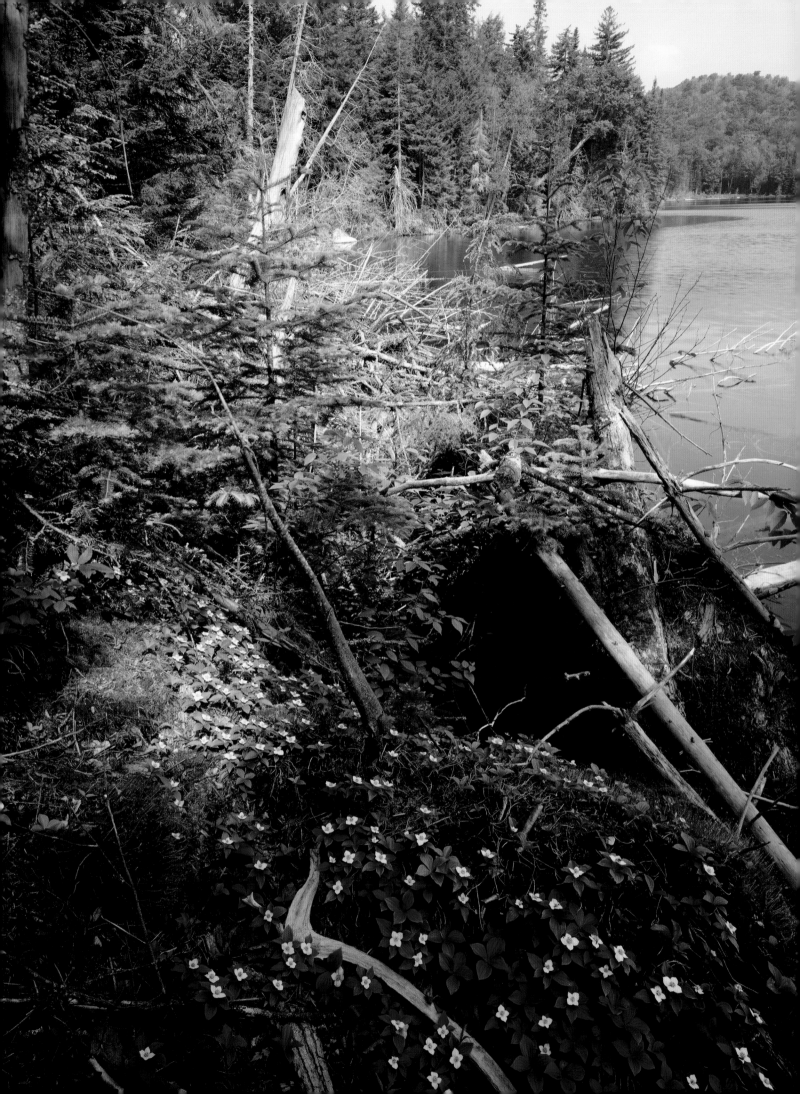

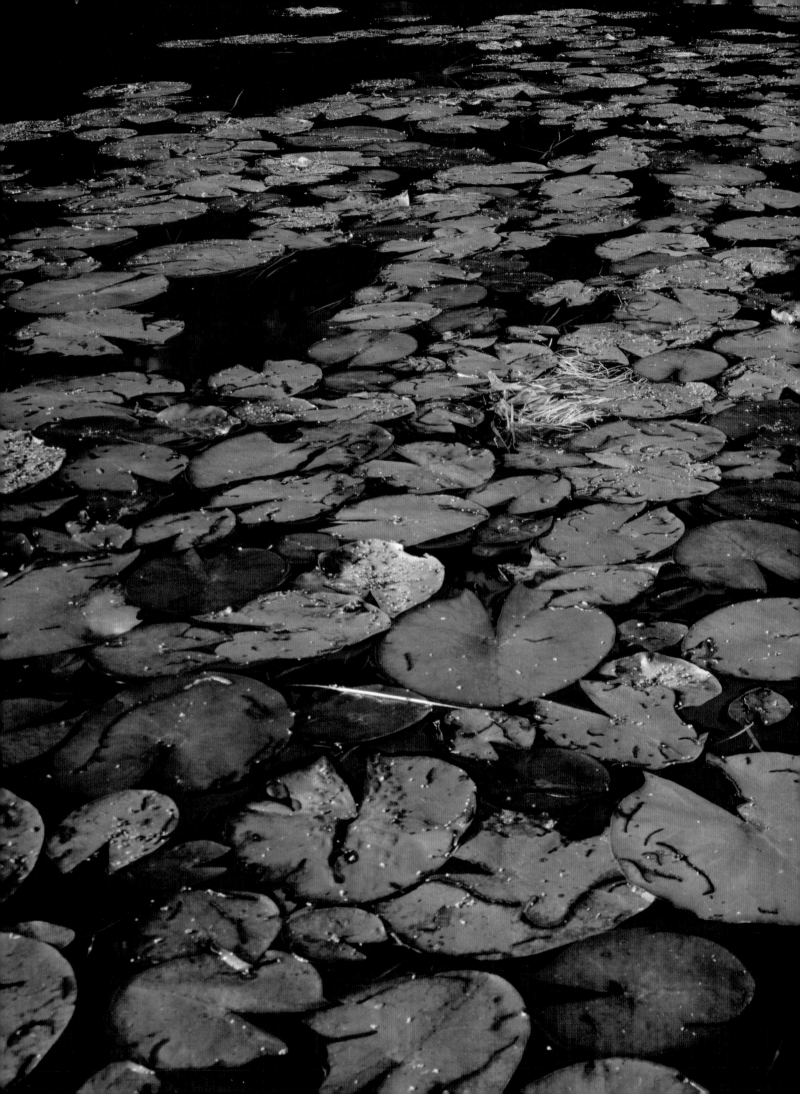

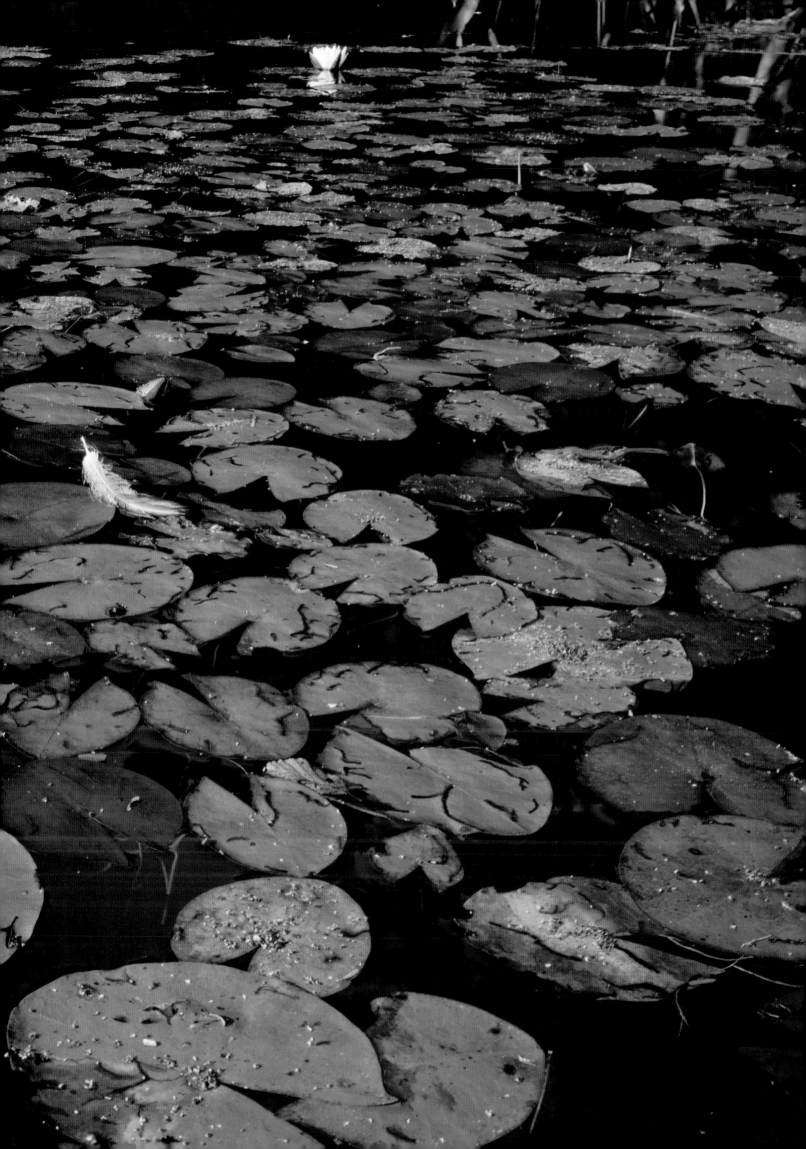

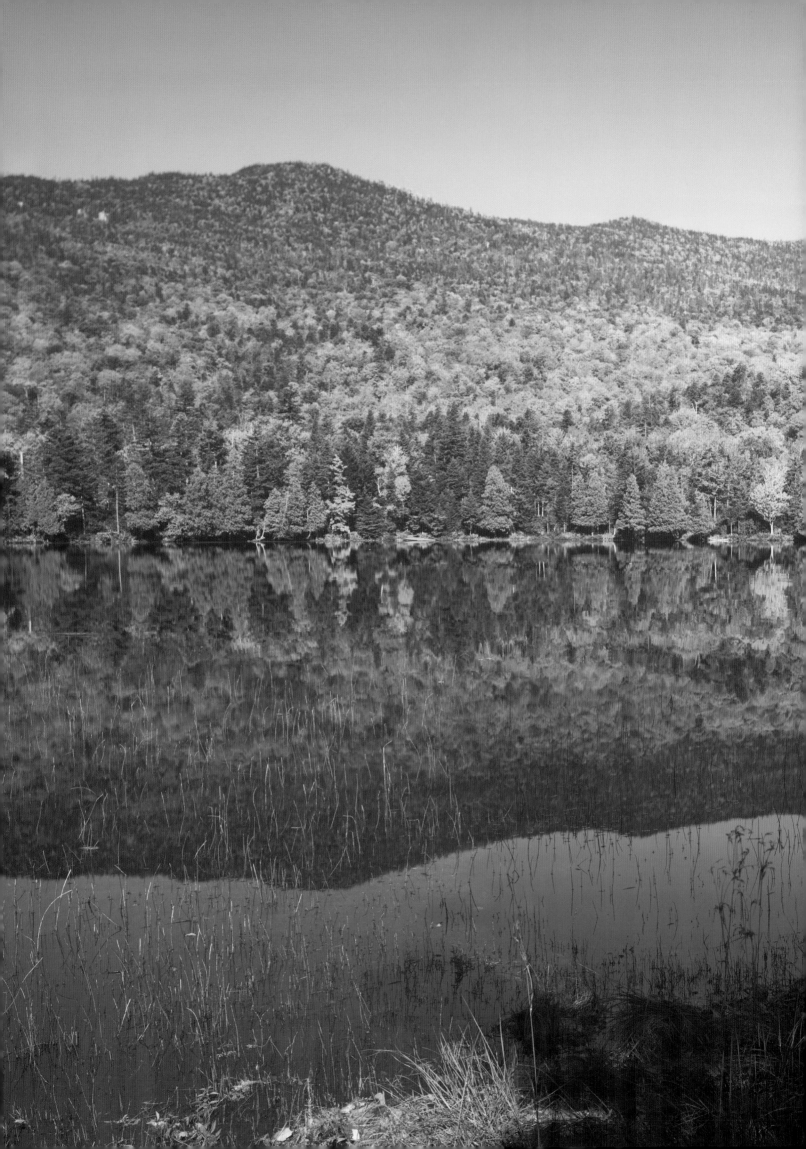

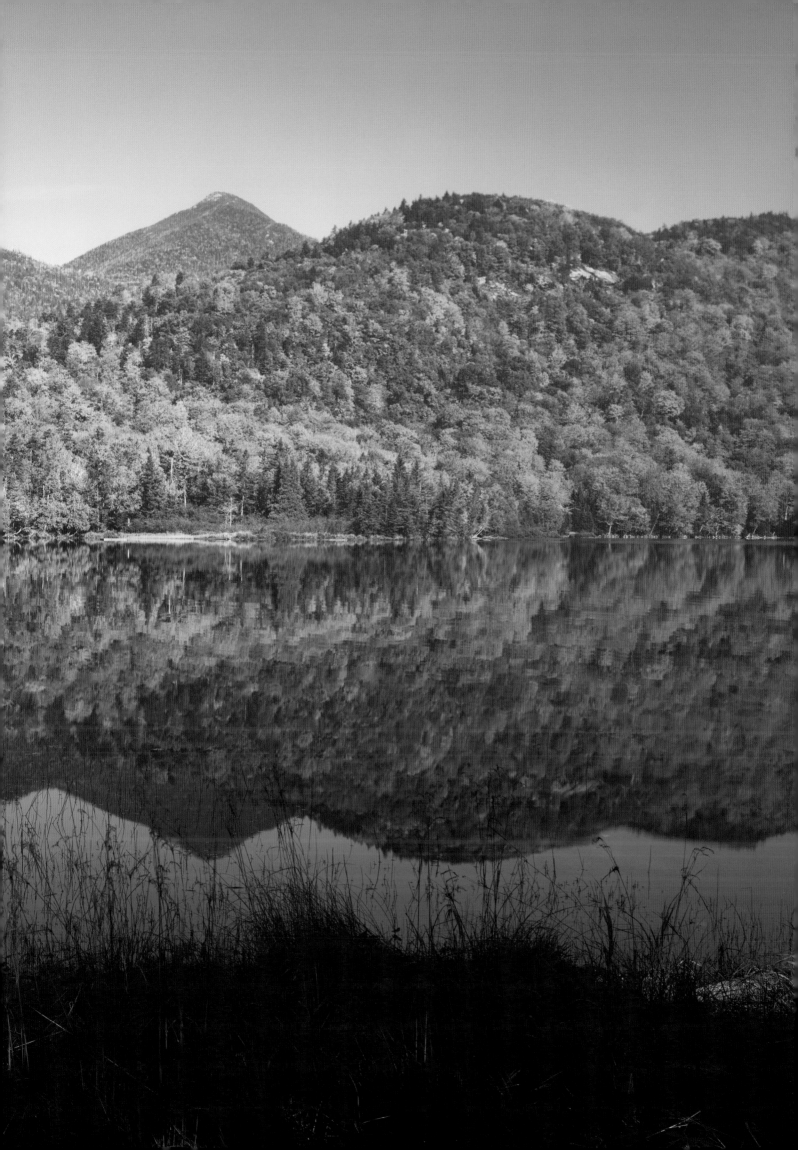

A Forest Turned Fragile

Nature has its own way of thinning a forest. In this case, a major ice storm in January 1998—one that left me without power for two weeks—caused many trees to break under the weight of ice. Affecting more than twenty million acres, this ice storm may have been the most ecologically significant disturbance in the Northeast in the twentieth century.

In certain weather conditions, a coating of ice can accumulate so that it becomes several times thicker than the smallest twig of a tree. The ice-covered branches are sometimes three or four times heavier than the tree itself.

The impact on trees is variable, depending in part on the tree species. The white birch in this photograph (opposite), surrounded by hemlocks, maples, and other hardwoods, has splintered and broken because its wood is not designed to hold that much excess weight. Indeed, birch trees were perhaps most affected: some snapped off, others bent into permanent "arched-over" shapes. The strong wood and resilient branches of the other tree species helped them to resist and recover from the Great Ice Storm of '98.

What happens to a forest after a storm like this? Forest recovery can be a slow process. Ecologists are studying things like species recovery and regeneration: changes to the understory due to increased light at the forest floor, effect on sap runs in sugar maples, and more. Nature will undoubtedly respond to this disturbance, and in a way, it gives us a new chance to learn more about the adaptive process.

BROKEN BIRCH, ICE STORM ▶

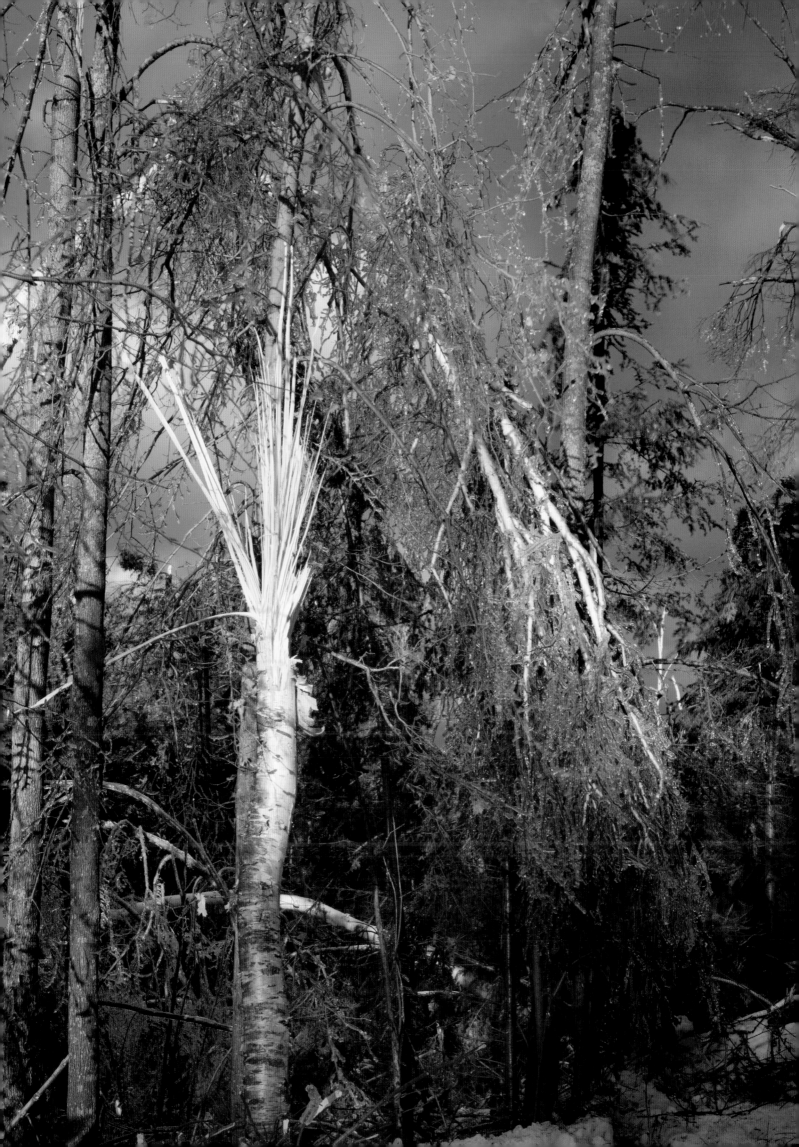

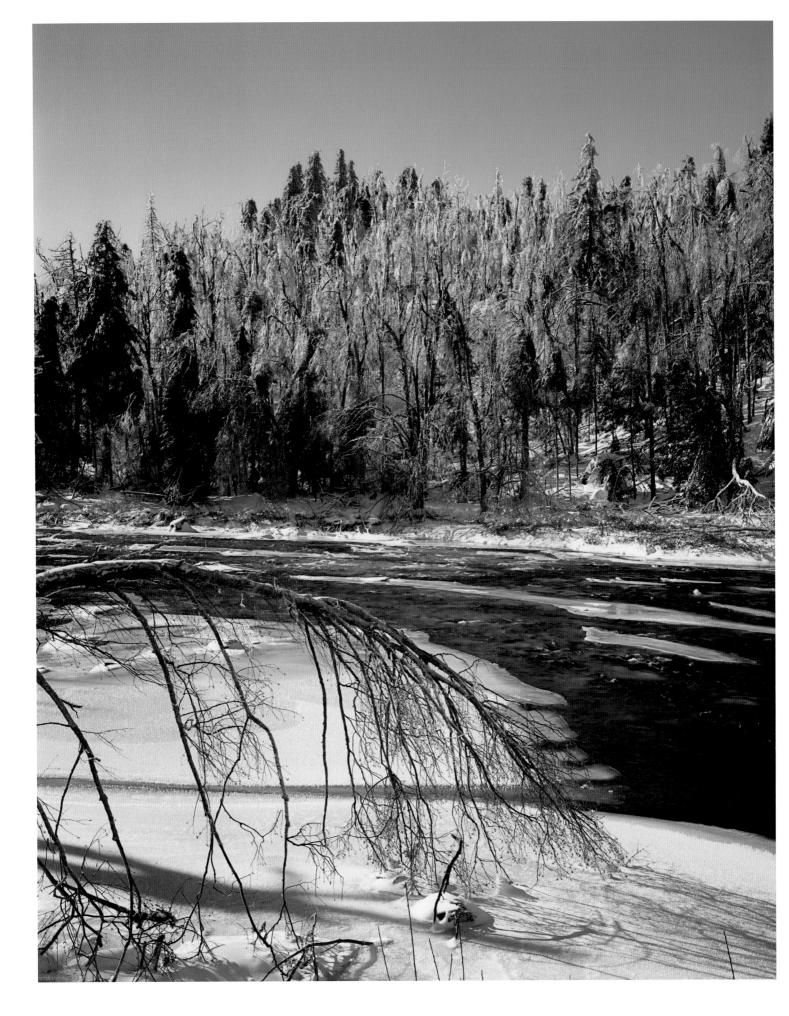

ICE CATHEDRAL

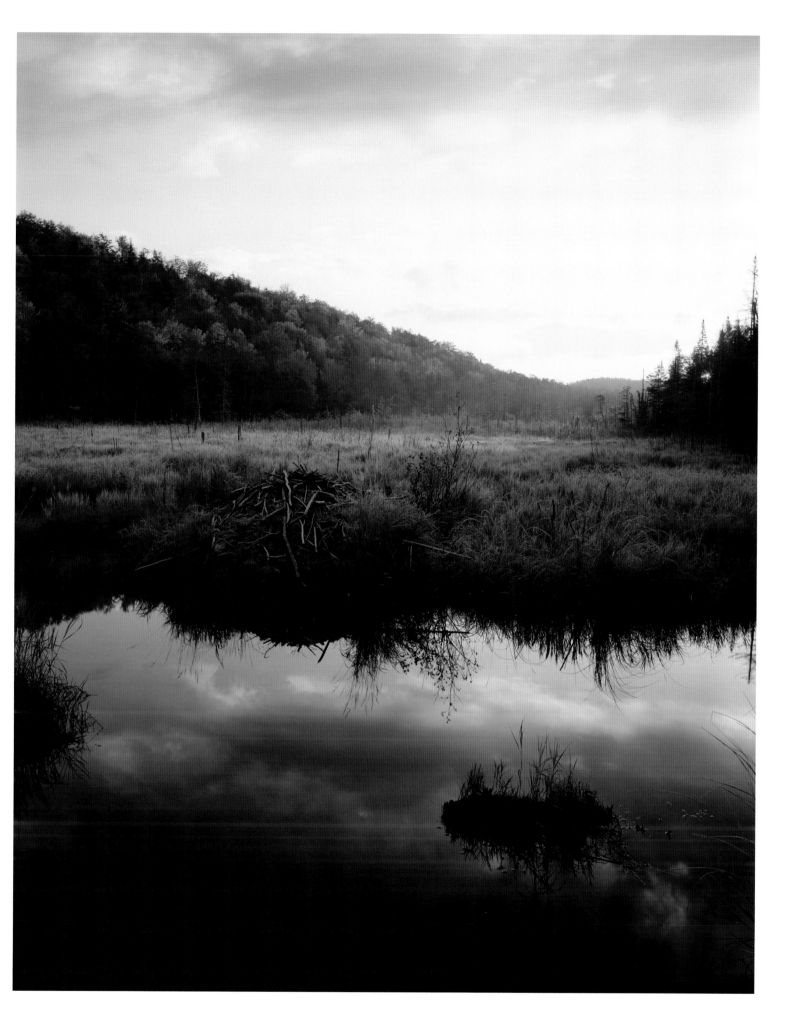

Salmon River Flow

From Pitchoff in Fall

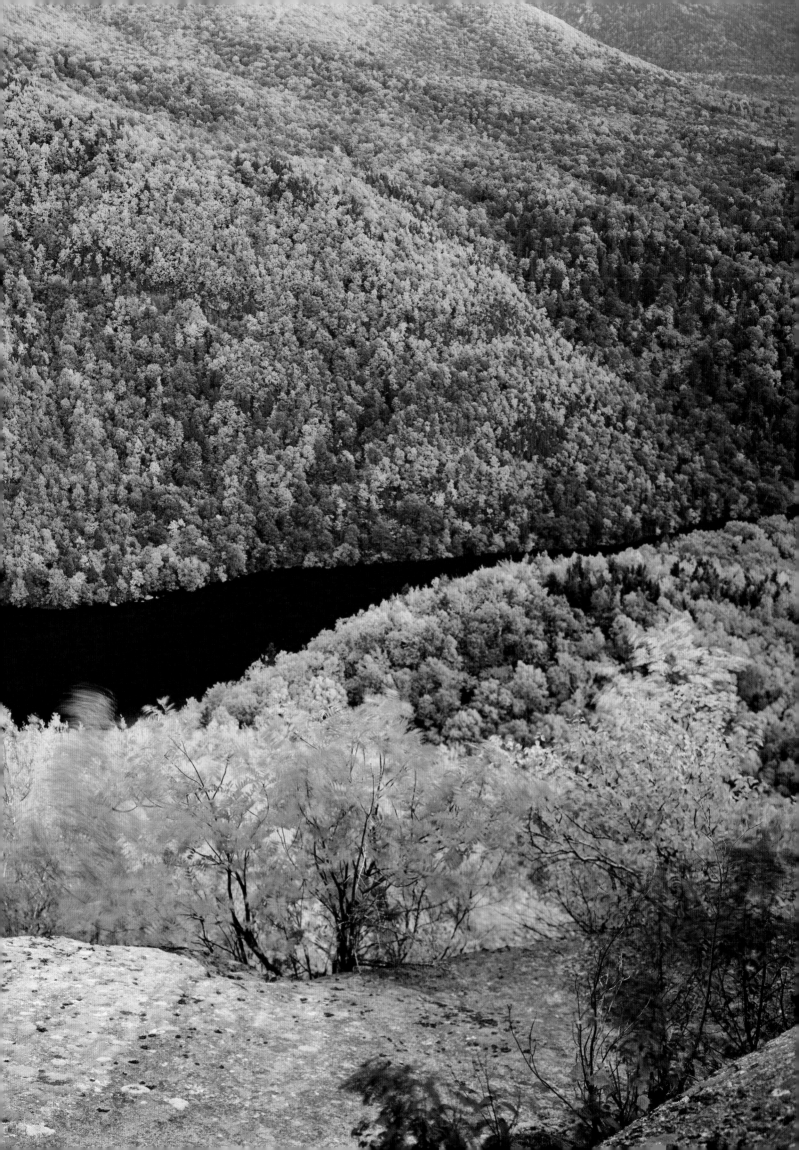

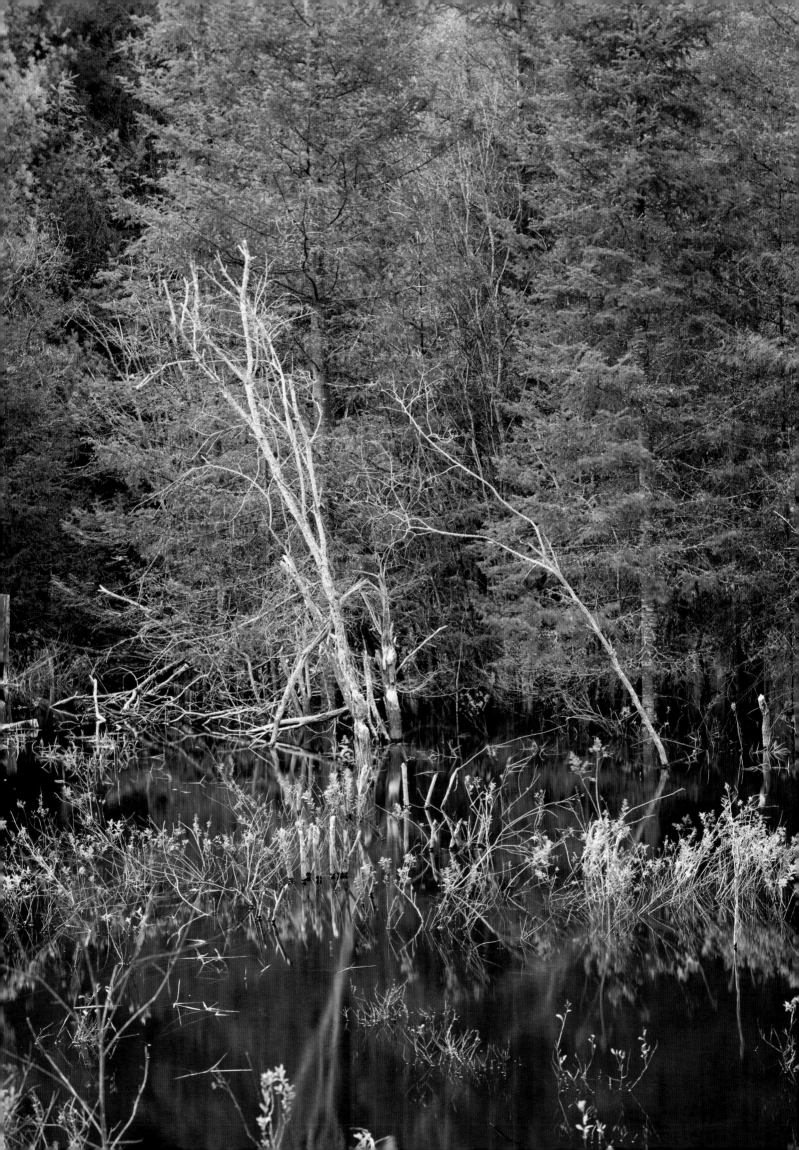

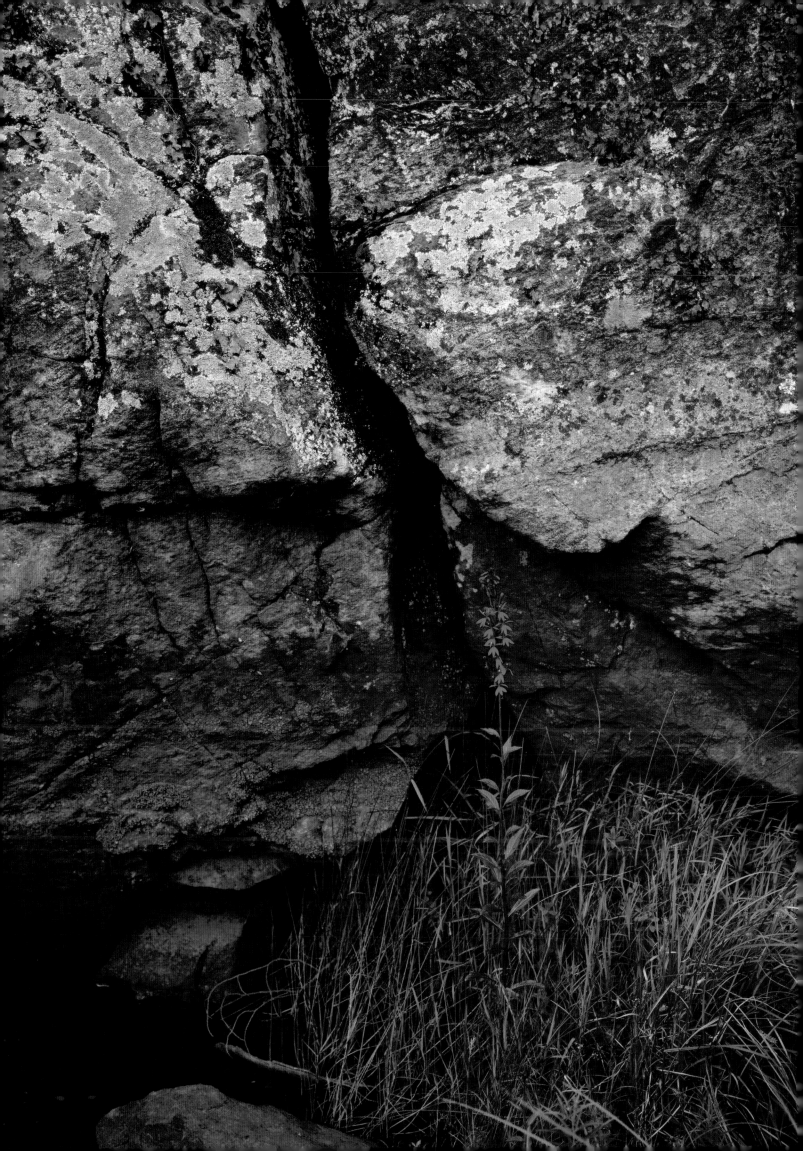

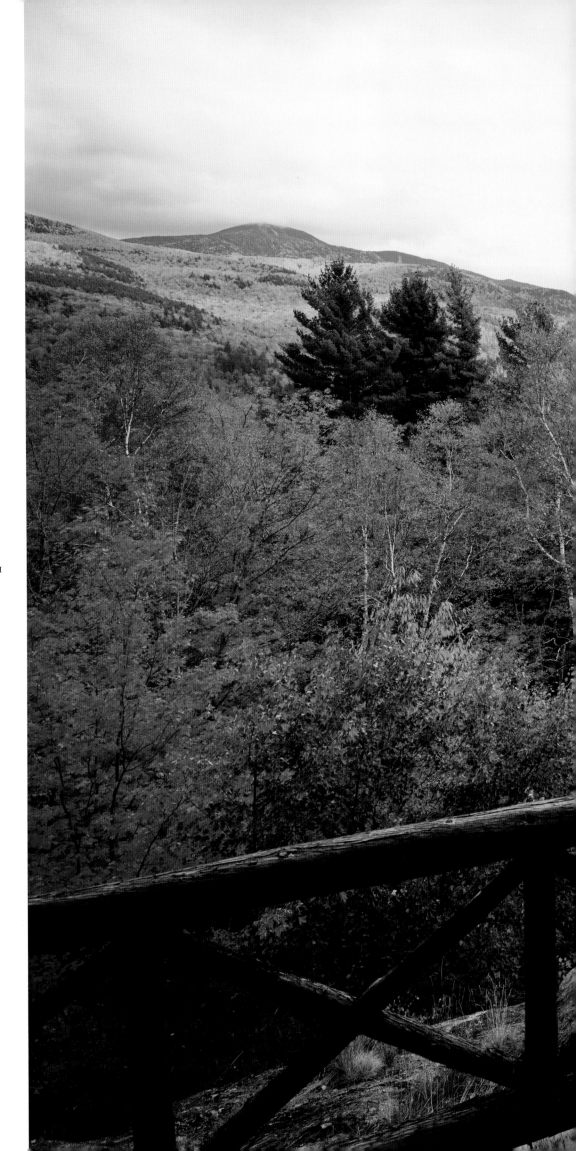

KEENE VALLEY PORCH

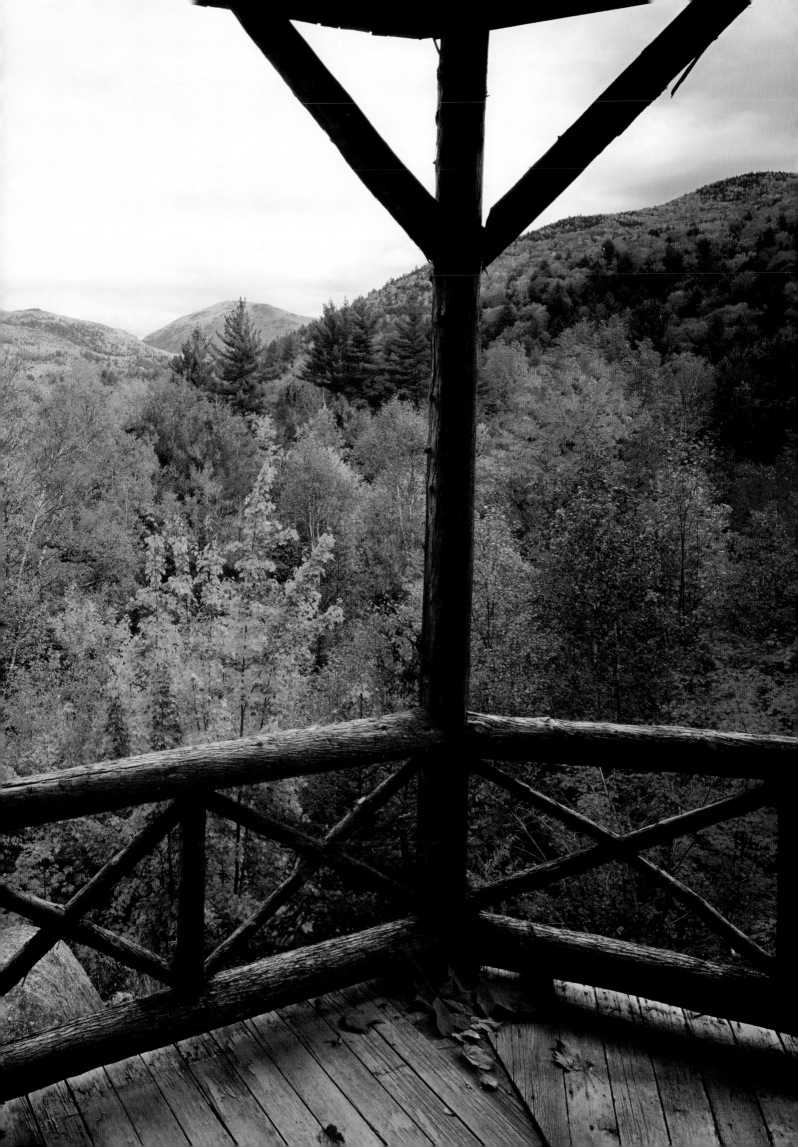

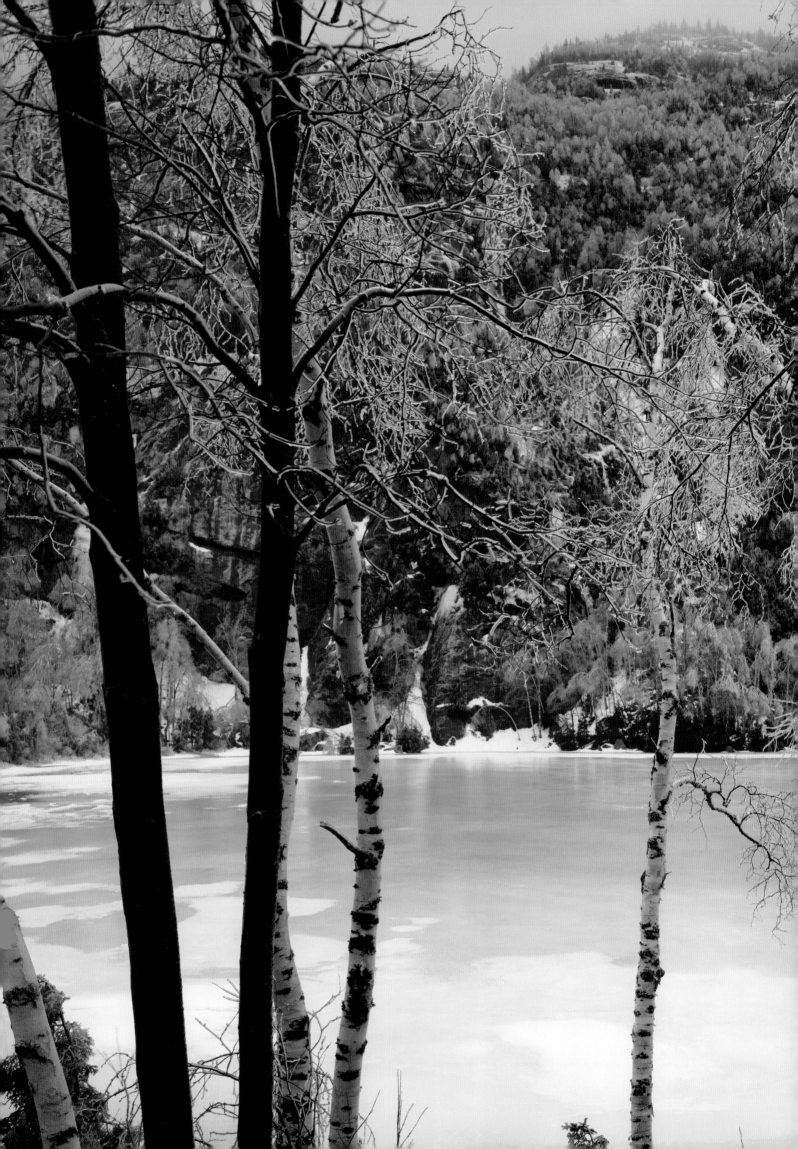

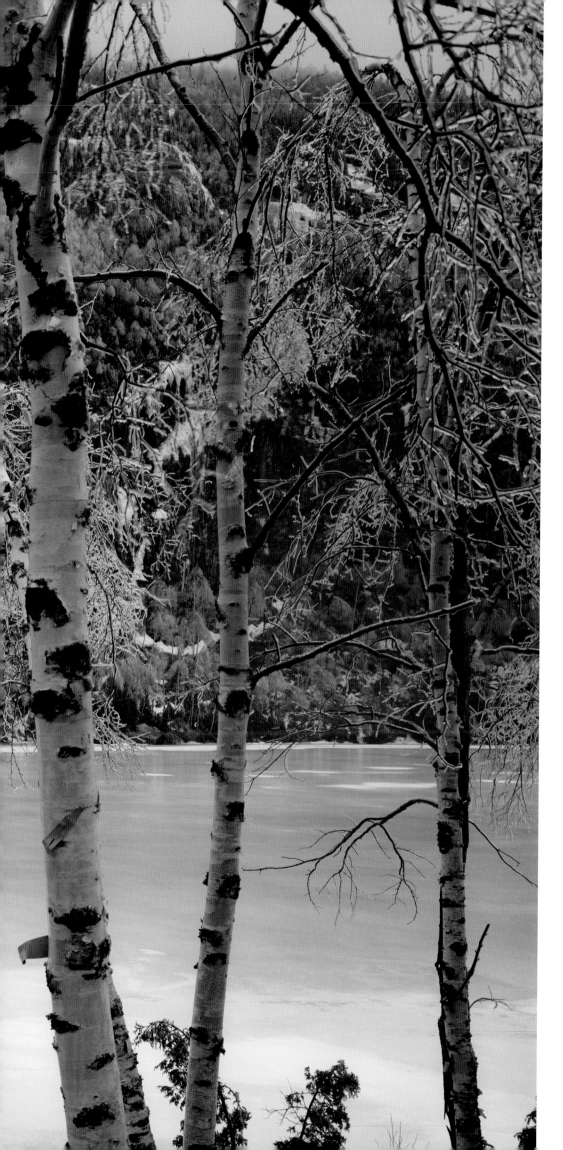

CHAPEL POND ICE STORM

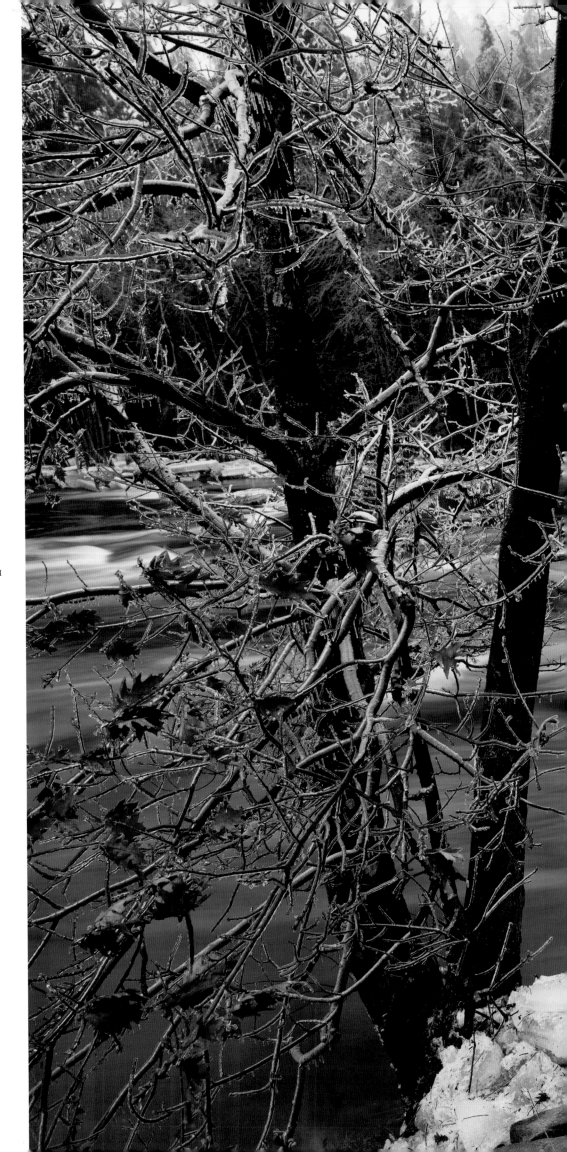

Spring Ice Storm

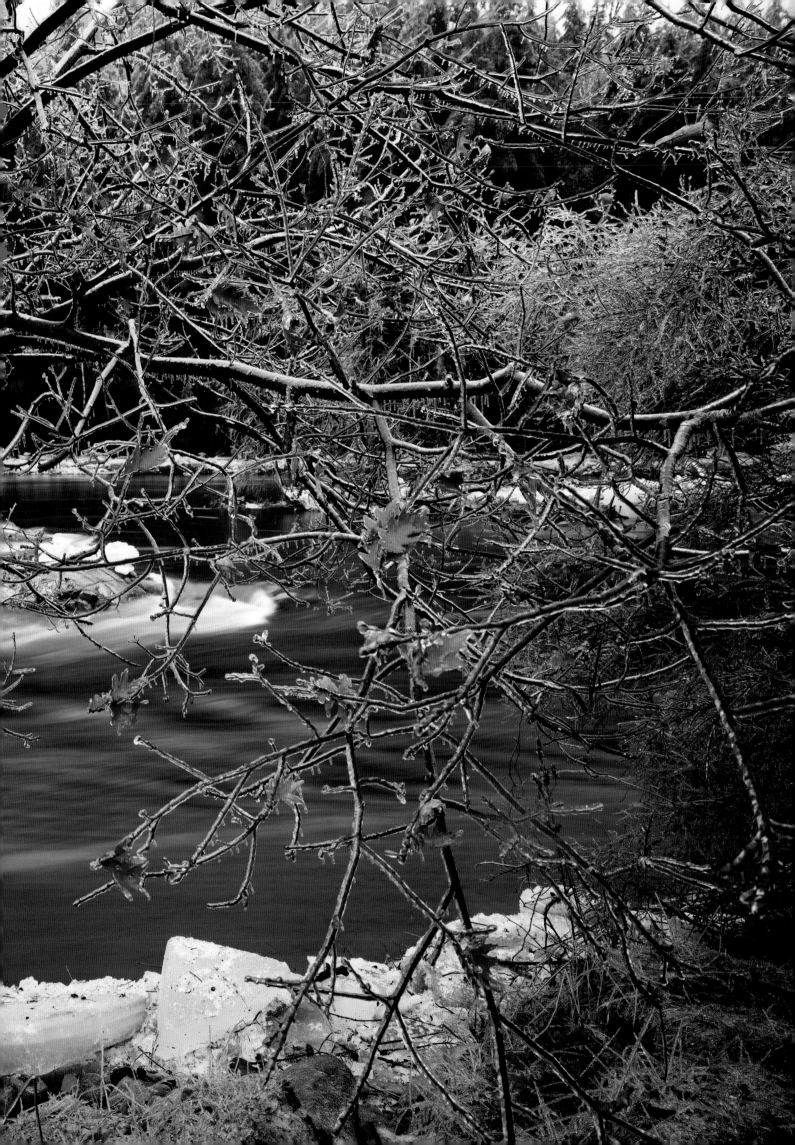

A Surrounding Presence

One early March morning I opened my eyes to an Adirondack landscape as different as any I had ever seen. I immediately wanted to photograph this encrustation—this unearthly and delicate coating on the land.

I had not opened up my camera since my mother died more than a month before. I had been dealing with the mundane details of her death and the transcendental transactions of her afterlife, sometimes wondering how I might make images that would somehow incorporate

Detail of Spring Ice Storm (previous pages), branches and leaves are encrusted with ice

my thoughts and feelings about her. As I worked that morning, I started to think that this muted, semiclear coating, this chromatic mutation of color, space, and dimensional elements, was an excellent metaphor for the transition between the living and not living. For months my mother had been extremely frail and delicate, almost not there. Now, I felt her presence everywhere.

The roads were pure sheets of ice; the only way I could even get to the edge of my property was to put my crampons on. Because the landscape was so completely transformed I knew that I could make interesting pictures almost anywhere. I was determined to drive at least to some familiar and easy-to-reach places. By the end of that day, I had gone as far as the West Branch of the Ausable River in the Wilmington Notch, on to Chapel Pond, and then home. Everywhere I went that day I was alone with my camera and my thoughts about my mother.

Detail of Spring Ice Storm ▶

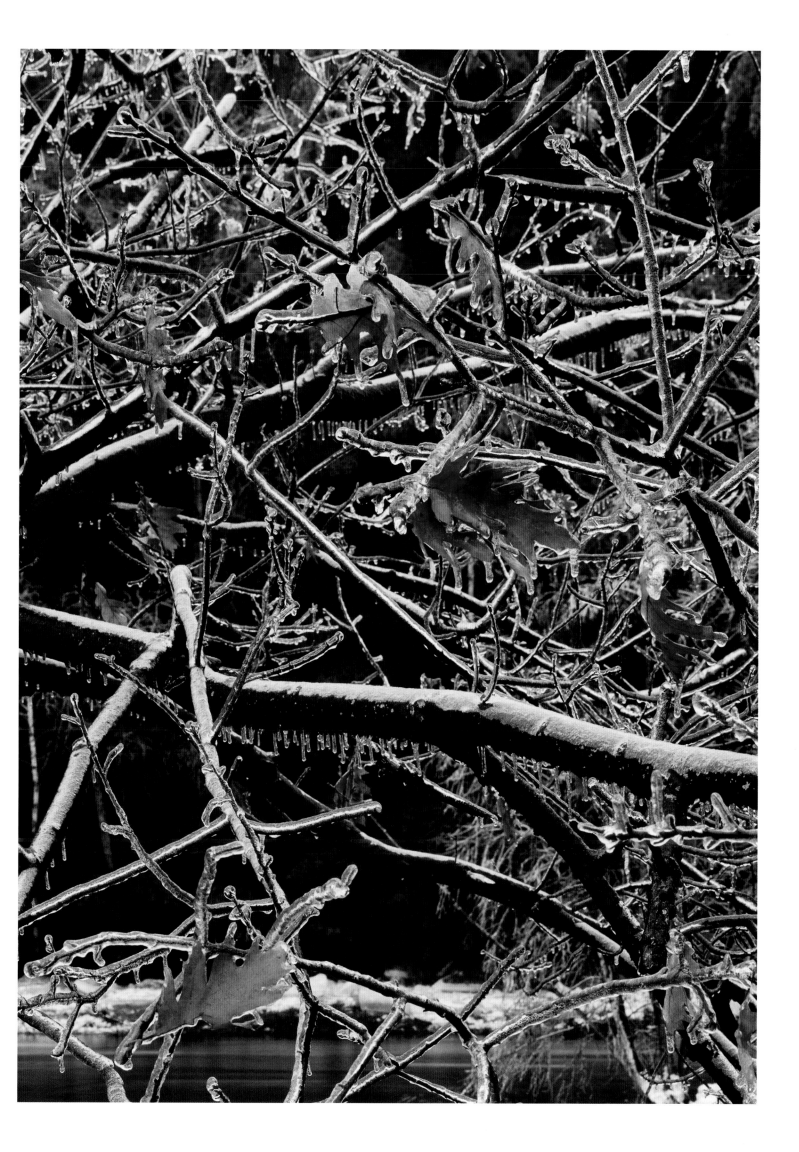

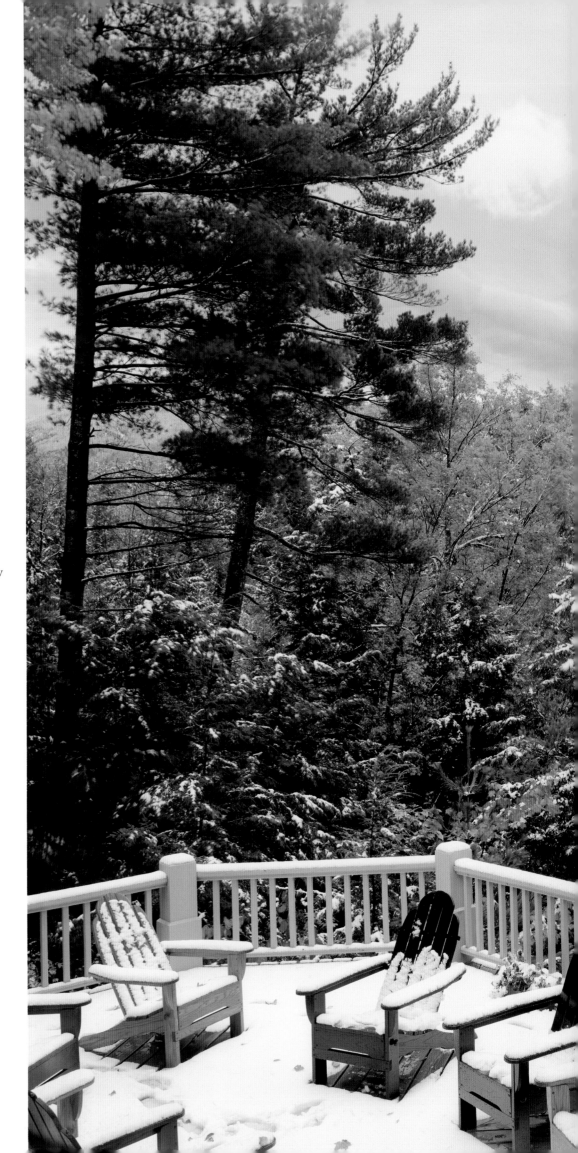

Adirondack Chairs in Snow

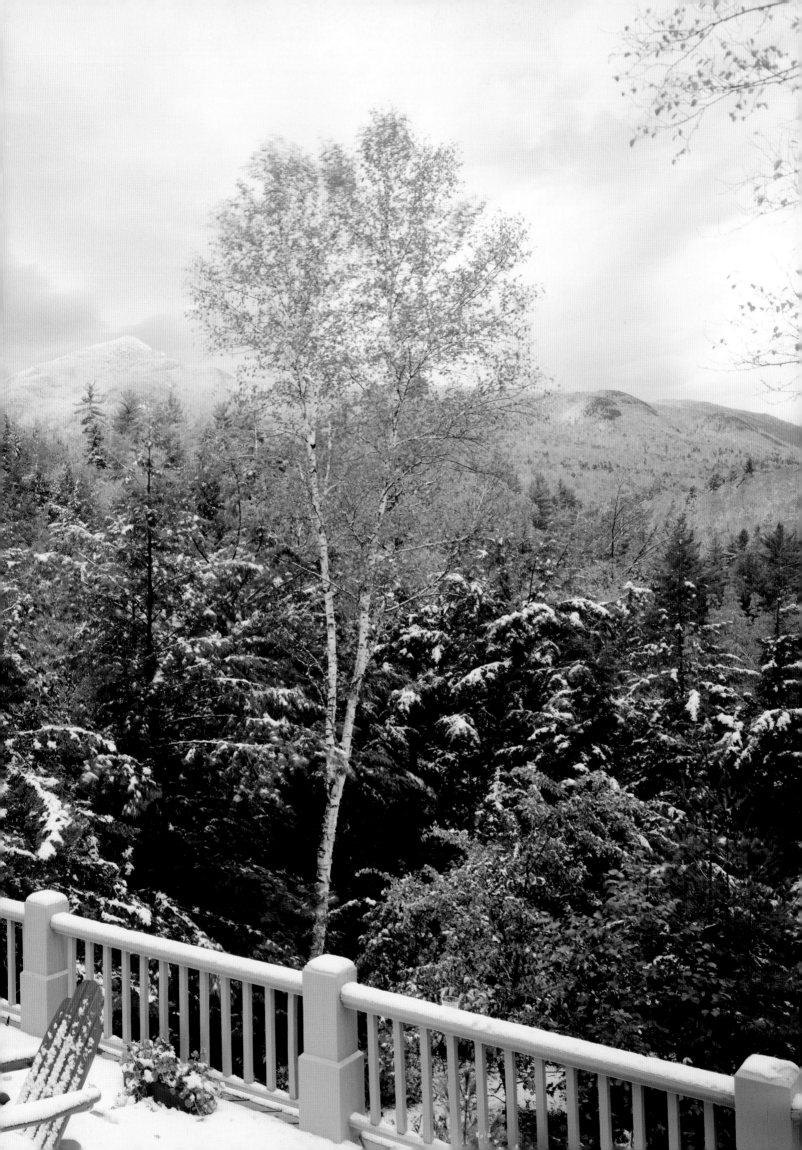

AFTERWORD

A Land of Integrity

It's a standing joke in our family. At any particularly beautiful moment—when the fog on Garnet Lake shines in the early morning sun as if lit from within, or if the snow high on Crane Mountain turns pink in an early January sunset, or the Hudson's collecting frazzle ice on a frigid North Creek afternoon—someone will say, "Where's Nathan Farb when you need him?"

This book does plenty to answer that question. Nathan Farb's off somewhere within the Blue Line, which circumscribes the Adirondack Park, lugging that heavy camera of his up another mountain before dawn, or standing stock still in Cherry Patch Pond for an hour waiting for the ripples to die and the lily pads to frame the distant peaks. He is our Ansel Adams, and his images are becoming the icons of the park. I realized how deeply they'd sunk in when I was able to immediately identify the fifteen or so photos in this volume that were first printed in his 1985 book *The Adirondacks.*

The proof of his power is that these pictures manage to capture many of the subtle qualities that make the Adirondacks what they are: arguably the most important experiment in nature conservation anywhere on the planet.

Size, for one. Because the Adirondacks lie in the eastern half of the nation, and because American heads swivel west when we talk about wild lands, it's hard for many to grasp how big the park really is. Six million acres doesn't really do it—in these post-agricultural days most of us have only a notional idea of an acre. Even "bigger than Grand Canyon, Glacier, and Yellowstone combined" is more a boast than a real measure. To feel its size you have to get up high, as Nathan has done over and over and over. And then you have to remind yourself that even from the highest points you can see only a small fraction of the land contained by the Blue Line. Stony Creek and Big Moose and Cranberry Lake and Elizabethtown are many, many days' walk, one from another, isolated outposts in a tremendous sea of green.

What's more, it's the right size. Yellowstone is a lovely park, but it doesn't contain an ecosystem; witness the annual sadness of bison being slaughtered because nature impels them to step across the park boundary. But because the Blue Line around the Adirondacks was drawn in part for ecological reasons such as preventing the silting-in of New York's rivers, it contains an essentially intact geological dome. If a biologist were asked to redraw the map today, it would look much the same, albeit with the corridors that should connect it more easily to the wild places north and east and south.

What's it like up here on the dome? For one thing, as Farb's pictures make abundantly clear, it's wet. I remember one time spending some days hiking in Vermont, and then picking up my trek on the western shore of Lake Champlain. The first thing that struck me was how much wetter it was (and the second thing, not unrelated, was how many mosquitoes were suddenly biting my neck). Unlike the drained farmland of the Green Mountain State, the great forests of the park serve as a giant sponge, catching rain and snow and slowly releasing it to the beaver ponds, and then the lakes, and then the fiber network of small rivers. That water—in the emerald moss beds, in the mist hovering above the lakes, in the snow lingering into May in the shady northern exposures, in the vernal croak-haunted pools—is a signature of this place, and for freshwater ecologists its greatest delight, albeit a delight always threatened by the plunging pH of our precipitation as acid raid continues to ravage our environment.

There are other particular pleasures for ecologists too, including the Adirondacks' unparalleled collection of rare and exemplary natural communities. Some are large and obvious: the great tracts of boreal forest, for instance, which make big stretches of the park feel like northern Quebec. Or the alpine habitat of the High Peaks—only a few score acres, and once casually trampled beneath a thousand Vibram hiking soles, but now much more cherished and understood. (There's something so cheering about arriving on top of Algonquin to find the summit steward, some fresh-faced college kid, eager to help you appreciate the tiny wildflowers and to listen politely as you become the hundredth person that week to compliment her on what a pretty office she has). Other treasures are better hidden—remote ponds with acres of floating peat bog along the shores, or the bizarre ice meadows of the upper Hudson, where the big bergs thrown up by the chaos of ice-out at the spring thaw pile along the shore and slowly melt till June, turning these few acres into a simulacra of Arctic tundra. I remember taking a Nature Conservancy ecologist out for a hike one day on a mountain, called Huckleberry, in northern Warren County, a trail-less peak climbed by a few dozen folks a year; when I was done showing off my favorite spots, he proclaimed it the best example of a red pine–rocky summit ecosystem in the entire east. Who knew? His final list, when he sent it to me a year or two later, showed dozens upon dozens of such finds: perfect tannic bogs, classic shoreline stands of white pine. Gems everywhere, and many of their facets revealed here by Nathan's photos and Jerry Jenkins's notes.

In recent years, however, groups like the Nature Conservancy have come to understand the world as more than a collection of rare and threatened patches. The refocusing of the conservation lens to look at whole landscapes makes even clearer the overriding importance of this land, for there are few places anywhere with this kind of large-scale ecological integrity.

That's why the work of the Adirondack chapter of the Conservancy is so crucial— instead of working on the ripped and shredded canvas that marks so much of America, they

have an Old Master to restore. Each new acquisition, each connecting corridor, brings it further back to full and vivid life. In an odd way, the Adirondacks is not unlike the other treasure of the Empire State, New York City. Down at the other end of the Hudson sits the single most culturally diverse place on the planet, a spot famous for having more kinds of people than

any city ever had—walk on the street beneath the 7 line to Flushing and you pass through half of the cultures on earth, Hindu temples and *dosa* restaurants a block from Ukrainian or Grenadan or Pakistani. Punk artists and investment brokers share Manhattan; everyone argues; it all works. It is, in some sense, an ecosystem of rare beauty, filled with exemplary communities. And preserving it is largely a matter of making sure key systems

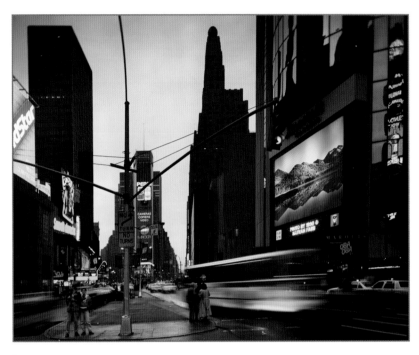

A photograph by Nathan Farb of the Upper Ausable Lake, displayed in Times Square in New York City, October 1992

are in place (subways, schools, art institutions, water pipes) and then stepping back to see what happens. When Times Square was being redeveloped some years ago, city officials realized that glitter was somehow one of the city's linchpins, and so they passed an ordinance requiring new builders to put up illuminated signs on their facades. What a pleasure that the picture above shows—a Farb image of Upper Ausable Lake looking over Broadway from one of those signs. It is a reminder of deeper connections than we can almost articulate.

To use a different metaphor, all the vital organs are currently intact here within the Blue Line. Years ago a few of us wrote a book called *25 Bike Tours in the Adirondacks*. To fill it up, we had to include just about every stretch of pavement in the park—once you get into the core Adirondack woods, there just isn't much. Look at any map of the east—it's a spaghetti bowl of roads, with the exception of the Adirondacks and the North Woods of Maine. And the North Woods of Maine, largely unprotected, look like the Adirondacks did a century ago—which is to say, cut over. Badly abused. Pretty damn ugly.

And that is the segue to perhaps the most important parts of the Adirondack story, parts that can't be thoroughly captured by the camera (unless you had a time-lapse system and let it run for a century). This land that we see through Nathan's lens? It is mostly recovered land. These great vistas? The largest scale experiment in landscape restoration the world has yet known. For more than a century now, the people of New York have been slowly stepping back and reducing their impact. Almost all of this three million acres of "forever wild" land was cut once upon a time, at least to some extent. So you're looking at something even better, in my mind, than virgin wilderness. You're looking at the incredibly hopeful evidence of what could happen in a thousand other places around the world if people there too could figure out how to take some steps back. The natural world retains enough vigor to fill the void: the beaver has ambled back, and the bear, and the moose.

But not just the beaver and the bear and the moose: this place hosts people too, 140,000 of them. They're not always present in Nathan's pictures, except implicitly; they're certainly there in the story of his life, one of the wilder Adirondack tales I can imagine. He was certainly the only rabbi's kid living within the Blue Line; his stepfather was probably the only adult male without a driver's license. But they were part of the fabric of this place, just like the garnet miners in my town, and the legions of small-scale loggers, and the teachers and the guides and the chefs and everyone else who has figured out ways to make a living here, more or less in the same place that nature is making its living. It's not perfect, it's not without tensions—but show me anywhere else in America where there's a comparable effort at compromise between people and the rest of creation. And this too is good news for the rest of the world, because an endless series of Yellowstones is unlikely. We need to be able to conserve in those places where people are part of the mix, and for more than a hundred years the Adirondacks have been figuring out how. It's no wonder that delegations of tropical environmentalists charged with planning "biosphere reserves" make regular trips to park agency headquarters at Ray Brook and to the college at Paul Smith's— without knowing what to call it, we've been building a biosphere reserve since the 1890s.

This is a place charged with meaning. Much of that meaning derives from the sheer diverse beauty that Nathan Farb can collect with his 8" x 10" Deardorff camera. But in a vacuum, that beauty would signify only so much. The Adirondacks is not a collection of views—as these photos make clear, it is a whole much greater than the sum of its lovely parts. Real beauty derives from meaning, and these frames are saturated with it. I could look at them the whole long day, except that sometimes I need to go out and see what's happening right now—and wish that Nathan were on hand to capture it for me.

Bill McKibben
Johnsburg, New York

The Adirondack Park

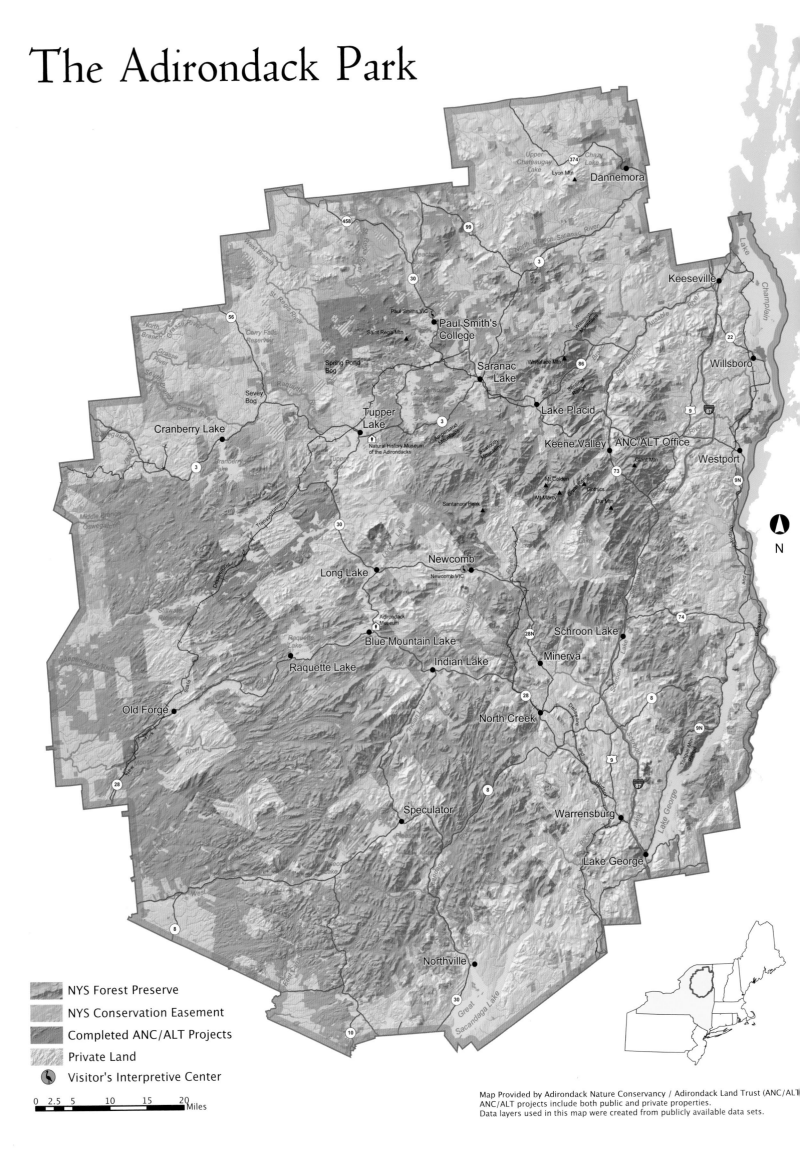

Upper Chateaugay Lake
374
Lyon Mtn
Dannemora

458
99
3
Meacham Lake
North Branch Saranac River

Lake Champlain

30
Keeseville

56
Paul Smiths VIC
Paul Smith's College
Saint Regis Mtn
Spring Pond Bog
Wilmington Mountain
22

Sevey Bog
Tupper Lake
Saranac Lake
Whiteface Mtn
86
Willsboro

Cranberry Lake
3
Natural History Museum of the Adirondacks
Ampersand Mountain
Lake Placid
9
87

3
Cranberry Lake
Sawtooth Mountains
Keene Valley
ANC/ALT Office
Giant Mtn
Westport

Middle Branch Oswegatchie
Transportation
30
Long Lake
Lake
Newcomb
Newcomb VIC
Mt Colden
Mt Marcy
Santanoni Peak
Gothics
Dix Mtn
9N

Stillwater Reservoir
Adirondack Museum
74

Raquette Lake
Blue Mountain Lake
Indian Lake
28N
Schroon Lake
Minerva

Old Forge
Raquette Lake
28
North Creek
8
9N

28
Speculator
8
Warrensburg
Lake George

Northville
30
Great Sacandaga Lake
Lake George

10
8

Legend

- NYS Forest Preserve
- NYS Conservation Easement
- Completed ANC/ALT Projects
- Private Land
- Visitor's Interpretive Center

0 2.5 5 10 15 20 Miles

N

Map Provided by Adirondack Nature Conservancy / Adirondack Land Trust (ANC/ALT)
ANC/ALT projects include both public and private properties.
Data layers used in this map were created from publicly available data sets.

List of Photographs

with Selected Naturalist's Notes by Jerry Jenkins

background, in middle fall. White birches, red spruce, mountain ash in foreground, a rounded ridge with a white-birch-dominated forest center, a few spruce or fir around the pond, and mixed woods, likely birch, beech, and spruce, in the background. The yellow band of birch to the right of the pond is quite striking and suggests disturbance. It could possibly be evidence of an old fire or repeated ice damage.

(68 | 69) FOLLENSBY POND

(71) ST. REGIS RIVER WITH BIRCH BARK. *A bar and still-water, on a slow river in July. Sedges in the foreground and on the bar, still in their translucent early-summer greens; bur reeds, arrowhead, and pondweed in the channel; bluejoint grass, meadowsweet, and herbs on the bar; alders in the background and a white pine reflected in the water. Arrowhead blooms in the foreground, pondweed flowers are just appearing, and meadowsweet and perhaps cleavers have newly bloomed on the bar. New flower clusters, not yet bloomed, appear on the grasses.*

(72 | 73) VIEW FROM HICKOCK MOUNTAIN

(74) WHITEFACE SKI CENTER

(75) SPIDER'S WEB

(76 | 77) VIEW FROM WHITEFACE

(79) THE BLUE LEDGE

(80) FIRE ON NOONMARK. *A mid-elevation, ridge, probably rocky, with a young forest of birch and aspen that has been opened up by a fire hot enough to burn through roots and throw down trees. In the background: mid and upper slopes of the High Peaks; beech and birch in the saddle; spruce-fir with scattered birches on the steep slopes; and a band of krummholz and avalanche scars in the cirques below the ridge. The picture was taken in middle fall; the beech are still green, the birch are colored on the middle slopes and bare on the upper.*

(81) ICE CRACKS ON UPPER CASCADE. *A mountain pond in early spring, with the snow half gone and the ice melting at the edges. The cracks in the ice are pressure cracks from deep winter; the mottling and translucent places suggest that the ice is thinning from below. Behind the pond, a steep rocky slope with white birch and red spruce. The spruce are, as always, on the steepest and rockiest places. The birch, which are heavily damaged from the 1998 ice storm, are on thin pockets of soil in between.*

(82 | 83) TEMPERATURE INVERSION

(85) AUSABLE RIVER MORNING

(86 | 87) BEAVER DAM IN JAY RANGE. *A new and fairly high beaver dam, flooding a shrub swamp, perhaps in a former meadow, and perhaps in a place that was previously occupied by beavers. In the foreground, meadow grasses and herbs, including some European immigrants; below the dam, wetland shrubs, grasses and sedges, including alder, willow, meadowsweet, and one of the tall white asters. In the middle distance, a young woods with white pine, white birch, and red maple.*

(88 | 89) AUSABLE RIVER WEST BRANCH

(90 | 91) VIEW FROM PEAKED MOUNTAIN

(93) SMALL FALLS NEAR THE HUDSON

(94) LICHEN ON PITCHOFF. *A moist and rather dirty rock face, possibly where a sheet of roots and soil has been stripped away, with mosses and liverworts. The small shingled plant covering much of the face is the liverwort Scapania nemorea; on top of it a sphagnum moss in bright shaggy tufts, and to the right, the dark starry shoots of Polytrichum moss.*

(95) DEAD TREE ON THE AUSABLE RIVER

(96 | 97) TUPPER LAKE SHORE. *A rocky and fairly steep shore, typical of recently made lakes, in early fall. White pine, red maple, and black cherry, with fall colors on the ledge; blueberry and sedges below them, just starting to turn color; a torn-up root mat, with grey Cladina lichen on the dead underside; sedges and some weedy European grasses on the disturbed soil below the root mat; cushions of mosses in the water channels on the rocks; and then scoured rocks with a thin growth of a bright orange algae just above the water. This is in fact a zoned community, with the plants arranged by the degree of disturbance, but, because of the steep shore, the zones are compressed and somewhat jumbled.*

(98 | 99) RIVER WITH IRISES

(100) WHITE PINE FLAG

(101) KING WALL

(102 | 103) GLASBY POND

(104) DETAIL OF GLASBY POND

(106 | 107) West Pine Pond Outlet

(109) Detail of West Pine Pond Outlet

(110 | 111) Adirondack Loj Road. *An agricultural valley at 2000 feet, which has been farmed for almost two centuries. This is near the upper limit of farming in the park.*

(112 | 113) Wilmington Notch

(114 | 115) Split Rock Falls

(116) Spring Debris. *Old melting ice in a cascade or on a wet ledge. Mountain maple twigs in the foreground, thin sheets of moss where the ice doesn't scour the rocks, crusts of algae and lichen where it does. The mountain maple is a good ravine plant—pliant, sprouty, low, tolerant of icefall and rockfall, quick growing, and somewhat impermanent.*

(117) Wolfjaw Brook

(119) Orebed Brook

(120 | 121) Guide Boats. *Seven guide boats along the Raquette River. The far shore, which appears to be partly marshy, is dominated by sedges, ferns, and bluejoint grass; behind them are patchy thickets, likely kept open by ice and flooding, of silver maples, dogwoods, and alders. The picture is from early July, when the river flowers are just beginning; swamp candles and turtlehead are in bloom; the bulrushes are in bud but haven't bloomed.*

(122 | 123) Ice and Mud

(124) Ice Flow at Avalanche Pass

(125) Edge of Pond

(126 | 127) View From Noonmark with Bush

(128 | 129) Algonquin Peaks in Storm

(131) Algonquin from Mt. Jo

(132) Buttermilk Falls

(133) Ironwood Trees

(134 | 135) Shadbush. *A ledge-crest in early May; woolly shad and lowbush blueberry in bloom; young red pines, with swollen buds but no new foliage, behind them; young white birches, with dark bark and full new leaves, to the left. The slopes behind them look as if they have swollen buds but no maple blooms or new leaves yet.*

(136) Remains of Otter's Lunch

(137) Loon Nest

(138 | 139) View of Johns Brook Valley from Gothics. *A sparse tundra of blueberries, lichens, and mosses in the foreground; yellow Caloplaca lichens on the boulders. In the background, mixed hardwoods forests with maple colors on the lower slopes, sharply bounded above, possibly from a cut or fire.*

(140 | 141) View of Giant from Gothics

(143) Near the Summit of Little Porter. *A dry ledge in the oak zone, with what is most likely an overturned pitch pine, dead and living oaks, and living white pines. Blueberry and sheep laurel below the trees, and black Grimmia mosses and yellow Cladonia lichens in depressions in the rock. A dry and difficult environment, where it is very hard for plants to build new soil; the lichens and mosses may be occupying the remnants of a soil mat that has largely been stripped away.*

(144 | 145) Between Kiwassa and Oseetah Lakes. *In the foreground, a shallow peaty channel with lily pads; in the background a floating sedge mat with leatherleaf, marsh cinquefoil, iris, sweetgale, and small alders and white cedars. The tall slender sedge, Carex lasiocarpa, is characteristic of wet floating mats, especially where there has been recent flooding.*

(146) On Utowana

(147) Near Tahawas

(148 | 149) Lower Cascade Lake from Pitchoff

(150 | 151) River Road, Lake Placid. *River, at low water, in mid-fall. A low-gradient river with alluvial thickets, kept open by flooding and ice. This is likely after the first frosts, when the trees are turned and flowers gone but the herbs are still green. Alder, white cedar (with its two-year-old branches colored), and blue-stem grass prominent on the left bank, white spruce and yellow birch on the right.*

ACKNOWLEDGMENTS

Once again I want to thank Winnie and Vern Lamb for their help in the early years when I returned to the Adirondacks. Ray Curran, the Adirondack Park biologist, is a good friend with whom I often discussed this work. Many patrons' support has enabled this work. Some of them are Dennis and Joie Delafield, John Eldridge, Richard and Diana Feldman, David Harris, George and Ruth Hart, Cynthia Lefferts, Attorney General Elliot Spitzer, Martin and Connie Stone, and Dr. and Mrs. Daniel Sullivan of St. Lawrence University. Carole Mathe and Cathy Tedford of the Brush Art Gallery at St Lawrence University have been friends and supporters. The same is true for The Lake Placid Center for The Arts, its staff and trustees. Also the same is true for Ed Brohel at SUNY Plattsburgh. Chuck Jessie, an Adirondack woodsman, trapper, and craftsman, has always been there to share his knowledge and wisdom of the woods. Sue Jessie has always been glad to get him out of the house and with me. Other people have contributed in special ways. Some have carried heavy equipment up steep slopes and some spent hours at the computer image processing. Among them are Kenneth Adams, PhD.; Jeannie Ashworth; Matt Bogosian; Mary Jean and Jack Burke; Mary Claire Carroll and Jim Oliver; Sue Cavanaugh; Hannah Cole; Lex Dashnaw; Susie Doolittle; Phil Feinberg; Mac and Margo Fish; Linda Fisher; Carl George, Professor Emeritus of Union College; Tony Goodwin; Steve and Lillian Greenberg; Anne Katz; Lynne Kurtz; Anne LaBastille; Paul and Lelia Matthews; Paul and Judy May; Amanda Means; Roger Mitchell; Marcy Neville; Frank and Martha Lee Owens; Ed Palen; George Papastravorou and Doug March; Anitra Pell; Kevin Rock; Dr. Mary Roden-Tice, mineralogist at SUNY, Plattsburgh; Ruth Sergel; Chris Shaw; Alex and Rosette Shoumatoff; Ben Stechschulte; Judith Treesberg; John Trevor; Denny Derr Uffelman; Lee Williams; and from the Adirondack Nature Conservancy staff, the inspiring Tim Barnett, Bill Brown, Mike Carr, Craig Cheeseman, and Connie Prickett. I wrote most of the text while a guest at the home of Dr. Donald Kreuzer and Johanna Neuhaus. I have had invaluable assistance from Kathleen Carroll, Amanda Jinks, David LaSpina, John Rosenthal, Rebecca Soderholm, and my editor, Christopher Steighner.

First published in the United States of America in 2004

by Rizzoli International Publications, Inc.

300 Park Avenue South, New York, NY 10010

www.rizzoliusa.com

Foreword Text © 2004 Russell Banks.

Map © 2004 Adirondack Nature Conservancy / Adirondack Land Trust.

Afterword Text © 2004 Bill McKibben.

Photo credit, page 20: "They of the Great Rocks." January 18, 2004. NASA/JPL/Cornell.

Design by Rebecca Soderholm

2005 2006 2007 / 10 9 8 7 6 5 4 3 2

ISBN: 0-8478-2638-4

Library of Congress Catalog Control Number: 2004095429

Printed in China

Little Marcy Marcy Gray Skylight

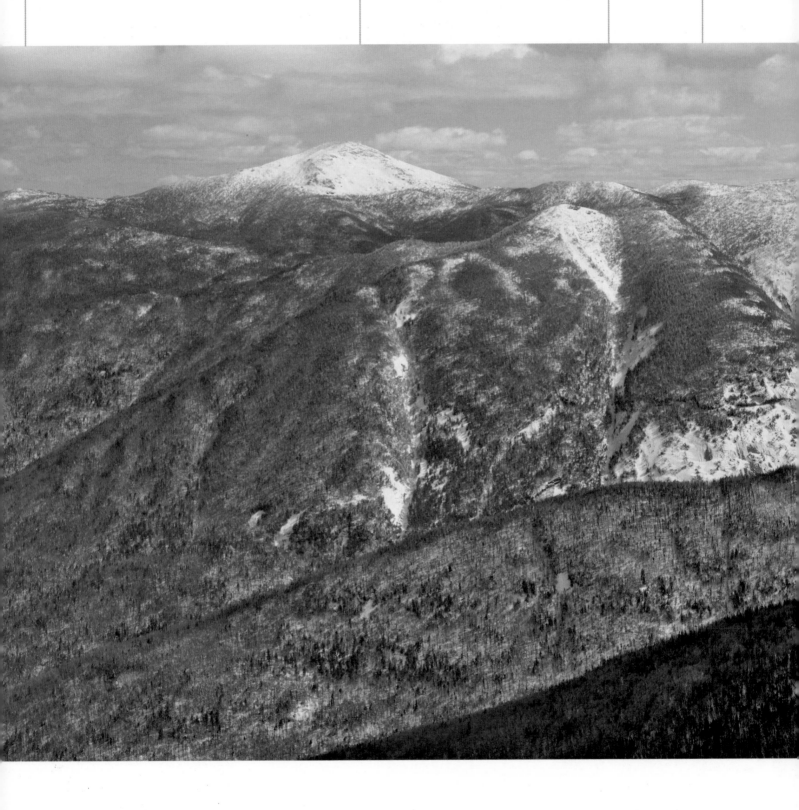